LEICA REFLEX
PRACTICE R5 TO R3

LEICA REFLEX PRACTICE R5 TO R3

Andrew Matheson

HOVE FOTO BOOKS

First Edition August 1987
ISBN 0-906447-36-4

"Reprinted July 1989"

Published by
HOVE FOTO BOOKS
34 Church Road
Hove, East Sussex
BN3 2GJ
England

U.K. Trade Distribution:
Fountain Press Ltd.,
45 The Broadway
Tolworth
Surrey
KT6 7DW

U.S.A. Distribution:
Seven Hills Books
Suite 300
49 Central Avenue
Cincinnati
Ohio 45202

Cover photography by Fred Maroon

Typeset by Direct Image Phototypesetting, Hove
Printed in Portugal by Printe Portugesa

Contents

Acknowledgements

The author and publisher would like to thank Ernst Leitz Wetzlar GmbH and E. Leitz (Instruments) Ltd for their technical assistance in helping to make this book as accurate as possible, for the loan of equipment and for permission to use their registered trade marks. The following Leitz trade marks occur in this book:

ELMAR®
ELMARIT®
LEICA®
LEICAFLEX®
PHOTAR®
SUMMICRON®
SUMMILUX®
TELYT®

and combinations thereof (e.g. MACRO-ELMAR®); also the following Schneider trade marks:

PC-CURTAGON®
SUPER-ANGULON®

1 Leica Reflex Cameras

Today's most popular type of camera among professional and more ambitious amateur photographers is the 35 mm single-lens reflex, or SLR. This is a particularly convenient type of 'seeing' camera: you can observe the image formed by the lens before you take the picture. This image appears on a screen inside the camera and accurately reproduces the view taken in with any lens. It also shows the changing sharpness of the image as you focus the lens.

The single-lens reflex does all this thanks to a hinged mirror located between the lens and the film. The mirror deflects the image-forming rays from the lens up towards a matt screen, forming there a fairly exact equivalent of the image to be generated eventually on the film. That is the image you observe for viewing and

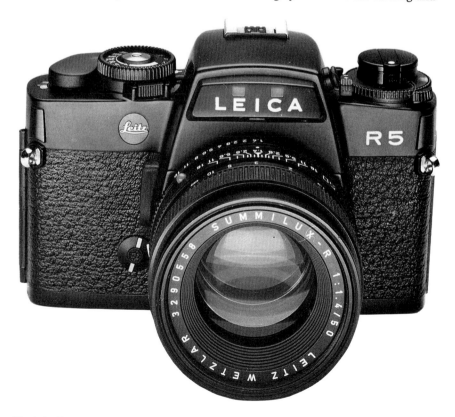

The Leica R5 is the latest and most advanced of the Leica range of single-lens reflex cameras.

focusing. At the moment of the exposure the mirror swings aside so that the lens projects the image on the film as the shutter opens for the exposure. In the Leica R models the mirror passes some light even during viewing; an auxiliary mirror system diverts that to a photocell for exposure measurement and control.

The film size — 24 x 36 mm frames on perforated 35 mm film — is the most widely used current film format. Initially responsible for its popularity was the then amazingly compact Leica camera that first hit the market in the 1920s. Produced by microscope and optical instrument maker Leitz, this was a viewfinder camera, later equipped with a coupled rangefinder. The compact 35 mm camera has evolved into today's mass-market point-and-shoot models with automated exposure, focusing, motorisation etc. It further survives in the rangefinder Leica M6 with its equipment system — the direct descendant of the legendary Leica of over sixty years ago.

At that time single-lens reflexes were bulky cameras, usually taking 4 x 5 inch or larger plates. But ten years later camera makers began to adapt the SLR concept to the 35 mm format, evolving from the 1950s onwards into today's eye-level viewing SLR.

The Leica was also the first precision-engineered 35 mm camera — an essential contribution to high-quality pictures with a small film format. Other cameras followed this lead and, among 35 mm SLRs, took it over. But when Leitz started to produce single-lens reflexes these maintained the same ultimate quality for which Leitz instruments were famous.

It is this precision tradition, rather than revolutionary design, that characterises Leitz's approach to its Leica R (for reflex) cameras. This conservative attitude means that Leica cameras are comparatively slow to incorporate latest hi-tech innovations. They have done so only when Leitz was satisfied that it had developed such facilities to optimum effectiveness. That has at times involved restraint over features not yet considered sufficiently efficient (such as electronic sharpness measurement for automatic focusing) or not ideally convenient (e.g. integral motor drives) nor ultimately desirable (for instance over-elaborate data displays).

This development policy also kept Leitz out of the frenzy of frequent model changes in the mass camera market. That stability contrasts the obsolescence trend of some other makes and parallels a similar continuity among Leica M rangefinder cameras. The basic design (and appearance) of today's Leica R5 hardly differs from the R4 launched over six years earlier.

Shorn of possibly questionable fringe benefits, the latest Leica R5 is an up-to-date SLR camera that concentrates on maximum reliability. Its convenience features are extensively based on professional user feedback. It is one of today's top-level camera systems.

The cosmopolitan camera

Modern cameras have evolved from almost hand-made instruments that could be put together in a comparatively small precision workshop. They have become sophisticated hybrid electronic and optical devices that need elaborate design and production facilities. These are cost-effective only in large-scale manufacture, which obliges smaller producers to seek collaboration with larger firms.

Single-lens reflex camera principle: The mirror **D** reflects the image-forming light from the lens upwards onto the screen **C** to be viewed through the finder system **B** (thick broken line). The mirror **D** is semi-reflecting; an auxiliary mirror **E** diverts some of the light (thin broken lines) to the meter cell **F**. A small prism system **A** also reflects an image of the lens aperture scale into the space below the finder screen. For the exposure (bottom) the mirror and auxiliary mirror swing aside so that the lens projects its image onto the film plane **D**. In the Leica R5 a meter cell also reads light reflected from the film during a flash exposure.

The output of Leica R models is a fraction of a percent of the 6 million or so SLR cameras turned out annually world-wide. Most of these come from Japan where Leitz found a partner in the Minolta Camera Co. For over ten years the latter has supplied body components and electronics for Leica R cameras.

The international aspect of Leica production goes even beyond that. Leitz is one of the most prestigious members of what remains of the West German camera industry. But Leitz (and the Leica Company which handles camera production and marketing) is now Swiss-owned. Some of its factories are in Portugal. Some of its lenses come from another subsidiary in Canada, others from Japan. The Leica R5 is thus one of the most cosmopolitan present-day cameras.

Leica reflex history

Leitz's conservative design attitude was responsible for the firm's comparatively late entry into SLRs in 1965.

The first Leicaflex of that year was a fully mechanical camera with a light-measuring cadmium sulphide (CdS) photoresistor built into the camera front. A follow-pointer coupled with the shutter speed adjustment (1 to $1/2000$ sec) permitted semi-automatic exposure settings. The viewing screen was clear glass with a central microprism spot as a focusing aid. That screen provided an exceptionally bright image but you could only focus it in the centre.

The Leicaflex SL of 1968 had the light meter inside the camera to measure the light of the image formed by the lens (TTL measurement). Leitz called this selective light metering (hence SL) as the cell predominantly measured the centre of the screen image. The screen was a very fine overall microprism area with a coarser microprism centre spot. A **Leicaflex SL MOT** produced in small numbers from 1972 onwards featured coupling elements for an external motor drive.

The Leicaflex SL2 of 1974 added further improvements, including a split-image wedge focusing aid in the screen, a more elaborate exposure setting display (apertures as well as shutter speeds) in the finder and a considerably more sensitive metering system. There was again an **SL2 MOT** version with motor drive coupling elements. The Leicaflex SL2 was the last of the mechanical Leica reflex cameras and the most sophisticated of its kind. Its ruggedness also made it a favourite among press photographers.

The Leica R3 Electronic in 1976 broke with tradition by being the first Leica SLR with electronic exposure automation. In automatic mode the meter circuits set the exposure time of the electronically controlled all-metal focal plane shutter (continuous range from 4 to $1/1000$ sec) to match the preset lens aperture and prevailing subject luminance. A total of three CdS cells provided a choice of either selective (centre) or full-area image measurement.

The Leica R3 MOT Electronic (1978) again had motor drive coupling elements and a few minor improvements over the R3.

The Leica R4 MOT Electronic in 1980 introduced a new generation of electronic Leica reflex cameras that runs through to the present. The automatic exposure (AE) control modes cover aperture priority, time (shutter) priority and program automation, the metering modes full-area and selective or spot measurement, using silicon photodiodes. The R4 takes interchangeable focusing screens, shows exposure settings by LEDs in the finder and automatically sets itself to the flash synchronising speed ($^1/100$ sec) when certain dedicated flash units are mounted in the hot shoe. The camera has motor coupling elements for use with a motor winder or motor drive. As there are no R4 cameras without motor coupling, the "MOT Electronic" part of the designation was dropped a year later.

The Leica R4s followed in 1983 as a slightly simpler version with aperture priority AE and manual modes only.

The Leica R4s mod. 2 (R4s mod. P in the USA) of 1986 is a modified R4s with minor handling improvements. (For brevity we shall refer to it as the R4s/2.)

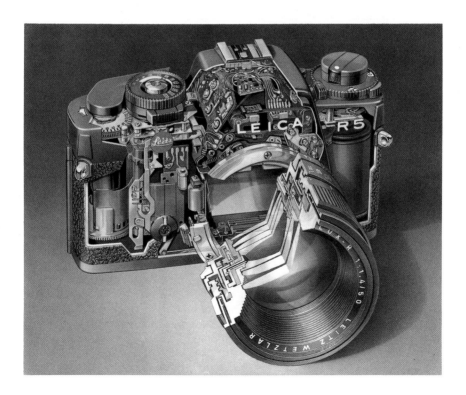

A modern camera contains as much electronics as optics and mechanics: in the Leica R5 microprocessors and circuitry look after exposure measurement and control.

The Leica R5 of 1987 has the full AE modes of the R4 with the improvements of the R4s/2 plus TTL flash automation, a top shutter speed of $1/2000$ sec, multiple program modes (program shift), an improved exposure display in the finder, better finder optics plus other minor modifications.

The equipment system

With the original rangefinder Leica, Leitz also initiated the 35 mm system camera — the concept of a basic camera and an extended range of accessories to adapt it to a variety of special accessories. This has been the key to camera versatility ever since. Quite early on these accessories included reflex housings to provide the rangefinder Leica with some of the facilities of a single-lens reflex camera. They were intended for use with tele lenses and with large-scale close-up gear — fields where screen viewing and focusing are clearly superior to a rangefinder. The current Leica R range of course incorporates the reflex features more elegantly and can directly cope with some applications initially catered for by additional sophisticated accessories.

The Leica R system currently covers the following main equipment groups, to be dealt with in their own chapters:

Lenses: Alternative lenses of different focal lengths are taken for granted in today's 35 mm SLR cameras. For the Leica R series this covers some three dozen optical systems of various types, in focal lengths from 12.5 to 800 mm, angles of view from 180° down and maximum apertures from f/1.4. Lens systems are constantly being redesigned and revised, many exist also in earlier versions. In some focal lengths there are alternatives of different lens speed.

Finder accessories: There are five alternative interchangeable screens for the R4 and later models, also correction lenses to adapt the finder eyepiece to individual eyesight variations, and a right-angle finder attachment.

Motorisation: The Leica R models take motor winders that automatically advance the film after every exposure, and motor drives for high-speed sequences. The motor system includes remote control and program accessories.

Close-up gear: After interchangeable lenses this is traditionally the most extensive accessory system. For the Leica R range it covers close-up lens attachments, macro lenses specially corrected for near distances, extension tubes, extension bellows and special copying setups.

Flash: The Leica R5, and to some extent the R4, offer additional automatic facilities in conjunction with certain dedicated flash units. These are not however made by Leitz or the Leica Company.

Others: Miscellaneous accessories include filters, cable releases, lens hoods and caps, table stands, camera cases etc. Many of these are available from various outside sources, with Leitz providing mainly a token range.

Dealing with the current Leica R range in general and with the Leica R5 and R4 in

particular, this handbook is a guide to a Leica SLR style of photography. It is not a theoretical introduction to photo technique, of which the basic concepts are covered in numerous textbooks. As we do need some basic definitions, theoretical points relevant to understanding camera operation are either explained on the spot or summarised in the **Technical Glossary** at the end.

2 The Leica R models in detail

Although the R5 is the latest model of the Leica reflex camera series, it is very closely related to the R4 and its variants. The R5 and R4 models are based on the same body castings, share most controls and the same system approach. Hence it is possible to cover the characteristics and operation of these cameras together. A separate section will describe the earlier generation of the R3 and R3-MOT, with its different but largely parallel features.

All Leica camera bodies, lenses and other equipment and accessories have an order code number, frequently marked on the item itself. Primarily the code is of course a catalogue reference. But by a long Leitz tradition these order codes are the

Most of the camera controls are on top, in two main groups — exposure, release and transport controls at the right; and film speed plus exposure correction settings at the left. In the centre, on top of the prism dome, is the hot shoe with its additional flash control contacts.

most reliable designation of the equipment — often more definitive than a description. Where feasible, such order numbers are therefore indicated in brackets — e.g. (10 061) for the black Leica R5 body — whenever this aids identification.

In descriptions of the camera we shall keep talking about 'left' and 'right'; this invariably refers to the camera as held ready to shoot, not to the usual front view. Thus the release button and winding lever are at the top right, the rewind crank at the top left. Seen from the back, the lateral references are correct for the normal view of the camera. To see them correctly from the front, regard the camera as being upside down.

Leica R5: The top deck

To start this with the least confusion, let us look first at the top of the camera — where most of the controls are, anyway. They are in two groups, to the left and right of the central prism finder housing.

At the right is the *winding lever*. It fits snugly against the back edge of the top,

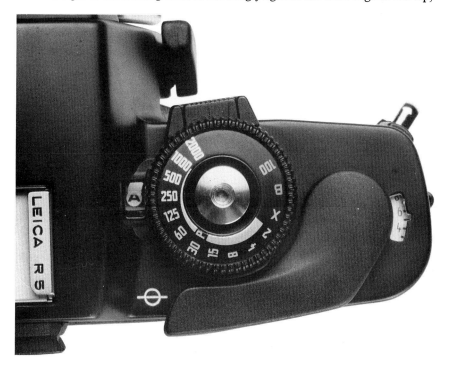

The main item of the righthand controls is the shutter speed dial with the release button in the centre and the cable release socket in the centre of that. The protruding lever below the dial, towards the camera front, is the exposure and metering mode selector. The window to the left of the dial shows that the camera is set to full-area readings in aperture-priority AE mode. The frame counter is the window to the right of the winding lever, the focal plane mark is visible to the left of the tip of the lever (lever fully swung in).

protruding just enough (¹/₈ in.) so that you can pull it out to its start position (about 50°). A further 130° swing advances the film and tensions the shutter after every shot. To the right of the winding lever the *frame counter* window shows the number of exposures made on the film.

Most prominent, to the left of the lever, is the major setting control, combining the *shutter speed dial*, the exposure *mode selector* or program selector and the *release button*. The central screw bush in this button takes a cable release. Next to the mode selector, right up against the dome of the finder housing, is the *mode window*. That is one of the two places where you can check the exposure mode — aperture-priority, program, etc — that you have set. (The finder is the other place.)

The shutter speed dial carries white numbers from 2000 to 2 — indicating user-selectable exposure times from ¹/₂₀₀₀ to ¹/₂ sec — as well as a yellow X (the user-selectable flash synch speed) and red B and 100 settings. The B setting provides long time exposures, the ¹/₁₀₀ sec is a mechanical fallback speed. (See **Long time exposures** and **Mechanical fallback** in Chapter 5.) The dial engages at every marked setting; you cannot select intermediate values. (But meter-set speeds are continuous.)

The curved bar just inside the scale on the dial is a program shift mnemonic (see **Program shift** in Chapter 5).

The mode selector lever protrudes forward below the speed dial and incorporates

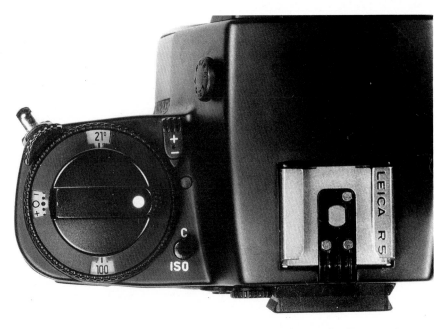

The lower window below the rewind crank indicates arithmetic film speeds (100 of the ISO 100/21° combination) the upper window logarithmic ones (21). The ISO button at the bottom right allows the speeds to be set and checks the battery. The left-hand window shows exposure override corrections, set with the lever protruding at top left. The ± lever at the top right unlocks the exposure correction.

a small spring-loaded release key. You have to depress this key to move the lever, and it needs sufficient effort to make accidental mode changes unlikely.

A mark, consisting of a small circle with a line through the middle, just to the right of the finder housing at the top rear, indicates the film plane. This is the reference point for subject distances marked on the distance scale of the lens. In close-up photography this differs significantly from the subject distance as measured from the lens front.

The centre of the finder dome carries the *hot shoe* for flash units, with a central synch contact and further dedicated control contacts.

At the left is the folding *rewind crank* and underneath it the combined *film speed* and *exposure compensation* dial. Film speeds appear in the front and rear windows, exposure correction values (EV) in the side window. The button labelled ISO next to the dial at the rear unlocks the film speed settings; it is also a *battery check* (in conjunction with a red LED just above it). A lever protruding from below the dial sets exposure corrections once you disengage the *override lock*. That is the button marked ±; you can depress and turn it to keep it disengaged for bracketing exposure sequences. (See **Bracketing exposures** in Chapter 5.)

One final item, in the lefthand side of the finder housing dome is the flash socket for older flash units without hot shoe. A black plastic plug normally protects it against dust etc.

The lens controls

With a lens mounted on the camera, the lens setting scales are also clearly visible from above. The arrangement of rings and scales is fairly similar on most lenses,

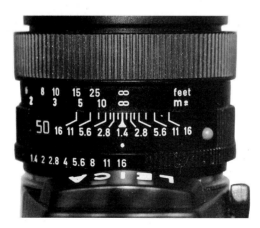

Nearest to the camera body on the lens is the aperture setting ring (here at f/16 for program mode operation). The large scale in front of that (above it in the illustration) is the depth-of-field indicator, the large figures on the left marking the focal length. In front of that is the distance scale of the lens's focusing ring with its ribbed rubber covering. The smooth section in front of that is the extended lens hood.

though of course the rings may be wider or narrower. Taking the standard lens as typical, here is how the controls run:

The rearmost ring (nearest to the camera body) is the *aperture ring* with the aperture scale. On rotating, it normally clicks into position at half-stop intervals.

Immediately in front of it is a fixed ring carrying the *depth of field scale* and to the right of that scale a protruding red pip which is the location mark for mounting the lens on the camera. Past the left end of the depth scale is the focal length in mm (e.g. 50) in large yellow numerals.

Next follows another rotating ring: the *focusing mount* with the dual *distance scale* (feet in yellow, metres in white). Finally, on many of the lenses you can pull forward the foremost ring which then becomes a *lens hood*.

The back and base

More or less centered in the upper part of the body is the square *finder eyepiece*. A groove around its rim can hold a rubber eyecup or eyepiece correction lenses. Immediately to the left of the eyepiece is a button controlling the *eyepiece shutter*. Turn the button anticlockwise (bars horizontal) to close the eyepiece against extraneous light; for example, when using the camera in an automatic exposure mode on a tripod. The closed eyepiece shutter displays a white triangle or circle.

Rear elements of the camera: the eyepiece with eyepiece shutter (the button to the left of the eyepiece) and eyesight adjustment (at the top left corner — on the R5 only). A white triangle (on the Leica R5) or a circle (R4 series) appears in the eyepiece and shows at a glance that the eyepiece is closed. A window on the left-hand side enables a check on whether there is a film in the camera and on details of the film speed (here ISO 200) and number of exposures (36).

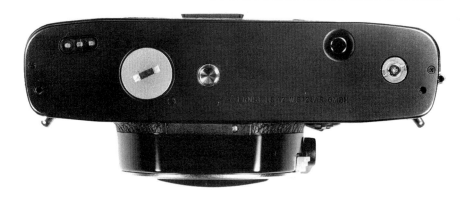

The film transport coupling at the right-hand end of the camera links up with the motor winder or drive shaft; the button just to the left of it disengages the transport for rewinding and double exposures. The contacts at the left (there is a fourth one in the centre, on the base of the lens mount) transfer signals between the camera and motor. Nearly in the centre is the tripod bush, just to the left of it the battery compartment lid.

Above the top left eyepiece corner is the *eyepiece focusing* button to adjust the finder (within limits) to individual eyesight variations.

The camera back itself has a *film window* near the left hand end. Current film cartridges carry indications of film length and speed, located so as to be visible through this window. A foam plastic light seal inside the camera back prevents light leakage to the film.

As you turn the camera over further, with the lens pointing down, the fittings in the base come into view. Nearly in the centre, in line with the lens, is the standard $1/4$ in. *tripod bush* and immediately to the left of it the *battery compartment cover* with its coin slot. To the right of the tripod bush is the *rewind release* — the button that disengages the film transport sprocket inside the camera to permit rewinding and double exposures.

The other items in the base are concerned with the motor winder and drive coupling. The coupling gear itself is near the righthand end of the base, three contacts near the left end and a fourth contact near the base of the lens mount. Finally, a couple of small holes near the left and right ends of the base are location holes for the winder and motor.

The front

If you continue to turn the camera over, its front will then face you upside down, with the remaining controls at the right located for righthand operation. They are the chrome *lens release key* for lens changing (at the lens mount rim), the black *depth preview* or stopdown lever protruding from the side of the mirror box, and the black *selftimer* button in the camera front.

The protruding piece with the 'LEICA' name below the lens mount (on the

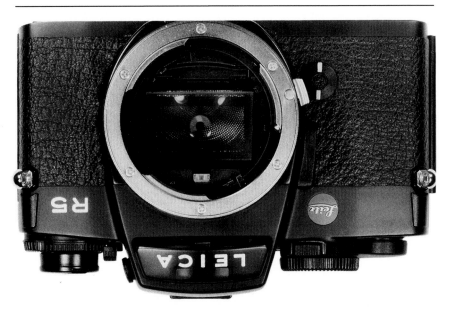

This upside-down view of the R5 makes 'left' and 'right' references the same as the hands when holding the camera. Main controls — now to the right of the lens mount — are the shiny lens release catch and the stopdown lever on the lens mount side, and the self-timer button on the camera front. Below these (in the upside-down view) the exposure mode selector and shutter speed dial are visible edge-on. The rings just inside the lens mount couple with the aperture controls of the lens. In the centre the special metering reflector is just visible through the semi-reflecting mirror.

inverted camera, or above it when right way up) houses elements to convey or illuminate finder information. The central window facing the lens reflects the working aperture from the aperture scale, the window next to the 'C' of 'LEICA' illuminates the preselected shutter speed, and the window next to the 'E' shows the selftimer signal.

When you remove the lens, you see main *mirror*, the patterned *auxiliary reflector* (visible faintly through the partly silvered mirror) that deflects exposure metering light to the meter cell, and the *finder screen*. The latter's handling tongue appears in a cutout of the screen frame at the front. You grip the screens there to change them.

Exposure modes

As we shall constantly come across exposure mode settings and signals, here is a summary of the ways in which the Leica R5 and R4 measure and control exposure. They will be discussed in more detail in Chapters 3 and 5.

There are metering modes, which are ways of measuring the light, and control modes, which are concerned with how the correct exposure is set. The metering modes are *full-area readings* where the photocell measures the average brightness of

more or less the whole image, and *selective* or spot readings that measure only a comparatively small central portion of the image.

The automatic exposure control modes are:

Aperture-priority (A mode): You select a working aperture on the lens. The camera's meter system then automatically sets a correct shutter speed for prevailing light conditions.

Time-priority (T mode) or shutter-speed priority: You preselect a given shutter speed. The camera sets an appropriate aperture.

Program (P mode): The camera sets a suitable aperture/speed combination and you don't have to preset anything (other than film speed).

Manual (m mode) is by definition the non-automatic mode. You preselect whatever settings you want but the camera shows what the correct exposure should be.

Metering and control modes combine in various ways, indicated by the mode signals in the window next to the mode selector and in the finder. **T** mode and **P** mode always go with full-area metering; the **T** and **P** symbols therefore always appear in a square field. With **A** mode you can have either selective or full-area metering — so there are two settings with the **A** in a circle or in a square respectively. Finally, **m** mode always involves selective metering (hence the **m** symbol appears in a circle).

User-preselection and meter settings

While we are on the subject of exposure modes, it is also useful to distinguish between the ways the modes yield their exposure combinations. We have:

(1) Settings selected by the user — apertures and speeds in **m** mode, apertures in **A**, shutter speeds in **T** mode. For clarity we shall in this book always refer to these as *user-selected* or as *preselected* apertures or speeds.

(2) Settings generated by the camera control system. The shutter speed in **A** mode, both aperture and speed (usually) in **P** mode. These we shall call *meter-set* exposure parameters. They include the synch time set by dedicated flash units.

Thus in aperture priority (**A**) mode the aperture is user-selected or preselected and the shutter speed is meter-set; in **T** mode it is the other way round. The viewfinder displays (see below) further differentiate between these types of setting.

Viewfinder information

Originally intended to take over the function of the ground glass screen at the back of the classical studio camera, the reflex finder screen has now also become an information and control centre of the modern SLR. Despite a temptation towards

technical overkill, with twinkling lights and other signals, there is some point in the notion that the user of even a sophisticated automatic camera does want to know what is going on. He finds out by:

The mode signals below the lefthand half of the finder screen. Here red LEDs light up to appear as **T, P, A** or **m** symbols on square or round surrounds to signal which exposure control mode (see above) you have set with the mode selector. The exposure compensation symbol (a red ± in a triangle) lights up when this feature is in use.

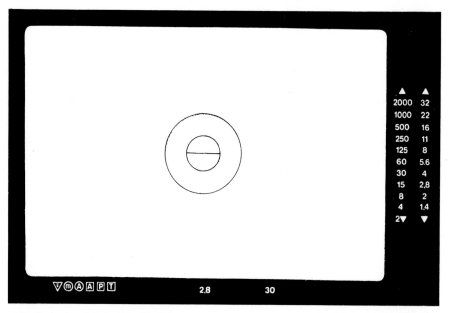

Viewfinder signals in the Leica R5. The two scales at the right are meter-set shutter speeds (in **A, P** and **m** modes) and apertures (in **T** mode). Only one value is visible at a time (or sometimes two adjacent ones), illuminated in red. The user-selected aperture (centre, below the screen) is visible all the time in all modes, the user-selected shutter speed to the right of it all the time in **T, P** and **m** modes. Below the screen at the left are red AE mode signals — **m** and **A** with selective metering, and **A, P** and **T** with centre-weighted full-area metering. Only one of these is visible at a time but may appear together with the ± exposure correction signal in the triangle.

The user-selected aperture and shutter speed (the latter not in **A** mode) appear in square windows below the centre and right of the finder screen.

You see the meter-set shutter speed or aperture (a red illuminated number — depending on exposure mode) along the righthand edge of the screen.

More modest with the R4s

For those who do not feel that they need the multiple exposure modes of the Leica

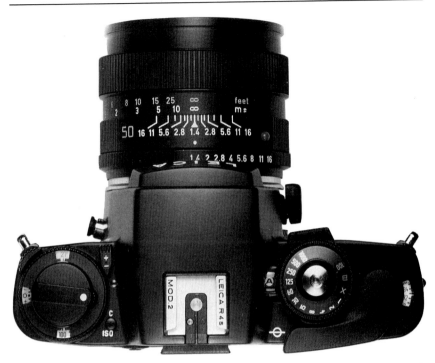

The original Leica R4s was derived from the R4. It was identical to it in all respects, except that the **P** and **T** exposure modes were omitted. It retained the integrated and spot metering of th R4 but had only aperture priority and manual modes. This R4s MOD 2 (called R4s MOD P in U.S.A.) is an improved model which incorporates a number of modifications to the controls resulting from experience in use of the camera, particularly among professionals. These improvements now feature in the R5.

R4 (or now R5), Leitz produce a simpler Leica R4s. Its exposure modes are restricted to automatic shutter control with aperture-priority (**A** mode — with a choice of full-area and selective metering) and manual (**m**) mode. The mode selector thus has only three positions — there is no **T** or **P** mode. Otherwise the R4s has the same features as the Leica R4 (below).

There are two versions of this camera, and the later Model 2 (R4s/2 or R4s/P) has most of the controls shaped like those of the R5. (But it lacks the TTL flash metering and the finder eyepiece adjustment of the R5.) On the original R4s some items (winding lever, mode selector, exposure compensation controls etc) are styled as on the Leica R4, as described below. Instant identification: The R4s/2 carries 'LEICA R4s MOD.2' engraved on the hot shoe (where the R5 is engraved 'LEICA R5'); the Leica R4 and original R4s have no engraving on the shoe.

The Leica R4 and original R4s

As mentioned at the beginning, R4 controls differ only slightly from those of the R5.

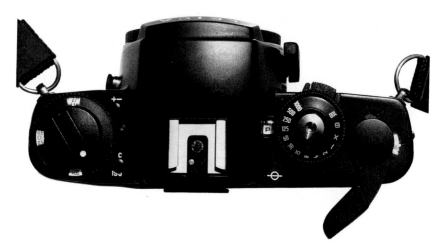

Controls in the top of the R4 (and R4s) are similar to those of the R5 (and R4s/2). Note the slightly different winding lever shape, simpler ± button for exposure correction and only a single dedicated contact in the hot shoe. The second window above the winding lever is the film transport check window.

So here are just the differences, which also apply to the original Leica R4s.

Starting at the top left, the winding lever is a thinner metal lever with a thicker plastic tip. Just above that lever (as you look down on the camera top) the R4 and R4s models have a small film transport check window. (See **The film transport check of the R4** in Chapter 4.)

The shutter speed dial lacks both the $^1/_{2000}$ sec setting and the curved program mnemonic bar. The mode selector release key protrudes slightly more from the selector lever, making the latter a little easier to shift. The hot shoe in the centre (also on the R4s/2) has only the central synch contact and one dedicated contact (not three) while the coaxial PC flash socket is at the side of the lens mount rather than on the finder housing dome.

The override lock for the exposure compensation dial is a simple button. When you depress this, you can move the dial by a tiny lever protruding at the left. The dial engages in $^1/_2$EV intervals rather than $^1/_3$EV.

In the back, the R4 models (including R4s/2) lack the finder eyepiece focusing facility. There are no external differences in the base or the front, apart from the different location of the flash socket.

R4 and R4s viewfinder displays

The Leica R4 (including R4s and R4s/2) conveys largely the same information in the viewfinder as the Leica R5, though in a slightly different form.

The main difference is in the LED display along the righthand edge. Instead of transilluminated numbers for the meter-set shutter speed or aperture, you see in the

R4 all the values as a complete vertical scale of transparent figures against a black ground. In the **A**, **P** and **M** modes these are shutter speeds from 1000 to 1 ($^1/_{1000}$ to 1 sec), or apertures from 32 to 1.4 in the **T** mode. The scales switch as you select the mode. Alongside the scale a red LED lights up to mark the actual meter-set speed or aperture. As in the R5, two neighbouring LEDs may light up for intermediate settings. There are again upward and downward pointing arrowheads (triangles) at the ends of the LED row.

The transparent figures in fact appear against an extension of the focusing screen. Hence the scales of meter-set values are clearly visible only as long as the screen shows a bright subject area. They almost disappear against dark parts of the subject on the screen (or the righthand part of it) and it then becomes difficult to identify which shutter speed or aperture an LED belongs to.

To show up slower shutter speeds liable to generate camera shake, the red LED is round for speeds from $^1/_{60}$ to $^1/_{1000}$ sec (and — as it happens — apertures between f/8 and f/32) and square for speeds of $^1/_{30}$ sec and slower (f/5.6 to f/1.4).

The exposure mode signals below the lefthand part of the screen differ very slightly in appearance on the Leica R4 (black symbols against a solid red square or circle, instead of red symbols inside a red circular or square, etc frame against black) but have otherwise the same function. There are no **T** or **P** signals in the Leica R4s or R4s/2.

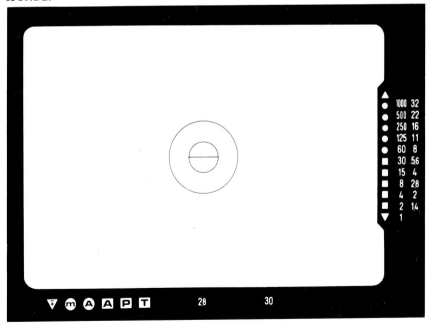

In the R4 models the whole of the shutter speed scale (or aperture scale) is visible all the time, together with one red LED alongside to mark the meter-set speed. Square LEDs indicate speeds of $^1/_{30}$ sec or slower.

The windows for the user-selected aperture and speed (below the centre and right of the finder screen) are the same as in the R5, except that the shutter speed window remains blacked-out also in **P** mode of the Leica R4.

The Leica R3

While this camera is obviously of an earlier Leica SLR generation, many of the facilities of the later R4 and R5 are already present, although sometimes in a less sophisticated form. The layout however is different and the camera is somewhat bulkier.

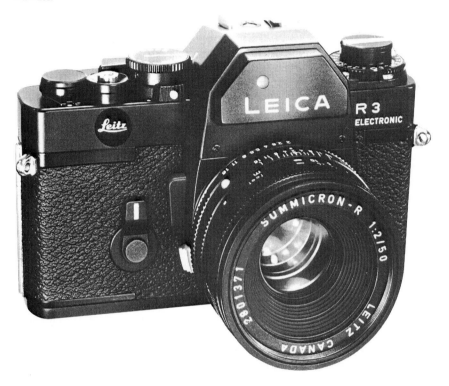

The Leica R3 looked chunkier than the R4 but already had many of the R4 features and controls. The lever on the camera front is the mechanical selftimer.

The righthand end of the camera top again carries the winding lever, release button and shutter speed dial. They are separate here, with the release button (with cable release socket) standing on its own in a small cup that also provides a support for the releasing finger. Underneath the winding lever is a multiple exposure lever that allows the shutter to be wound without advancing the film.

The mode selector underneath the shutter speed dial offers only metering options

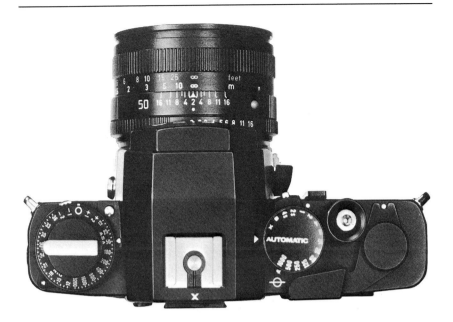

The film speed dial — at the left of the top — on the Leica R3 includes exposure correction settings. The AUTOMATIC setting on the shutter speed dial selects aperture-priority AE, at all other settings the camera is in manual mode. The lever below the dial selects full-area or selective readings. The small lever above the winding lever controls multiple exposures.

— selective or full-area readings. The speed dial carries settings from 1000 ($^1/_{1000}$ sec) to 4 full seconds (marked 4s) plus B, X and AUTOMATIC. The latter sets aperture-priority auto mode; with all other shutter speeds the Leica R3 is in manual mode. The B and X settings are mechanical speeds and work without a battery, too. X is also the flash synch speed ($^1/_{90}$ sec).

Again there is a film speed setting dial below the rewind crank and also an exposure compensation adjustment from -2 to +2 EV. A small button in the protruding boss near the rear corner is the battery check; the LED check signal is in the camera side just below the film speed dial. The Leica R3 has a hot shoe like the R4, but only with the single synchronising contact.

There are more controls on the back of the camera. At the righthand end is the frame counter and immediately above it a film transport check — the equivalent of the check window on the Leica R4 and R4s models. Next to this is a main switch: you have to swing this down to the 'I' position to switch on the camera circuits. At the 'O' setting all camera functions (other than the mechanical X speed) are switched off — a useful safeguard also against accidentally releasing the shutter.

In the centre of the back the Leica R3 has its finder eyepiece and an eyepiece shutter. The lefthand end of the camera back carries a light-trapped film window similar to that on the Leica R5 and R4.

The features in the camera base depend on the model. The plain Leica R3 only

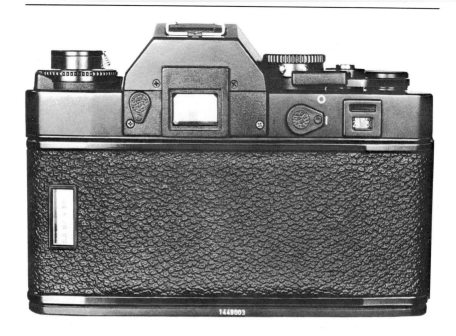

The rear of the R3 already had the eyepiece shutter — here controlled by a lever to the left of the finder eyepiece — but the frame counter and transport signal were also in the camera back (extreme right). The lever between the frame counter and eyepiece is the main switch.

has the tripod bush, battery compartment cover and rewind release. The R3 MOT also has a recess with electric contacts, a locating hole for a matching locating peg on the motor winder, and the coupling shaft for the transport.

The features on the front are once more equivalent to those on the Leica R5 and R4. The lens release catch and depth preview stopdown lever are virtually the same. The selftimer however is mechanical, not electric (and there is no window for a blinking red LED, either). The side of the mirror box has two coaxial flash sockets: one for electronic flash (marked X) and an M socket for combustion type flash bulbs (which hardly anybody uses these days).

The R3 finder

The earlier generation of technology is apparent here too. Instead of LEDs the R3 uses a meter needle that moves over a scale of shutter speeds along the right edge of the finder screen. As in the R4, this scale shows meter-set speeds (in auto mode), while user-selected settings appear in two windows (apertures and shutter speeds) above the screen.

The R3 finder screen is fixed. It is similar to the standard screen with central split-image wedge surrounded by a microprism ring and a matt area made up of even finer microprism elements.

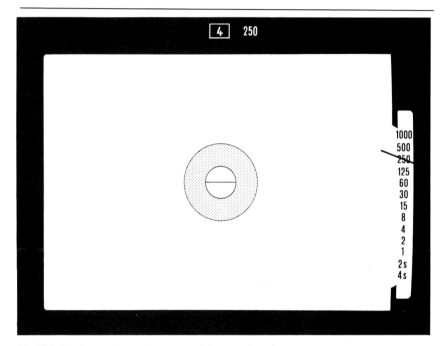

The R3 finder shows meter-set shutter speeds by a needle moving over a speed scale along the side of the image. Visible above the finder are the user-selected aperture (here f/4) and shutter speed — e.g. $^1/250$ sec. In auto mode, **A** replaces the shutter speed value.

3 Straightforward camera handling

One result of the multiple operating modes of the Leica R5 and R4 is that these cameras can meet widely varying user needs. With straightforward programmed automation the Leica R is almost a point-and-shoot camera: you view, focus and shoot. With the other auto modes (including the program shift on the R5) you increasingly influence the exposure parameters and their secondary effects on image sharpness in depth and in arresting movement.

Furthermore, almost any beginner can cope with these cameras and then progress in stages to more sophisticated levels of control. The Leica reflexes can serve modest picture-taking ambitions too, but they are then a somewhat expensive way of achieving not a great deal. Let's admit that the casual snapshooter will manage just as well with a less sophisticated and less costly camera.

In line with this natural progression from basic to more ambitious picture-taking, we shall also look at camera operation on two levels: straightforward handling and more creative application. The distinction is more one of scope than of complexity; once you know what the camera can do beyond responding to pressure on the button, you can choose when to utilise the extra facilities.

The basic operations are fairly simple. The best way of getting to know them is to practise them step by step. You can do it with an empty camera to start with (or a dummy film) — there is no need to waste film on these trials. (That's why we'll deal with film loading later.)

Batteries

While you don't need a film to operate the camera, you do need batteries. (Very limited operation is possible without batteries — see **Mechanical fallback** in Chapter 5.)

The electric functions of exposure metering and control require a 3 volt power supply of one of the following types:

— A pair of silver oxide cells of 1.5 volts each. The international designation is SR 07, specific brand names and types include S76E (Eveready, Ucar); EPX 76 (Ucar); G13 (National and other Japanese brands); V76PX and V76H (Varta); MS76H, 10L14 (Mallory); SR 44F (Maxell); RS76G (Ray-o-Vac). Silver oxide batteries are the most expensive but also the most reliable, especially at low temperatures. The battery voltage remains constant during the whole life of operating the cell, which in normal use is at least one year per set. It is still a wise precaution to replace them after a year.

— Alkaline cells of the same size, again of 1.5 volts; usual designation A76 or LR44. Their voltage is not quite as constant and the capacity (and price) is about half that of a silver oxide battery.

— Lithium cells of 3 volts — type DL 1/3N (Duracell, Mallory) or CR 1/3N (Sanyo, Varta etc). The lithium cell yields twice the voltage of a silver oxide cell and is twice as high; hence one lithium cell replaces two silver oxide ones. A lithium cell costs about the same as a pair of silver oxide cells, but has a longer shelf life when not used for extended periods. Some lithium cells do not stand up well to the comparatively heavy current drain of AE camera systems, though the latest types should be OK. But I usually take at least one spare pair of silver oxide cells as a last fallback.

Do not use mercury oxide cells. Though of the same size as silver oxide cells (usual designation No. 675 or HC), their 1.35 volts are insufficient for the R5's exposure meter system.

The batteries are housed in the battery compartment in the camera base. To open its lid you need a coin — 2p or 5p in Britain, or a nickel in the US. (The thinner cent and quarter are less easy.) This is a fiddly nuisance, but very few camera makers have so far bothered to think of a more convenient way of dealing with the battery compartment! If you are using silver oxide or alkaline batteries insert two cells in the retaining spring holder of the battery compartment lid — with the flat (+) side up. Alternatively insert a single lithium cell. If the cell or cells drop out of the holder too easily, you can gently bend in the spring cheek. Then screw the lid with the cells into the compartment.

To ensure good contact remove any traces of grease etc before inserting the cells: Wipe them with a clean handkerchief, then avoid touching the front and back with the fingers. If the camera is likely to be out of use for weeks or months, preferably remove the batteries to avoid damage through possible battery leakage. (The risk is greatest with alkaline cells whose leaking chemicals can corrode the contact spring

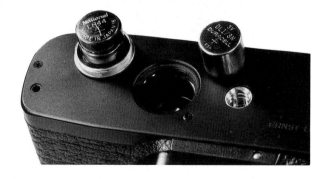

Push two 1.5 volt silver oxide cells, flat (+) side up, into the spring holder of the battery compartment lid. Alternatively use a single lithium cell (right).

in the battery compartment. Chemicals emerging from silver oxide cells are comparatively harmless and easily wiped off.)

Always change batteries in complete sets. Combining a fresh and a nearly spent cell increases the leakage risk. Also don't combine alkaline and silver oxide cells.

As batteries are liable to fail quite abruptly, it is a good idea to carry at least one set of spare cells. (Two sets don't take up much space either.) With lithium batteries I like to carry an additional spare silver oxide set as well (see above).

Battery check and film speed setting

Check straightaway that the batteries are working. Press the small black ISO/C button just to the left of the finder dome on the camera top: The red LED just above it should light up. If the LED doesn't light, or quickly goes faint, the batteries are spent or too old — so replace them.

You can usefully combine this check with the film speed setting. Depress the same button while you turn the serrated rim below the rewind crank to bring the arithmetic ISO speed value of your film into the lower window on this dial. That is the window nearer the rear camera edge. The film box — and usually also the cartridge — carries this information, e.g. '100' or 'ISO 100/21°'. Or, set the '21' part in the upper window.

This usually takes a few seconds; if the LED stays on evenly bright during this time, you know that the batteries are OK, too.

Fitting the lens

To fit a lens (if not already fitted) hold the lens against the camera mount so that the red pip beyond the right-hand end (on most lenses) of the depth-of-field scale is in line with the lens release catch on the camera. In this position push the lens into the mount and turn clockwise to engage the bayonet lock.

To remove the lens depress the bayonet catch, turn the lens anti-clockwise (as seen from the front) and lift off. Usually this is possible with one hand. Grip the lens from the front (or from the top if it is a longer lens) with the right hand, and press on the catch with the right thumb while you rotate the lens.

Before changing lenses, refit the cap on the lens on the camera. On removing the lens fit also the rear cap from the lens you are about to mount on the camera. When off the camera every lens should always wear its front and rear caps. Fussy, perhaps, but less of a bother in the long run than having to keep carefully wiping off dust or fingerprints.

Shooting steps

Here are the main operating steps summed up. To make the first trial run simple, we'll do it in programmed AE mode. Set this by moving the mode selector lever (with the key on the front of the lever pushed in) so that **P** appears in the window next to the shutter speed dial. Turn the latter to 30 (with **P** next to it) on the R5, or to any of the white speeds (not X, B or 100) on the R4. Turn the lens aperture ring to the

When attaching the lens, line up the red locating stud on the lens with the bayonet release catch on the body.

To remove the lens depress the the bayonet release and turn the lens anticlockwise.

smallest stop (highest f-number, e.g. 16 on the standard lens). You can check this stop number in the square window for user-set apertures below the finder screen centre.

(1) **Preparation:** Swing out the winding lever to its start position. If you can move it further, do so (i.e. the shutter is not tensioned).

(2) **Check:** Look through the finder and slightly depress the release button. Check that the red **P** in a square field below the finder image at the left is steady. If it blinks, the lens is not set to the smallest aperture. (If you see no image, you forgot to remove the lens cap.) Check that the shutter speed lit by the LED at the right is 60 ($^1/_{60}$ sec) or higher. On the Leica R5 the LEDs stay alight for 10 sec after you touch the release; on the R4 you have to keep the button slightly depressed during this check.

(3) **Focus:** Point the camera to centre the main subject. Turn the ribbed focusing ring (with the distance scale) on the lens till the subject detail is unbroken across the split-image wedge in the screen centre and/or appears sharpest in the microprism ring surrounding this wedge.

(4) **Release:** Reframe the subject the way you want it and smoothly depress the release button all the way. Hold the camera steady while doing this.

(5) **Operate the winding lever:** Pull the lever out all the way and let it swing back. This advances the film and tensions the shutter, ready for the next shot.

You could wait with winding until just before the next shot — that avoids the risk of accidental releasing. But if you wind after every shot, you are always ready for the next one and handling is more consistent.

The above steps are reasonably simple. But they involve some technical and also some practical points. The former concern exposure (step 2) and focusing (step 3); practical matters are a correct camera hold and releasing (step 4).

A basic exposure question

For shooting with the camera hand-held the $^1/_{60}$ sec or faster shutter speed helps to avoid picture blur through camera shake. What if at step (2) above the camera indicates 30 for $^1/_{30}$ sec or a longer time?

It means of course that the light is not good enough for a programmed exposure combination with $^1/_{60}$ sec. With the Leica R5 you can shift the program (see **Program shift** in the Chapter 5) — or you can switch to aperture-priority AE mode. (With the Leica R4s and R4s/2 which have no program mode you have to do that, anyway.)

For aperture-priority AE turn the mode selector to bring **A** (in a square) into the mode window next to the speed dial. Check in the finder that the speed is faster than $^1/_{60}$ sec — i.e. with the R4 series models a round red LED rather than a square one

should light up at the right. If it doesn't, select a larger lens aperture: turn the aperture ring as required while observing the display in the finder. More about the why and how of exposure in Chapter 5.

Viewing and focusing

By simulating the film image, the reflex finder system of the SLR camera shows both the coverage of the picture and its sharpness. The frame of the finder screen inside the camera measures 23 x 34.6 mm — a shade smaller than the 24 x 36 mm film area, or about 92% of it. The extreme margin that you lose is roughly the same as gets masked off in mounting in a colour slide frame. The finder is thus fine for practical accuracy. (In prints made by a photofinishing lab you are liable to lose more of the picture area; but that is hardly the fault of the camera.)

The precise image framing of the reflex finder not only eliminates all viewing problems with different lenses. It has also made the increasing use of zoom lenses possible.

As you turn the the focusing ring on the lens — usually the frontmost of the ribbed rings, carrying the distance scale — the image on the matt area of the screen appears sharper or less sharp. What is sharp on the screen will then also be sharp on the film.

The standard screen (there are others — see **Alternative screens** in Chapter 9) has two aids to facilitate sharp focusing:

A split-image wedge in a central 3 mm circle. Here the image appears split horizontally. Though sharp most of the time, the upper and lower halves are displaced sideways against each other when the image on the matt screen portions is unsharp. As you focus the lens, the part images in the wedge sections join up. The lens is correctly focused when the outlines are continuous across the horizontal split.

A microprism ring of 8 mm outside diameter surrounds the wedges. The microprism pattern consists of over 2000 tiny prism-shaped wedges (hence the name). In this pattern an unfocused image appears broken up by a coarse grainy structure that abruptly clears at the point of correct focus.

The eye is much better at noticing slight discontinuities in detail than slight unsharpness, especially in poor light. So the split wedge image helps to locate the sharpest focusing point more precisely. However, to show up the discontinuity you need outlines more or less at right angles to the wedge split — vertical lines when you hold the camera horizontally. If the subject has only prominent horizontal lines, turn the camera upright for focusing and horizontal again for shooting.

The transition between sharp and unsharp is slightly less clear with the microprism ring than with the split wedge. But it does not depend on clear directional outlines. Texture — hopeless in the split wedge — is easy to focus in the microprism area. When slightly out of focus, that texture flickers as you move the camera slightly, but becomes clear and steady at correct focus.

Optically, both the wedge and the microprisms depend on the intersection of light rays from opposite edges of the lens. That presupposes a certain minimum lens aperture. In the Leica R5 and R4 models these focusing aids function only with

lenses of f/5.6 or larger apertures. That covers all Leica R lenses except for the Telyt systems of 400 mm and longer. You can only focus those on the matt area of the screen; the microprism pattern shows no change on focusing and half of the wedge is always dark so making observation of any displacement impossible.

Visual screen sharpness

You can judge the sharpness of the screen image only if you see the screen itself sharply. In most SLR cameras, including the Leica R models before the R5, the optical system of the finder presents the image on the screen as if it were an object about 1 m or 3½ ft away. (Opticians and camera specifications talk of a − 1 diopter finder eyepiece correction.) If your eyesight is such that you need no spectacles to see things sharply at such a distance, you should have no problems with the Leica R finder.

The Leica R5 offers the further option of a focusing eyepiece, adjustable from − 2 to + 2 diopters. This accommodates slightly myopic to moderately longsighted users, i.e. with spectacle prescriptions in the range mentioned. To set the adjustment, remove the camera lens and pull out the setting button near the top left eyepiece corner. (It pulls out only very slightly.) Point the camera at something bright (sky or window) and turn the setting button while observing the standard screen's microprism ring through the finder. (Don't push the button in again while doing this.) Turn until the microprism pattern appears sharpest — it will keep alternating between sharper and less sharp. If this adjustment allows you to see the screen pattern really sharply, that is all there is to it. If you cannot see the finder image clearly, you have to consider wearing glasses or use eyesight correction lenses.

Go by the screen pattern rather than the LEDs and other signals around the screen because these usually appear nearer and clearer if you suffer from myopia. For accurate focusing it is the screen image that matters.

Eyesight correction lenses

These are available in powers from − 3 to + 3 diopters (14 330 to 14 339) and come with an adapter frame that clips over the square eyepiece mount to hold the lens itself in position. You can also hold the lenses in position with the eyecup (14 215). On the current versions a small spring engages a notch in the eyepiece frame on the R5 to stop the adapter from being pushed off accidentally. The Leitz repair service can modify the eyepiece frame of the R4 and R4s accordingly. The same correction lenses fit the Leica R3, as does an earlier range (14 240 to 14 249).

With the basic − 1 diopter correction of the Leica R4 and R4s models the effective correction is thus − 4 to + 2 diopters, while with the R5 the range becomes − 5 to + 5 — enough for most users. Ophthalmologists may be able to provide lenses even beyond this range, or to supply lenses with astigmatic correction.

One problem if you wear glasses and look through a finder fitted with a correction lens is that you have to take off the glasses or push them up on your forehead, and then put them on again for normal distance viewing. The alternative is to view with glasses all the time — which in turn has the drawback that you may not be able to take

in the whole of the finder view together with the exposure signals. For the eye must be quite close behind the finder eyepiece to cover everything, or else it has to keep squinting around from side to side.

In the Leica R5 the eye can be a little farther back (this camera's finder has a greater eye relief) so the problem is less serious there. I find viewing with spectacles more convenient than correction lenses on the camera, but this is a matter of personal preference. It might be a good idea to go with the camera to a specialist dealer who stocks the lenses and try viewing through the finder with and without correction.

The right-angle finder

Occasionally eye-level viewing is not the most convenient way of looking at the screen image. With the right-angle finder you can look into the camera finder from above when the camera points up from a low angle, or at eye level when the camera points down on a copying or similar stand. You can even use it for unobtrusive shots by pointing the camera at right angles to the direction you are facing.

Push the finder fitting (version 14 300 for the Leica R5) over the rails at the sides of the camera eyepiece, and rotate the right-angle part up (or to the side or down as required). You can also switch between normal and 2x magnification; the latter enlarges the centre of the view for accurate focusing on the wedge/microprism part of the screen. (This magnification is specially useful when focusing on the centre of a matt screen, Nos. 2 or 4, or on the clear screen, No. 5.) The Leica R4 version (14 328) fits into the camera's accessory shoe. There are still earlier forms without switchable magnification.

The eyepiece itself has a further focusing adjustment from −5 to +3 diopters — so you don't need eyesight correction lenses. To adjust it, look through the eyepiece while the finder is mounted on the camera and rotate the ribbed eyepiece sleeve until the central circle and/or microprism pattern of the screen appears sharpest. Small self-adhesive paper strips on the sleeve and body can help to mark this setting.

Sharpness in depth

The sharpness of items seen in a photo generally varies from pinsharp through reasonably sharp to noticeably fuzzy. What you focused on the screen or with its focusing aids is sharpest; the fuzzy items (if any) are objects very much nearer or farther away. You have some control over the extent to which nearer or more distant will appear reasonably sharp — i.e. come within the depth of field zone. One main controlling factor is the lens aperture. The sharp zone gets deeper with smaller lens apertures and more restricted with larger apertures. Either can be desirable in the picture (see Chapter 9).

There are complex mathematical equations for working out the depth of such sharp zones. In the last resort they depend on subjective assumptions of what we consider acceptably sharp. The quick way of checking sharpness in depth is to look: as you watch the image in the finder, use your right middle finger to pull back the depth preview lever towards the camera body. It's easy with the right camera hold

(see below) as your right index finger can remain on the release button to keep the camera switched on.

This stops down the lens to the preselected aperture. The screen image gets darker but you see how nearer and more distant items get sharper on the screen. You can watch the spread of sharpness as you adjust the lens aperture — in aperture-priority AE or manual mode, for in the **T** and **P** modes the depth preview lever stops down the lens to its smallest stop. Look at the sharpness outside the split-image wedge or microprism area — these are no help when the lens is stopped down.

Judging relative sharpness of portions of the image on the screen is necessarily approximate, especially when the image gets dark at small apertures, but is adequate for most occasions.

The depth-of-field scale

The other way of estimating depth of field is with the depth-of-field scale on nearly every lens. This indicator is a simplified application of mathematical depth calculation and consists of pairs of white lines to each side of the central focusing index. That is the line with the triangular mark opposite the distance scale. F/numbers identify matching line pairs.

At a given aperture and distance setting the depth-of-field zone extends from the distance (on the distance scale) opposite the left index of that aperture to the distance opposite the right index for the same f/number. Thus with the standard lens set to 5 m or 15 ft, the left f/2.8 index points to what we could estimate as 4.5 m (about 13-14 ft) on the distance scale, the matching right f/2.8 index to an about 6 m or 20 ft. The depth index lines for f/16 mark about 2.5 m at the left and infinity (the ∞ sign) at the right, thus at this setting everything is sharp from 2.5 m, or about 8 ft, to infinity.

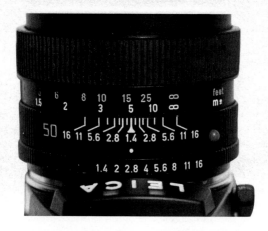

The depth-of-field scale on the lens indicates the approximate zone of sharpness. Here, with the lens focused on 5 m, the depth extends from about 4.5 to 6 m at f/2.8, or 2.5 m to infinity (∞) at f/16.

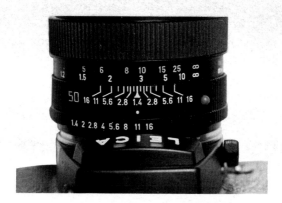

To find settings for a required sharp zone — e.g. from 2 to 5 m — adjust the ring with the distance scale to centre the distance limits to either side of the index. The distance opposite the focusing index is then the focusing distance (3 m or 10 ft) and the f/number opposite the required limits (e.g. f/11) the aperture to be set.

The depth-of-field indicator can also yield aperture and distance settings for a required sharp zone. To get everything sharp between 2 m and 5 m, turn the focusing ring with the distance scale so that the markings for 2 m and 5 m are opposite matching depth-of-field indexes. That is the case with the 50 mm lens when 2 m on the scale is just beyond the left f/11 depth index and 5 m just past the right f/11 line. That at the same time brings a distance just below 3 m or 10 ft opposite the focusing index — the required lens setting for this sharp zone. You then only have to stop down to f/11 (a good enough approximation).

You often have to imagine intermediate settings and also intermediate aperture indexes. Sometimes the latter have short index lines without an f/number mark. Note that the distance scale expands at nearer distances. Thus 20 ft is nearer to 25 ft than to 15 ft and halfway between 10 and 15 ft you are at a little over 13 ft. At the maximum aperture the width of the triangular base of the focusing index marks the (rather limited) sharp zone.

Camera holds and steadiness

Apart from faulty focusing, one major cause of unsharp pictures is camera shake. The cause is camera movement during the exposure: any unsteadiness of the camera while the shutter runs down blurs the image on the film. The remedy is to select a fast enough shutter speed and adopt a steady camera hold during releasing. A fast shutter speed tends to freeze movement blur (from the subject — see Chapter 9 — as well as from camera shake). A steady hold avoids the blur in the first place, and incidentally allows the use of a slower shutter speed.

In the **Shooting steps** section $1/60$ sec was suggested as a longest exposure time for hand-held exposures; $1/125$ is better still. In reasonably good light and with a standard or wide-angle lens that is no problem. But even $1/125$ sec may be too long with longer-focus lenses — which magnifiy not only the image but also any blur. On

the other hand some photographers can with practice, and with certain aids, manage hand-held shake-free exposures even of $^1\!/_8$ sec.

Three factors count here: The camera hold itself, additional support and smooth releasing.

A comfortable grip

The camera shape is most conducive to horizontal shots. For a comfortable and steady hold, grip the right-hand end of the camera with the right hand, with the middle and ring fingers curled round the front and the little finger underneath the camera base. Let the index finger rest on the release button and the thumb against the camera back between the finder eyepiece and the winding lever (the latter being swung out to its start position). Let the carrying strap run up out of your right palm between the thumb and index finger.

Support the camera centre with the left hand, tucking the ring and little fingers underneath the base. Place the left index finger below the focusing ring of the lens and the middle finger below the aperture ring. The left thumb normally rests on top of the focusing ring but can switch to the aperture ring when the latter requires adjustment.

The basic horizontal camera hold: The right hand grips the right body end, operates shutter release and winding lever (behind the camera back), the left supports the body and operates the lens focusing and aperture rings. Select finger positions for best comfort and steadiness.

Two holds for upright shots. Note that the forehead and nose support the camera back with the second hold (right hand down).

Further functions of the right hand: The middle finger can operate the depth preview lever; the index finger can move the mode selector lever while depressing the locking key in the lever end. If you have to change shutter speeds, move up the right thumb to grip the speed dial together with the index finger. These are the functions you need fairly constantly during shooting, so it is just as well that you can operate them all without taking the eye from the finder eyepiece.

Press the camera against your face, the right eyebrow against the eyepiece and the nose against the camera back. This provides a third point of support, especially if you tuck the elbows into the sides of the chest. It also assumes that you view with the right eye, which is more convenient for unimpeded shooting. If eyesight problems force you to view with the left eye, the right eye is in the way of the winding lever and you will have to take the camera from the eye for advancing the film.

There are two ways for upright shots. One is to swing up the right hand, keeping the same grip on the camera. The camera now sits in the left palm while the left little and ring fingers are stretched out along the base. The left thumb with the middle and index fingers again operates the focusing and aperture rings. For right-eye viewing support the right eyebrow against the right thumb; for left-eye viewing (easier than with a horizontal hold) support the forehead against the ball of the right hand.

For an alternative upright hold support the camera in the palm of the right hand and use the left to press the top and back of the camera against your forehead and nose respectively. The left hand at the same time grips the lens barrel for extra

support (and operates the focusing ring). Most of the steadying here comes from the forehead against which the camera back rests — though this hold is generally suitable for right-eye viewing only.

The above holds are my preferred ones with lenses up to 90 mm; I also use the camera strap for additional support (see below). You may prefer to modify them if you have small hands. What counts is that your personal camera grip should be comfortable, and that you get used to instinctively picking up the camera and holding it as steady as possible.

Longer lenses

The horizontal hold is similar with longer-focus lenses up to 180 mm, though the left hand may have to support the lens further forward and operate the focusing ring with the middle finger and thumb. With the 70-210 mm (and the earlier 75-200 mm) one-touch zoom lens you will also have to get used to using the left hand constantly for focusing as well as zooming. With zoom lenses you can usually focus most accurately at the longest focal length, so here is the best sequence for that:-

Zoom to the longest focal length by pulling the combined zoom/focus sleeve fully back, focus sharply by rotating the sleeve, zoom to cover the field of view you want, and refocus if necessary. The art lies in making the smallest adjustment (such as final refocusing) at the end, immediately before releasing.

The 35-70 mm zoom lens has a separate zooming ring but is only about ¹/₂ inch

With longer lenses support the lens barrel from underneath with the left hand. Wedging the two hands together also helps to steady the setup.

longer than the 50 mm f/1.4 standard lens — so here the normal hold is fine. Use the left middle finger for focusing, the ring finger for zooming and switch the latter finger to the aperture ring when needed.

A preferred upright hold for the longer lenses, derived from the alternative upright hold for the standard lens described above, is to support the camera with the right hand but support the lens from underneath with the left. You should be pressing the outer end of the left hand against the outer end of the right — at first sight slightly cramped for people with very big hands, but comfortable and steady once you get used to it.

With still longer lenses (250 mm Telyt-R and longer) the tripod mounting ring makes the lens easier to support. But with unsupported hand-held shots the risk of camera shake is considerable; there the universal hand grip and shoulder stock provides additional support (see below). Better still for such tele shots is a sturdy tripod.

Use the camera strap

The camera strap is not only for carrying the camera but provides valuable additional steadiness. For shooting readiness you must be able to get the camera quickly up to eye level. There are three ways of using the strap:

(a) Run it round the neck, with the camera on the chest. You are instantly ready to shoot — and instantly recognisable from a mile off as a typical photographer/tourist.

(b) Hang the strap and camera over one shoulder (usually the right). The anti-slip pad inhibits it from riding down. In this position the camera is less conspicuous — yet you can still raise it quickly to shoot. However it is also easier to lose — or to be torn off by a hit-and-run thief. The camera is better protected and better hidden if you carry it underneath a jacket which hides it until you are ready to shoot.

(c) With the strap running round the neck and diagonally across the chest, the Leica is still more secure and — if the strap is long enough — still easy to raise to the eye. Here, too, you can hide the camera under a jacket.

The optimum strap length necessarily depends on your own size. Adjust the strap until it gives the best support with your selected camera hold but is still easy to carry comfortably.

A rule of thumb (or of elbow) for the strap length for first two holds: Let the camera dangle on the strap from the base of your thumb while you hold your arm out straight. Bend the lower arm up at the elbow: the camera should now hang just below the elbow.

Now for the strap-supported holds. If the camera is hanging round your neck, push up your right hand underneath the strap — before raising the camera to your eye — and wind the strap once round the right wrist. That shortens the strap to bring

For unobtrusive shooting readiness carry the camera over one shoulder — possibly underneath a jacket.

Elbow rule for strap length: suspended from the hand, the camera should hang just below the elbow. (But adjust it for your own comfort as needed.)

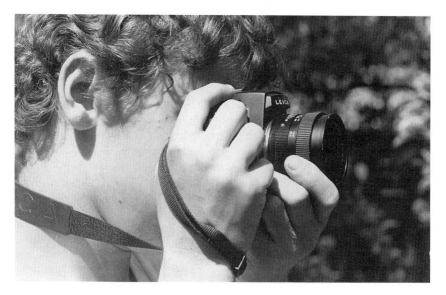

Wind the strap round the right wrist and tension it against the back of your neck to brace the camera against your head.

the camera close to the face. By moving your right wrist you should be able to tension the strap sufficiently to press the camera against your face. The camera, your head and two hands should form a rigid block. (Shorten the strap further if you cannot manage to tension it sufficiently.)

With the camera hanging over the right shoulder (over or under a jacket) raising it to the eye is easier still. In this case the strap should run from the right camera eyelet under the right arm, forward over the shoulder and up underneath the camera to the left strap eyelet. If the length is right, the strap braces the right arm and the camera for a steady hold. The left strap end must run underneath the camera as it would otherwise be in the way of the nose.

For the third way of carrying the camera — (c) above — the strap must of course be longer. In this case raise the camera to your eye so that the strap runs from the left eyelet over the left shoulder, round your back and below the right arm, ending between the right thumb and index finger.

With just a little adjustment of the strap run you get similar additional bracing with an upright camera hold.

Releasing

The above ways of supporting the camera should keep it as steady as possible during that fraction of a second while the shutter is open for the exposure. But you must not jog the Leica, either, when you press the release.

The best way with a horizontal hold is to squeeze the release whilst gripping the the camera firmly with the right hand. Place the whole of the end digit of the right

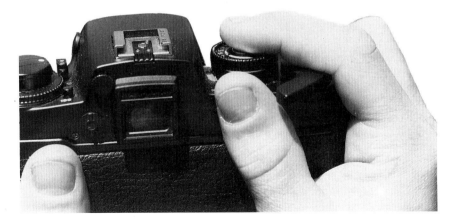

For releasing just squeeze the button while you firmly grip the camera with the right hand.

index finger on the shutter speed dial — a steady squeeze then releases the shutter.

Normally the release closes a switch which then triggers the camera shutter electromagnetically. Although the release travel is quite short (only 1.3 mm), there are three stages.

(a) A first touch of 0.3 mm, which feels like just taking up the slack on the button, switches on the meter circuit.

(b) When you are in aperture-priority AE mode with selective metering, depressing the button by a further 0.7 mm cuts in the exposure memory (the mode signal below the finder screen goes out — see Chapter 5).

(c) The last 0.3 mm of the travel closes the release switch. Without the selective metering memory there is a noticeable pressure point before this last 0.3 mm.

Practise this operation. Depressing the button just to this holding point will soon become instinctive. The very last pressure should then be totally smooth, never jerky.

On the rare occasions that you might operate the camera with a manual shutter speed, the mechanical release operation comes into action after a release travel of 2.2 mm. (That's still only a mm more than the electromagnetic release.)

Release in the same way with an upright hold where the right hand is on top. When however the right hand supports the camera, the right index finger will be sharply bent to push rather than squeeze the button in. So provide counter pressure with the left hand against the camera base.

You cannot release smoothly after heavy exertion, for instance if you have just arrived out of breath at the intended viewpoint. Better wait half a minute before shooting. By all means hold your breath while releasing, but only at the last instant, not for half a minute beforehand.

Oddly enough, steady releasing is even easier with the thumb — useful when 'stealing' unobtrusive shots from waistlevel (with a wide-angle lens).

More support

Always look for additional ways of steadying the camera. Try to lean against something solid — a wall, tree etc. Or support the elbows on railings, a low wall, a table top, the arms of a chair (when seated). Or, when sitting on the floor, support the elbows on your knees.

But avoid leaning against, or supporting the camera on, any part of a moving vehicle from which you are shooting. Such movement is linked with vibration — and that should not be transferred to the camera. Preferably stand free, possibly with slightly bent knees so that the body becomes its own vibration damper. This applies equally when shooting on board ship (the engine vibration is insidious but nonetheless camera shaking), from aircraft, or especially from helicopters. If you have to shoot in such circumstances, use the fastest possible shutter speed. (Professionals photographing from helicopters sometimes use special vibration compensating camera mountings.)

The table tripod

A steady camera hold is fine, but a solid support is better still. For instance place the

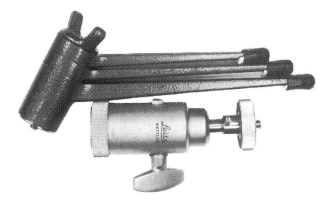

The Leitz table tripod with large ball head can go in a pocket. (This is an older version of the ball head.)

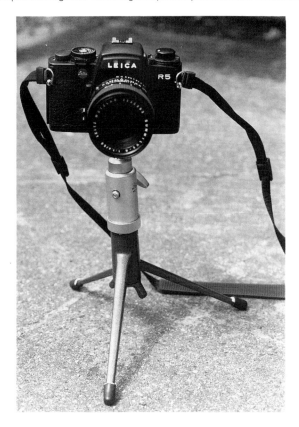

The table tripod supports the camera with a not-too-heavy lens on any more or less level surface. The ball head permits full adjustment.

camera on a table top, a wall etc. More convenient is the Leica table tripod (14 100) with the (14 110) ball-and-socket head (ball head for short), for you can set it up almost anywhere and level — or incline — the camera at will.

For horizontal shots this combination supports the Leica R with a standard or wide-angle lens about $9^1/2$ in. above whatever its stands on. When folded up and with the ball head unscrewed, the table tripod fits in an odd pocket of the camera bag.

When setting up, align the longest of the tripod legs underneath the camera to keep the setup from toppling over. Screw the head firmly to the tripod and the camera firmly to the ball head, then line up the camera precisely while looking through the finder and tighten the ball head clamping lever. For shake-free exposures, preferably release with a cable release screwed into the release button.

Interiors in churches and other poorly lit locations call for a large solid tripod (see below) — a nuisance to carry, especially with a 35 mm camera outfit. (In museums, tripods and flash are usually banned.) Here I often use the camera mounted on the table tripod and press the latter against a wall, a column or the like. That way I have managed shake-free exposures of several seconds.

The universal handgrip

More of a heavy-duty unit, especially with longer (and heavier) lenses is the Universal Handgrip and Shoulder Stock (14 239). Originally conceived (in an earlier version) as a shoulder support for hand-held sports photography with the 400 and 560 mm Telyt-R lenses, this is equally useful with the 250 mm to 350 mm Telyt-R lenses (and even the bellows unit) and can be a remarkably solid table tripod, too.

The Universal Grip consists of a solid hand grip, an extendible arm (minimum length about 16 cm or $6^1/4$ in., maximum 23 cm or 9 in.) and a shoulder stock. You can attach the latter either to the end of the arm or to the front of the grip. Engage it with the two locating pins and screw in the screw knob.

To use the grip as a shoulder support, attach the shoulder stock to the end of the arm. Mount the camera on the grip platform by screwing the tripod screw into the camera's tripod bush (screw in by the knob in the grip base). Adjust the length of the grip arm — unscrew the large collar nut on the arm, extend the latter and screw the nut tight again. Extend the arm by at least $^1/4$ in. to keep the shoulder stock firm. (When fully pushed in it turns slightly to facilitate compact storage.) Adjust also the angle of the arm on the grip by slacking off the knob of the ratchet joint, then tighten again. With medium tele lenses (up to 180 mm) where the grip is attached directly to the camera, the arm is usually best set at right angles to the grip. When correctly set, the camera eyepiece should be comfortably in front of your right eye while the stock is jammed into your right shoulder. This may involve having the arm point diagonally to the left from the right shoulder, and mounting the camera so that it points to the right on the grip platform rather than straight ahead.

The right arm and hand now steadies the camera while you focus the lens with the left. As you cannot now reach the release button with the right hand, use the left, reaching across the camera top. Use this hand also to operate the winding lever. (This seems peculiar but works well.)

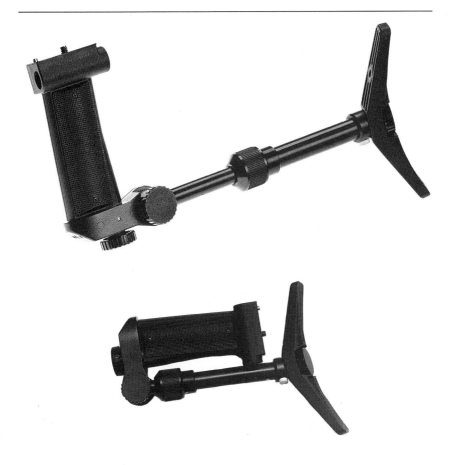

The Universal Handgrip and Shoulder Stock. When folded up it is reasonably compact.

Alternatively, fit the twin cable release (16 494) into the large opening through the top of the grip and screw one of the cables into the camera's release button. Then release by pressing the cable release plunger. (The twin release is needed because the tunnel opening through the grip top is too large to hold a single cable release firmly. Clamp the twin release by turning the black milled button in the side of the grip near the top.) The twin cable release is useful also for hand-held close-up shooting with the bellows (see **The bellows and hand grip** in Chapter 11).

A still more elegant way is to fit the motor winder or drive on the camera and release with the electric release switch (14 237). See Chapter 10.

With the 250 mm Telyt-R and longer focal lengths (other than the 500 mm MR-Telyt-R) attach the grip to the tripod bush of the lens rather than of the camera. The locating pin on the grip top here engages a locating hole in the lens's tripod mounting block. In some cases — e.g. the tube of the 400 and 560 mm Telyt-R and

the closeup bellows — the block has a central and an off-centre locating hole. With the latter the lens points slightly to the right of the grip — often more convenient. But you can always angle the lens at will by not engaging the locating pin as you mount the lens on the grip. Again adjust the arm angle and length for best comfort.

The grip as table stand

Unscrew the shoulder stock from the end of the arm and fit it on the base of the handgrip itself. The latter now stands firmly on any reasonably flat surface and supports the Leica R with lens for short and long time exposures.

With a standard or wide-angle lens on the camera, fit the grip so that the long arm (which now becomes the third leg of the table stand) points to the rear. That way this leg won't intrude into the field of view.

The universal hand grip and shoulder stock gives extra support for hand held shots with the longer lenses. The position of the left hand for releasing is a little unusual here, but steady.

With long-focus and tele lenses up to 180 mm and with the 500 mm MR-Telyt-R mirror lens, turn the camera round on the grip so that the long arm sticks out in front to prevent the stand from toppling forward. The tripod mounting of the 200 mm Telyt-R supports this lens at its centre of gravity, so you can mount it on the (14 239) grip either way. Still longer tele lenses are too heavy to be steady on the grip/stand and need a more solid support.

The hand grip supports long tele lenses below the lens itself. The winder and remote release permit convenient releasing from the grip.

On a table or other surface the stand is fine for a level shooting direction but you cannot point it up or down very far. That is limited by the degree of adjustment in the arm's ratchet joint. For a wider movement range fit a ball head between the grip and the camera — but you then sacrifice solidity.

Like the table tripod, the stand setup of the (14 239) grip can steady the camera against a wall or broad pillar, etc., indoors. But keep a firm hand on the camera and grip assembly.

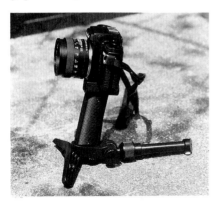
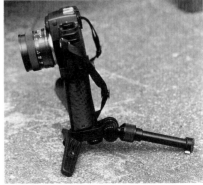

Alternative table stand configurations with the universal hand grip: It supports the camera on a level surface and permits some upward (left) and downward (right) tilting.

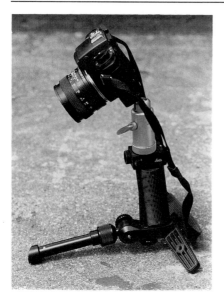

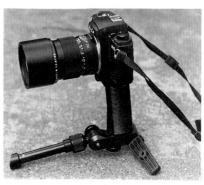

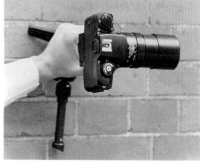

More flexible but less stable is a ball head between the grip and camera (left). For long lenses locate the long arm of the grip underneath the lens (top right). It can also steady the camera against a wall (bottom right).

A big heavy tripod seems incongruous luggage to go with a small camera. It looks less big compared with the Leica plus a long tele lens — and is then the best (and sometimes only) insurance against camera shake and vibration. If you feel you need a full-scale tripod, get the most rigid one you can find. Avoid like a plague amateur tripods that extend to 6 ft or so but collapse or fold up to go into a pocket. They sway in the softest wind and pick up the faintest vibration. Almost invariably they are worse than no tripod at all.

Camera cases

Obviously the camera needs some protection when you are not actually shooting or carrying it ready to shoot. For the camera and one lens (standard or short zoom) on its own a soft leather case is ideal. It protects the camera against knocks and scratches, as well as against dust, yet you can quickly pull such a case off the camera and stuff it in your pocket. When you go to buy such a case take the Leica and lens with you to check that it is easy to fit and take off.

There are also so-called ever-ready cases where you can in theory open the front and shoot without removing the camera from its case. Unfortunately, such cases are not particularly 'ready' in practice; they are not only bulky but outright uncomfortable for holding the camera steady. There are two such cases for the Leica

With scenes like this pavillion in the Royal summer palace in Bang Pa-In (Thailand), balanced brightness and colour distribution allows straightforward centre-weighted exposure measurement in any of the AE modes to yield perfectly exposed pictures. Kodachrome 200 film.

(Photo: Andrew Matheson)

Above: Average readings of high-contrast subjects can be misleading as the brightness distribution tends to be unpredictable. Use a selective reading on a representative midtone, such as the woman porter's back (in the Nyaung-oo market in Pagan, Burma). Or, if you have time, selectively read the brightest significant highlight (i.e. that should still show detail) and darkest significant shadow, then set a mean value. Kodachrome 200 film. (Photo: Andrew Matheson)

Right: You just have to keep shooting to record life in a market (this one was Nyaung-oo in Pagan, Burma). Keep the camera in program mode, look for and focus on single figures — such as this monk — in the constant coming and going. Kodachrome 200 film. (Photo: Andrew Matheson)

When not to use exposure correction. The brilliant sky and bright gold covering of this stupa in the Royal Palace in Bangkok tend to make the Leica's metering system underexpose the shot. In fact this brings out the dramatic brilliance of the gold; a corrected exposure may yield a truer, more airy, rendering but without much impact. Kodachrome 200 film. (Photo: Andrew Matheson)

R5 and R4 models: with a normal front (14 569) for the camera with a wide-angle or standard lens; and with an extended front (14 568) for the camera with a medium tele lens (up to 90 mm) or a bulky wide-angle one. Either case becomes cumbersome when you switch to other lenses.

Holdall cases

A separate container is desirable once you have the beginnings of an outfit — the Leica R with more than one lens, a flash unit, winder or drive etc. You can buy a wide range of universal and holdall cases, from small ones to big outfit cases to hold a couple of cameras with extensive gear. Leitz has two so-called Combi-R cases, each available in leather or canvas; there are also innumerable types in plastic, waterproofed nylon and other materials — and at all price levels.

The best way of buying such a case is to take the outfit to a photo dealer and try out different cases until you find one of the right size, quality and features. Choose a case with adjustable inside divisions; so that you can reorganise the space as required. The most flexible types use Velcro-fixed dividers.

Other points:

— You should be able to dump the most frequently used camera combination (e.g. with standard or zoom lens) in a compartment as it is, without dismantling. The same combination should also be instantly accessible, i.e. at the top when you open the case.

— The other items must be accessible, too. Deep cases are not too good of you have to remove a lens to get at your flash unit.

— The carrying strap must be tough (e.g. nylon webbing) and run right round the case underneath. A Leica R outfit can become heavy and if you keep snatching up a full case, the strap fitting sooner or later gives way. A wide strap (say 2 in.) makes the case more comfortable to carry.

— Avoid further containers (such as lens cases) in the holdall case itself. The holdall should hold everything for instant access, without wasting time wrapping or unwrapping items.

— One holdall case is not the last word. Start with a small case for a small outfit. When that gets bigger, get a second, bigger case. You can still pack the small one (for instance in your luggage on a trip abroad), so that you don't have to carry the big one all the time to go out with just the camera and a couple of lenses.

— The bag should also have one or more pockets for small items. Not just filters, lens hoods and film, but also a ball pen, a small notebook, waterproof felt pen (to write data on the film leader), a small blower brush to clean the lens, spare batteries for the camera and flash unit. Often I also carry a microcassette recorder (for quick notes of subject details — more convenient than writing

them down), a tiny battery tester for AA cells, a penlight torch and a piece of chamois leather for lens cleaning, kept in a plastic film can. These extras are of course a matter of individual choice.

Really big lenses are too bulky for a holdall. Leica R lenses of 200 mm and longer focal length come complete in a tough (and bulky) leather container with strap that you just have to lug around if you use such a lens. But the case really protects it. There are also soft leather cases for the assembled 400 mm and 560 mm Telyt f/6.8 lenses, with a side pocket for the folded Universal Handgrip.

4 All about films and filters

The perforated 35 mm film (No. 135 is the official cartridge designation) used in the Leica R cameras is today the most widespread photo film format and packaging. It is also a fairly awkard one, for the cartridge has to contain the film light-tight outside the camera, yet allow it to run smoothly and straight through the film plane behind the film gate.

This makes physical film handling (especially loading) somewhat fiddly, though with a little practice you soon learn how to handle this. For that practice it is worth buying a cheap 24-exposure film to sacrifice it on a few trial film handling runs. Film loading is one of the operations you should be able to do do instinctively and by touch only — you may at times have to do it in the dark or while watching other things going on.

Loading the film

Avoid loading films in broad sunlight — do it in the shade or at least the shadow of your body. Here are the steps:

(1) Open the camera back.
(2) Hook the film leader onto the takeup spool.
(3) Insert the film cartridge in the cartridge compartment.
(4) Check film flatness and alignment.
(5) Close the camera back.
(6) Advance the film to frame No. 1.

Points of detail:

To open the back, pull up the rewind crank, then swing open the back. The features now visible are the empty film compartment at the left, the film track — two sets of shiny rails — in the middle, the black transport sprocket (with teeth to engage the film perforation) immediately to the right of the track and the take-up spool further right still. A grey metal or plastic slotted sleeve surrounds the lower half of the spool. Between the rails of the film track is the film window or gate, normally closed by the camera shutter.

Inside the open camera back is the long sprung pressure plate to push the film against the track, and the film window for reading film details on the cartridge.

This layout is largely the same in all Leica R models. Small additional details in the R5 are two chrome film guide studs at the left end of the film track and two contacts below it for the data back.

Prepare the camera by setting the shutter speed dial to 100 (the mechanical $^1/_{100}$ sec). Keep the lens cap on the lens. Tension and release the shutter. Have the film at

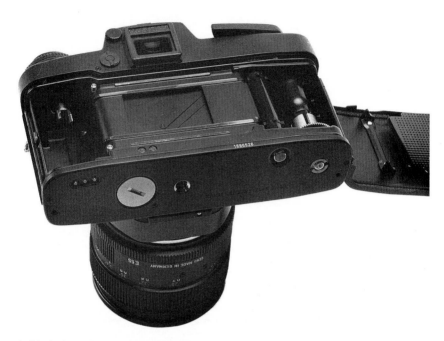

Inside the Leica R5, with the feed cartridge compartment at the left, the film track rails above and below the film gate, the transport sprocket to the right of the track and the takeup spool in the compartment at the right. The rewind release button in the camera base is just below the sprocket shaft and disengages the latter from the transport gear.

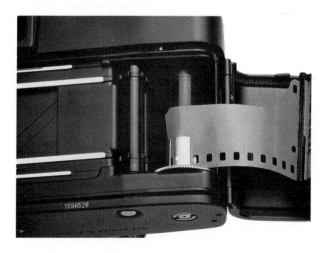

Start loading by pushing the end of the film leader underneath two of the tongues or prongs surrounding the takeup spool core.

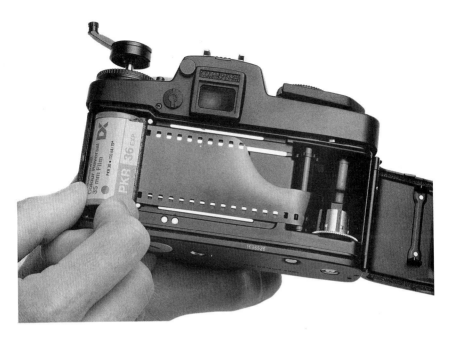

After inserting the cartridge in the cartridge chamber check that the film lies flat in the track. The takeup spool will wind it up emulsion side out.

hand and check that it protrudes by no more than a couple of inches from the cartridge. The rewind crank should remain pulled up.

Push the perforated edge of the narrow film leader into a slot under one of the tongues surrounding the lower half of the take-up spool. The back of the film (the darker side) must face the spool core and the film end point in from the right. The cartridge spool knob should point downwards. Push or hook in the film sufficiently to go in part under a second tongue. But don't let it emerge from a second slot — that could cause problems later in unloading.

Draw the cartridge to the left across the film track and insert it in the empty cartridge chamber. Push the cartridge slot down flat against the film track and push any excess film — bulging up on the film track — back into the cartridge. Check that the film lies flat between the outer film track rails. Pull the winding lever to advance the film so that its perforations engage the transport sprocket teeth at the top as well as the bottom. Then close the camera back. (If it doesn't snap shut, the cartridge is not lying flat — recheck.)

Complete the pull of the winding lever. Push the rewind crank back, turning it slightly clockwise (arrow direction) if necessary, so that the crank is flush against the film speed dial again. Gently turn the crank until you feel a resistance as the film is tensioned inside the camera, then fold up the crank.

Press the release button and operate the winding lever to advance the film. During

this the rewind crank should rotate anticlockwise as a check that the film is advancing, and the frame counter should have moved from S to the division between S and 1. If the rewind crank does not rotate, turn it to retension the film as described above. Press the release and operate the winding lever once more. The frame counter should now be at No. 1 and the camera ready for shooting. Finally turn the shutter speed dial away from 100 to whatever speed you want to select in **P, T** or manual mode, or to any of the white speed settings in **A** mode.

If during this last film advance the rewind crank still does not turn, you may not have attached the film securely to the take-up spool. Open the camera and repeat the whole loading sequence.

The frame counter

This shows the number of exposures (not counting double exposure) made on the film. Every time you open the camera back, the counter returns to its start setting — the red 'S' mark. During loading it should advance to No. 1. After that it shows index lines and frame numbers for even frames (2, 4, 6 etc) and index lines on their own for intermediate odd frames. Nos. 20, 24 and 36 (for usual standard lengths of 35 mm film) appear in red.

When using the motor (winder or drive), frame counter contacts cut out the motor after No. 36. With manual advancing the counter goes up to 37 (and stops there). You know that the film is finished (also with shorter films) when the winding lever or the motor blocks. At this point never use force because you could tear the perforations, or even the whole film and ruin it.

If you get films processed by a photofinisher, preferably write-off the last exposure too (just before the lever blocked), and repeat it on the next film. Photofinishing labs usually splice films together to endless lengths for running through automatic processing machines. The very last frame on a film is liable to be the splicing area.

The very last frame on a slide film tends to get ruined by the processor splicing tape. Better repeat the shot immediately on the next film.

Unloading

The fully exposed film must be rewound into its cartridge — straightforward but a bore. Depress the rewind release button in the camera base, unfold the rewind crank and turn clockwise (in the direction of of its arrow head) until you feel (and hear) that the film leader has left the take-up spool. Open the back: the film leader should now be in the film gate. Lift out the cartridge.

Rewinding a 36-exposure film needs about 30-31 turns of the rewind crank, 24 exposures need 20-21 turns.

There are arguments for and against winding the film fully back into its cartridge. You can use a protruding film leader to note down exposure information (with a waterproof felt pen). But without anything on it you may later wonder whether the film was exposed or not. If the leader is wound fully back, there is no doubt.

It is also open to argument whether the light-trapping of the velvet cartridge slot is better with or without a protruding leader (the leader protrudes on the unexposed film, anyway). That should be relevant only if you leave the cartridge lying in the sun. Like loading, unloading should be done in the shade and the film immediately wrapped up light-tight. The original plastic film container (preferably not transparent) is fine for that. I use plastic slide boxes in which Kodak (and some other film makers) send back processed slides. These hold four cartridges in less space than four separate film containers. When going through airport security checks I pocket these boxes with my films to avoid X-raying (which affects all films). Posso now has similar boxes for three cartridges in a radiation-protective plastic. (But I still prefer to avoid X-raying altogether.)

Partly exposed films

Don't wind the film back fully if you unload a partly exposed film and intend to reload it later — for instance to switch in mid-film from prints to slides or from an ISO 64 material to ISO 400. Professionals rarely do that. They either carry two camera bodies for the two film types or they unload the partly exposed film and waste the unused frames. (On an assignment there is rarely time to fiddle with reloading partly exposed films.)

Here is how to do it if film economy is important. After the last exposure (and after advancing the film) note the number from the frame counter. Rewind the film, keeping the leader outside the cartridge, and write this frame number on the film leader. For reloading proceed in the usual way, covering the lens with the lens cap while advancing the film to the first frame. Still with the lens cap in place, keep releasing the shutter and advancing the film until the frame counter shows one number higher than the number you noted. Then carry on taking pictures. If the frame counter showed, say, No. 18 when you unloaded the film, advance it after reloading to No. 19 before you start taking further pictures. That keeps last exposure of the first run clear of the first shot of the second.

The film transport check of the R4

Inside the take-up spool chamber of the Leica R4 and R4s models there is a small

lever near the top of the spool. When a film winds up on the spool, this lever operates a signal in the film transport check window above the winding lever.

When the camera is empty, this window is black. As the film winds up on the takeup spool, a white strip appears at the bottom and progressively fills the window. The white area is thus a quick check that a film is attached to the spool and very rough guide to how much of the film is exposed.

In fact this is somewhat redundant information. Rotation of the rewind crank (see above) is a more reliable check of correct film transport, and the frame counter shows more precisely the number of exposures. That is no doubt why the Leica R5 has dropped this window. (I have never bothered with it when using the R4.)

Film types

The most widely used film type is colour negative or print film. Some way behind is colour slide film and a long way behind comes black-and-white.

Negative film yields colour prints to carry in your wallet and show around, and also big enlargements. It is most popular among snapshooters, but professionals like it too. Colour slide film yields colour transparencies for projection. On the screen these appear exceptionally brilliant and sharp (if properly focused and exposed) and come closest to conveying the effect of the original subject or scene. On the other hand they need more elaborate viewing preparations — setting up a projector, blacking out the room etc, or else transferring the slides onto video cassettes. The pursuit of that top quality thus calls for some dedication; hence slide users tend to be more advanced amateurs.

So the choice of the film type — print or slide — depends primarily on the intended use of the image. While you can have prints made from slides, you get better quality in prints from negatives. (You can even have slides made from negatives.) Generally slide film is the material for top image quality (that's when professionals use it, too), and print film for snapshots on the one hand and big enlargements on the other.

Black-and-white is nowadays a medium for special effects that depend on monochrome reproduction, or for applications (e.g. newspaper reproduction) limited to black-and-white images. It is not a low-cost alternative to colour — the film may be cheaper, but photofinishers often charge more for black-and-white prints than for colour. Nearly all current black-and-white films yield negatives for enlargements.

All three groups include films of various speeds and also of other differences in characteristics.

Extreme-speed films, usually of ISO 800 to 1600 or even 3200 are almost exclusively intended for poor-light shooting, such as at night or in bad weather, or for sports photography where fastest shutter speeds are vital. Mostly these are colour films whose effective speed may be boosted further by push-processing. That may sacrifice colour saturation and fineness of grain. Grain is sometimes utilised pictorially for special effects.

In daylight, extreme-speed films can raise overexposure problems by being too

fast. In bright sunlight an ISO 1600 film, at the smallest f/16 aperture of the standard lens, would still need a shutter speed of $^1/_{4000}$ sec — just beyond the shortest exposure possible even with the Leica R5.

High-speed films of ISO 200 to 400 are to all intents and purposes universal materials, especially ISO 200. They exist both as print and as slide films. They are fast enough for many poor-light subjects and can still cope with brightest lighting conditions. Black-and-white emulsions of this speed range are usually ISO 400. A limitation with outdoor shots is that you can rarely use large apertures for deliberately restricted depth of field. In recent years makers have improved the grain and sharpness performance of emulsions in this group immensely.

Medium-speed films of ISO 64 to 125 are fine-grain emulsions of high acutance and thus specially suitable for slide projection at high magnification and for giant enlargements from negatives. Most films in this group are around ISO 100. These films are less suitable for interiors and low light, but are fine for all subjects not requiring high speed.

Ultrafine-grain films are again a special group (ISO 25 to 50) which today includes a few colour slide films (e.g. Kodachrome 25, Agfachrome 50, Fuji 50) and certain black-and-white materials. They are high-resolving emulsions of specially fine grain whose advantages are noticeable however only in greatly enlarged prints or slides. Their low speed limits their general use to subjects in good light.

Instant-picture films are a film type of one make (Polaroid) not covered by the above classifications. After exposure you wind the film through a small manually operated or motorised table-top processor that applies a chemical solution to the film surface and within a few minutes yields finished slides. Materials for this process include colour slide and black-and-white slide films and are intended mainly for scientific, industrial and other special applications rather than for general or amateur photography. The emulsion surface is black, which precludes the use of TTL flash exposure automation.

Colour balance and filters

Colour films, especially slide films, record the colours not only of the subject but necessarily also of the prevailing light and the way this affects subject colours. Thus they respond to the variation between midday and evening sun, or between direct sunlight and reflected light solely from a blue sky. The film also reacts to the spectral balance differences of daylight and of incandescent (tungsten) lamplight. (Electronic flash is sufficiently similar to daylight and rarely causes problems.) For professional use different daylight-balanced and tungsten-balanced films are available.

If the spectral composition of the prevailing light does not suit the film in use, you can modify the light with filters. These can also alter the colour effect in the picture, for instance excessive blueness of a subject lit by skylight only or the reddish effect (if

unwanted) of evening sun. Filters are less important with colour negative film as colour casts get corrected in printing. But the use of correction filters while shooting can still improve the quality of bulk prints produced on photofinishing printing machines.

For such correction, film makers specify a range of bluish and amber filters, ranging from very pale upwards in each case. The bluish filters compensate when you expose daylight-type colour slide film by tungsten lighting. Amber or orange filters range from colourless UV-absorbing (to eliminate blue cast due to ultraviolet rays in, for instance, alpine views) through the pale amber Skylight filter for warmer colour rendering, to distinctly orange correction filters for tungsten type film used in daylight.

Apart from the above there are a few more types:

Filters for black-and-white film modify the way in which the film interprets colour hues as greys, especially to retain or create monochrome contrast between colours of similar luminosity. Thus a yellow filter darkens the rendering of blue sky in landscapes to make clouds stand out better. Orange and red filters enhance this effect. An example of colour contrast control would be a a shot of red roses and green foliage which a normal black-and-white film renders in the same grey tones. With a green filter, however, the roses become darker against lighter foliage, whilst with a red filter they become lighter against darker leaves.

Polarising and other special filters

Polarising filters absorb polarised light and, in suitable orientation, suppress light reflections and glare from shiny surfaces. They can also darken the sky in colour pictures and have various special uses in scientific photography. Polarising filters suppress glare only from surfaces of reasonably transparent materials — water, varnish, polish, plastics, glass and glazes etc — but not metals.

Normal polarising filters also affect the way the semi-reflecting main mirror of the Leica R splits the light between the finder and meter cells. Therefore to avoid exposure metering errors use the so-called circularly polarising filters (Leitz filters marked 'P-cir' on the mount), rather than normal linearly polarising types. A circularly polarising filter is only effective if the correct side faces the subject. The Leitz versions carry a yellow dot on the mount; this must face forward when the filter is mounted on the lens.

Check the filter effect in the finder and rotate the filter on the lens until the reflections appear weakest. If rotating the filter appears to make little or no difference, check that you have mounted the filter the right way round — or remove and reverse it. Don't switch between horizontal and upright format *after* adjusting the polarising filter; such switching would kill or reverse the effect.

Leitz offers a limited range of filters to fit most Leica-R lenses (see **Filter fittings** below) — ultraviolet-absorbing, yellow, yellow-green, orange and circularly polarising — and a couple of extra ones for the 500 mm MR-Telyt-R (neutral density and red). For additional filters you may have to fall back on other makes of filter — especially for Skylight and similar filters. Look for optical quality. Preferably use plane-parallel dyed-in-the-mass glass filters by reputable filter manufacturers.

Finally, there are filters for special effects on black-and-white and colour film. They include innumerable split, graduated, diffusing, scattering, star effect etc filters from specialised suppliers. Often these are dyed plastic. Where the special effect counts — star patterns, multi-images etc — rather than top image quality, such filters are adequate. But avoid plastic filters for precise recording applications.

Filters and exposure

Filters absorb light; therefore the picture needs more exposure to compensate. TTL metering largely allows for this light loss and most of the time needs no further correction. Meter readings with a deeper colour filter for black-and-white (e.g. orange or red) tend to be less affected by the filter than the film would be; there it may be wise to increase the exposure (by the exposure compensation control) by +1 EV.

The effect with such deeper filters also depends on the exposure. Underexposure enhances the filter action, overexposure tends to subdue it. Much depends also on the tone correction aimed at. Take the example mentioned before of the red rose and green foliage. Exposed through a red filter with a straightforward meter reading the picture would show a normal-looking rose against dark leaves. With a +1 (or +2) EV correction you would have normal foliage offsetting a very light rose.

Filter fittings

Filters usually screw into the front lens mount. Most current Leica R lenses take 55, 60, 67 or (in a few cases) 77 mm filters. (See the lens table at the back.) There were earlier Leica R lenses (including earlier versions of present lenses) taking different filter sizes (44, 48, 54, 59 and 72 mm). If you have to buy a filter for such a lens, take the lens to a photo dealer and find the right filter size to fit on it. There exist also step-up and step-down rings, to use for instance 55 mm filters on an older lens with 54 mm thread.

Another type of fitting comprises the Series 7, 7.5, 8 and 8.5 filters with outside diameters from 51 to 76 mm or 2 to 3 in. These drop into a recess inside the lens front and are held in place by a screw-in adapter ring. Filter changing is thus more cumbersome, but with different Series adapters you can, for instance, use Series 7 filters on lenses with screw-in threads of 48, 54 or 55 mm. On some wide-angle lenses the clip-on lens hood holds the Series filter in place (21, 24 and 28 mm, also the 35 mm PA-Curtagon-R) and has provision for rotating the polarising filter (see **Lens hoods** in Chapter 7).

Two ultrawide-angle lenses — the 15 mm Super-Elmar-R and the 16 mm Fisheye Elmarit-R — incorporate four internal filters, because mounting a filter in front of the lens would cause vignetting.

Filter problems

Optically lenses are designed for optimum performance using the glasses in the lens. Additional unforeseen elements (including filters) tend to impair image quality. Pictures will be sharpest without a filter; so avoid using filters unless you specifically

want the filter effect. Also the filter reflects light between its front and rear surfaces. In certain lighting conditions that light scatter can reach the film, causing flare. So with filters mounted on the front of the lens use a lens hood if possible.

On the other hand, some lenses such as ultrawide-angle and mirror optical systems include the filter in the lens computation. There you should always use one the the filters provided, for instance the ultraviolet-absorbing one.

For the same reason it is not a good idea to keep an ultraviolet absorbing filter permanently on the lens for 'protection'. Such filters accumulate dirt and fingerprints. You would have to take the filter off for shooting; so you might as well use the lens cap. The only exception is in the rain when a *clean* UV filter protects the lens against unexpected splashes during shooting.

5 Creative exposure options

Exposure is the quantitative control of the action of the light on the film to produce the picture in the camera. Modern SLR cameras measure this light and, more or less automatically, modify its intensity (by the lens aperture) and the exposure time (with the shutter) for which it is allowed to act.

This generalisation leaves undefined (a) just what the camera is measuring, (b) how you expect the picture to look, and (c) which of alternative exposure combinations you should use. The first is a matter of light-metering modes, the second of overriding control, and the third of exposure control modes. The Leica R5 and R4 are particularly versatile in all three of these respects.

Simple exposure systems measure an average brightness or luminance of a scene and set the camera exposure to record that scene in an average way. The Leica R5 (and R4) does that in programmed AE mode (P mode). This yields good results in nine cases out of ten. Unusual brightness distribution or other conditions can however mislead an average exposure meter — or at least render the picture differently from what you expected.

To cope with such special cases some SLR cameras use sophisticated evaluation systems to measure different parts of the image. Microcomputers then compare and process the result and select an optimum exposure compromise. This foolproof automation is impressive in publicity but it is a compromise. The Leica way is to provide straightforward automation on the one hand plus the means for individual metering and control on the other. You have it both ways, and with the second way you control the exact result you want.

The metering modes

The light-measuring silicon photodiode of the Leica R5 and R4 sits in the base of the camera's mirror box. Some 30% of the image-forming light from the lens passes through the camera's semi-reflecting main mirror (the other 70% are reflected up into the finder for viewing and focusing) to an auxiliary reflector. The latter deflects and concentrates this light onto the photodiode.

The diode takes in light from the whole subject area, but more from the centre than the edges. Such centre-weighted measurement is a good compromise for the majority of subjects and is most convenient for automatic exposures.

But you can also move a small collecting lens in front of the cell to select just the light from the image centre. The central 7 mm circle in the finder screen (the outer circle of the microprism ring) marks the measuring field of such selective or spot readings. It covers less than 5% of the full image area. With spot readings you can select parts of the scene that are more representative for exposure purposes without being influenced by the (possibly misleading) remainder.

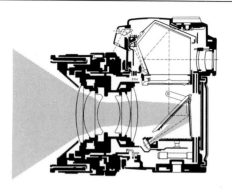

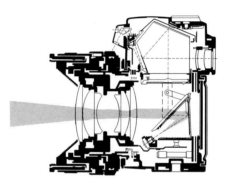

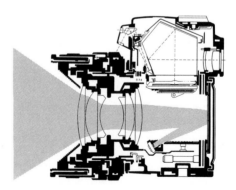

With centre-weighted metering (top) the photocell in the camera takes in the light from more or less the whole image field covered by the lens. For selective readings (centre) a collecting lens in front of the cell restricts the coverage to the centre of the image. TTL flash metering off the film (bottom — see Chapter 6) registers the light from the film.

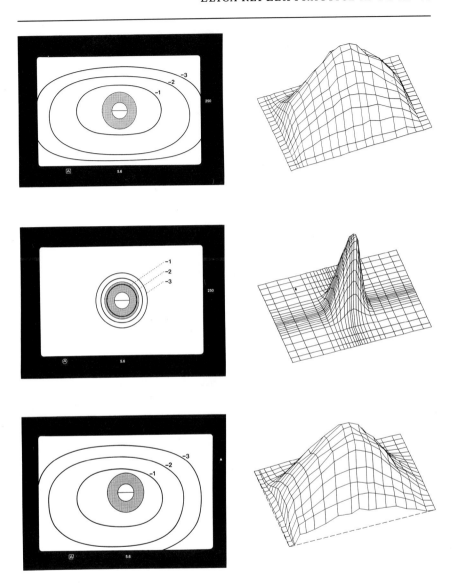

The viewfinder patterns (centre and right) show the corresponding sensitivity distributions. With centre-weighted metering the sensitivity is highest in the centre but most of the rest of the image area contributes to the light measurement. The 'contourline' circles mark levels where the cell response has dropped by 1, 2 or 3 EV steps. This drop is much more dramatic with selective metering (centre): the −1 EV level is reached within the 7 mm circle that marks the selective metering target on the screen — the −3 EV circle is only 11 mm in diameter. (This applies to the Leica R5; on the R4 series the selective reading cut-off is a little less steep but still very marked.) The sensitivity distribution with TTL flash metering (bottom) is similar to centre-weighted readings.

Metering cells seen from the back of the Leica R5 (shutter held open for this illustration). The central small square is the TTL-reading photodiode; the circular lens to the left of it slides over the cell to restrict the measuring angle for selective readings. The second cell at the right measures flash illumination reflected from the film during the exposure.

Selecting the settings

The same mode selector lever sets both metering and exposure control modes. The lever protrudes forward below the shutter speed dial and incorporates a key that you have to press in (towards the speed dial) before you can move the lever. On the Leica R5 (and R4s/2) the key is flush with the front — you need more of an effort to move it (and are less likely to do so accidentally). On the R4 and R4s the key protrudes slightly and is easier to move.

On the Leica R5 and R4 the lever has five positions. At each a different symbol appears in a square or a round field in the window between the shutter speed dial and the prism dome. The same symbols light up on the right below the finder screen. As indicated in the **Exposure modes** section of Chapter 2, the symbols indicate exposure control modes, the shape of the field the metering mode. Starting with the selector lever pushed fully to the left, the five positions are:

m (round field) = Manual control, selective readings
A (round field) = Aperture-priority AE, selective readings

A (square field) = Aperture-priority AE, full-area centre-weighted
P (square field) = Programmed AE, full-area centre-weighted
T (square field) = Time-priority AE, full-area centre-weighted
The Leica R4s and R4s/2 have only the first three positions and thus lack programmed AE and time-priority modes.

For the first trial run (see **Shooting steps** in Chapter 3) we set the camera to program mode with centre-weighted metering. Here are the alternatives.

When to read centre-weighted

When a meter cell measures average light, the camera's exposure computation or setting assumes that this average is the same thing as the brightness or luminance of a medium subject tone. We further assume that when the exposure records this as a midtone in the picture, all other tone values and colours appear lighter or darker to the correct extent.

For much of the time both these assumptions — average/midtone equivalence, and tone range match — are valid approximations. (Exposure automation would be impossible otherwise.) The average will match a midtone luminance if the scene has a fairly good spread of tones from light to dark, with no predominant dark or bright areas. The other tones will fall into place if they are not extremely bright or dark.

So use centre-weighted metering for all such subjects — outdoors in daylight with not too much sky and not too deep shadow, pictures of people and animals against medium-toned backgrounds, closeup and tele shots; evenly lit indoor scenes. By concentrating more on the picture centre, full-area readings counteract the influence of bright marginal sky areas, too.

Use centre-weighted readings also for subjects of mainly very light tones (e.g. snow, sand) or very dark ones. But if tones are lighter than average, the meter still works out the exposure as if they were average. That would make the result too dark, so such scenes need more exposure. Set that by the exposure compensation (see below). Similarly, a group of people all in very dark clothes would need less exposure (unless you want the dark clothes to appear lighter).

Using selective readings

Use selective or spot readings whenever you have smaller representative parts of subjects but where an abnormal brightness distribution (large bright or dark areas) would mislead the meter. Thus if in a snow shot a person appears large enough to fill the selective reading circle in the screen centre, read that (instead of adjusting the exposure compensation). Selective readings are fine, too for pictures of people in front of a very light or very dark background (e.g. sky or dark doorways respectively).

The same applies if the representative subject takes up a smaller area of a larger view, e.g. a sunlit scene through a dark arch or doorway. With a centre-weighted full-area reading — especially if the sunlit portion is not in the picture centre — the dark foreground makes the camera set too much exposure, overexposing the bright part.

With scenes of unbalanced distribution, or with very high contrast but no key

subject detail, select a mid-tone area. Aim the camera at that and let it determine the exposure. Most of the lighter and darker tones (except possibly the extreme ones) should then find their own level.

Selective readings are a must also if you have to ignore part of the tone range. If you are photographing people outdoors at night looking into a lit shop window, you cannot expect detail in the unlit night portions. So read the shop window — or perhaps a face lit by the shop illumination — and forget about the rest.

Holding the reading

Such a selectively read area won't necessarily be in the centre of the picture. In automatic mode (aperture priority — the only auto mode for selective readings) therefore you aim the camera at the subject point you want to read and hold the reading while you reframe the shot to your liking.

So start to depress the release button until the red **A** symbol in the circle (below the finder screen, right) goes out. Keeping the button in this half-pressed position holds the exposure reading (and automatic setting) until you let go of the button — or of course until you have taken the picture by fully depressing the button. The shutter speed shown by the LED at the right also stays constant as you repoint the camera.

The reading hold works only if the shutter is tensioned. You hold the reading in the same way with the Leica R4 (also R4s and R4s/2). But in this case the LED indicates the actual rather than the held reading and may shift to a different shutter speed as you repoint the camera.

The exposure modes: The basic program

When you turn the mode selector to **P** mode, check that the red **P** signal below the finder screen is steady as you half depress the release button. If the signal flashes, turn the lens aperture ring to the smallest stop (f/16 on lenses of f/2 or faster, otherwise usually f/22). Only then can the auto aperture setting part of the program select f/stops from the full range.

For the normal program set the shutter speed dial to $^1/_{30}$ sec — as also marked by **P** on the dial. Programmed AE now means that for any lighting level the camera's process computer selects a particular combination of aperture and shutter speed.

At low lighting levels this is the largest lens aperture and a matching speed. When the light gets good enough for an exposure of $^1/_{30}$ sec at the largest aperture (say f/2) — this is EV 7 — the program begins to reduce both the exposure time and the aperture together. At a lighting level requiring EV 9 the combination will be $^1/_{60}$ at

Right: In normal program mode (**P** and $^1/_{30}$ sec setting on the Leica R5, **P** and any speed other than X, B or 100 on the R4) and in low light the camera selects an appropriate shutter speed at the largest lens aperture, but from $^1/_{30}$ sec onwards reduces both the exposure time and the lens aperture together (solid program curve **A**). At for instance a subject luminance of 4000 cd/m², or EV 15 with ISO 100 film, the program selects an exposure combination of $^1/_{500}$ sec at f/8. With a slower lens — e.g. f/4 — the whole program curve is displaced upwards (broken line **B**). The lens must be set to its smallest stop — otherwise the program cannot stop down beyond the actual lens aperture set, e.g. f/11 (broken curve **C**).

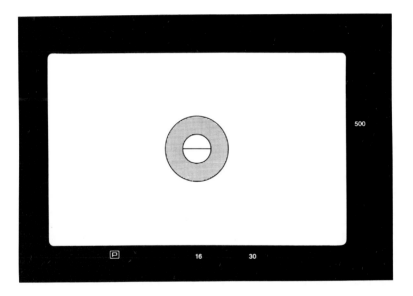

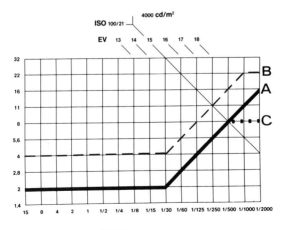

f/2.8, by EV 15 it reaches $^1/_{500}$ sec at f/8, and by EV 19 $^1/_{2000}$ at f/16. The combination changes fairly continuously — you could have, say, $^1/_4$ sec at f/2.4 somewhere along the line. The LEDs would in that case light up both '30' and '60' together just to indicate a meter-set in-between value.

With a lens of smaller maximum aperture, say f/4, the program still runs to $^1/_{30}$ sec at the full aperture and then starts increasing both aperture and speed. As f/4 with $^1/_{30}$ sec is EV 9, the whole program curve in effect shifts upwards.

Program shift

Programmed AE relieves you of the need to choose exposure settings, but normally you then have to accept the settings the program offers. For instance at EV 15 you are stuck with $^1/_{500}$ sec even if you are shooting a running child at close range and would prefer $^1/_{2000}$ sec to freeze the movement.

On the Leica R5 you can change things with the program shift. Instead of keeping the shutter speed dial at $^1/_{30}$ sec in program mode, set it to a faster speed until the LED at the right of the finder lights up at $^1/_{2000}$ sec. You are in effect overriding the program to get the faster speed. But the camera is still in program mode and automatically adjusts aperture/time combinations if the light changes. Compared with the standard program at EV 15, this shift has now produced a combination of $^1/_{2000}$ sec at f/4.

In case the signals in the finder get confusing, remember that the *red* LED at the right indicates the meter-set shutter speed — the one at which the picture will be exposed. The right-hand window *below* the finder shows in *white* the shutter speed you selected to shift the program. It could be for instance $^1/_{500}$ sec and would in that case be the starting point for the program. Shutter speeds go slower than this only if the lens is at full aperture and there is not enough light for a $^1/_{500}$ sec exposure.

If all that is still too complex, just go by the shutter speed shown by the red LEDs at the side.

On the other hand you may wish to get a near foreground sharp together with far distance. The greater depth of field may call for a smaller aperture than provided by the program combination. In that case set a slower shutter speed — perhaps $^1/_2$ sec. That shifts the beginning of the program's stopdown limit. The program begins to stop down the lens as soon as the light is sufficient for $^1/_2$ sec at the full aperture.

The meter-set shutter speed is again that indicated by the LEDs at the right. The effect of shifting the program towards smaller apertures however is less clear in the finder, as you don't see meter-set apertures. Where you need a specific aperture for adequate depth of field, it is easier to switch to aperture-priority AE (see below) and simply select that aperture on the lens.

The Leica R4 has only one program — the standard one you get with the Leica R5 set to $^1/_{30}$ sec. But on this camera it doesn't matter which shutter speed you set, as long as it is not X, B or 100. If you need a given aperture for depth of field, again

Right: On the Leica R5 you can shift the program towards faster shutter speeds for action subjects: select program mode but set the shutter dial to, for instance, $^1/_{500}$ sec. This moves the program curve so that the program starts stopping down the lens only once the light is good enough for a shutter speed of $^1/_{500}$ sec or faster. At EV 15 that yields, in this case, an exposure combination of $^1/_{2000}$ sec at f/4.

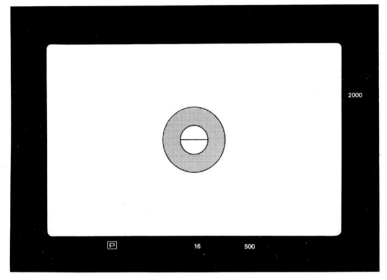

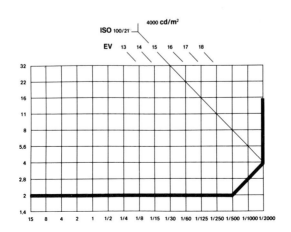

select that in aperture-priority AE mode. And for a specific fast shutter speed, select that in time-priority mode.

Aperture-priority AE

If programmed AE is the (comparatively) lazy way of handling exposure, aperture-priority, or **A** mode, is convenient for more imaginative control.

In **A** mode you select the lens aperture you want to use. That aperture appears in the central window below the finder screen. The meter system of the Leica R checks the light coming through the lens and the input of the aperture setting ring. It then (i.e. immediately) sets a correctly matching shutter speed for the prevailing light and shows it by the LEDs to the right of the screen.

The aperture could be one required for a given depth of field. Check the sharp zone you need on the depth-of-field indicator (see **Sharpness in depth** in Chapter 7) and select an appropriate aperture.

But **A** mode also automatically allows for all conditions that modify the light coming through the lens without changing the nominal aperture setting. That includes the exposure correction for macrophotography (see Chapter 11) and for many of the filters. Aperture-priority is also the one automatic mode you can use with all lenses and lens accessories, including those incapable of automatic aperture control (see **Lens types and automation** in Chapter 7).

In **A** mode you can still control shutter speed indirectly. Check the LED indication at the right of the screen. If you feel that likely subject movement (or risk of camera shake) calls for a faster shutter speed, just turn the lens aperture ring till the LEDs show the speed you want. (This is a little like the program shift of the Leica R5.)

The arrowhead at the top of the LED scale (above 2000 in the Leica R5 or above 1000 in the R4 models) is an overexposure warning. With the aperture and film speed selected you would need a faster shutter speed than the camera has. So stop down the lens until the LED again lights behind (or next to) one of the marked speeds.

Time-priority AE

This is the ideal AE mode when you have to work with a specific (usually fast) shutter speed, for instance in sports photography. When you move the mode selector lever to **T**, an aperture scale replaces the LED scale of shutter speeds. As in **P** mode, you must also set the lens to its smallest aperture — until you do so, the red **T** mode LED below the finder screen blinks and there is no aperture LED indication.

T mode (like **P** mode) requires lenses capable of automatic stopdown control. That excludes the 500 mm MR-Telyt-R mirror lens and also setups involving macro

Right: Selecting a slow shutter speed such as $^1/2$ sec in program mode shifts the program to start stopping down the lens sooner for greater depth of field. In this case the program starts stopping down the lens already when the shutter speed reaches $^1/2$ sec. At EV 15 this yields a combination of $^1/125$ sec at f/16.

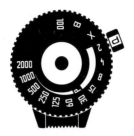

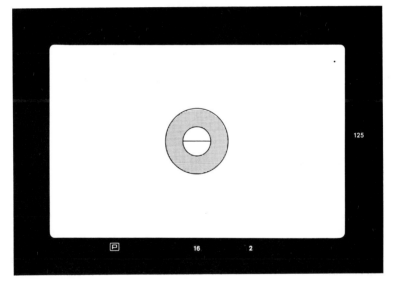

extension tubes and bellows. Exposure metering is confined to centre-weighted full-area readings; there is no selective reading alternative.

To expose in time-priority mode, preselect the shutter speed — check it (white figures) in the right-hand window below the finder screen — then focus and shoot. For hand-held shots select a fast enough shutter speed to avoid camera shake; in practice that means $^1/_{60}$ sec or shorter with a standard lens (see **Speed against camera shake** in Chapter 3). The LEDs at the right then show the meter-set aperture at which the camera will expose the picture. The LEDs cover only the aperture range of the lens. The coupling levers transmit this as you fit the lens on the camera.

With this manual shutter speed selection you can use only the settings marked on the speed dial. On the Leica R5 these are the full steps (no intermediates) from $^1/_{2000}$ to $^1/_2$ sec, on the R4 and R4s models from $^1/_{1000}$ to 1 sec. The exposure times however are still controlled electronically. Do not use the yellow or orange X, B or 100 positions on the speed dial; at these settings **T** mode is inoperative and the camera exposes at the smallest lens aperture. (Only the top arrowhead LED lights up.)

When the shutter speed is too fast for an exposure at the largest aperture, the downward-pointing arrowhead lights below the lowest f/number on the scale. Similarly, the upward-pointing arrowhead lights if the shutter speed is so slow as to risk overexposure. However, the Leica R5 and R4 not only show these over- and underexposure limits but also do something about them. If the user-selected shutter speed risks underexposure, the camera overrides the selected value to set a longer time. If the selected speed risks overexposure, the camera resets to a shorter time. The arrowheads show that this override is operating, but you don't get to know what the reset shutter speed is.

Time-priority AE thus provides similar control of shutter speed to programmed AE. However, in **T** mode the time remains fixed at the chosen value and only the aperture changes (as long as it can change) with light changes. In **P** mode both the time and aperture change with the light.

The Leica R4s and R4s/2 models do not have a **T** mode. There you can still control shutter speed indirectly as described for aperture-priority AE.

Manual control

With the mode selector pushed fully to the left (**m** in the window) the camera is in manual mode: You directly set both apertures and shutter speeds. When moving from **A** (in circle) to **m** on the Leica R4s/2, release the key of the mode selector lever and depress it again. This delay lock stops accidental movement from aperture priority to manual, but permits quick switching between full-area and selective readings in **A** mode.

As you are more likely to use manual mode for subject conditions requiring special exposure measurement, it is combined exclusively with selective metering. The user-selected settings are the ones visible below the finder screen: lens aperture in the centre window and shutter speeds in the window to the right of it. The meter-suggested (no longer meter-set) shutter speeds are those indicated by the LEDs at the right.

To follow meter-suggested settings, either:
(1) preset the aperture and then adjust the shutter speed dial until its setting is the same as the LED indication, or
(2) preset the shutter speed and adjust the aperture until the LED indication has moved to the same value as your preselected speed.

As in **T** mode, you can set any of the fixed shutter speeds marked on the speed dial, but no intermediate values. Apertures engage in half-stop intervals. At these, two aperture figures appear to either side of the centre in the window. At the marked f/stop settings the latter is centred in the window. Still finer f/stop intervals are possible but not really necessary — they are likely to slip into the nearest half-stop engagement point anyway.

Exposure compensation

Unbalanced brightness distribution of some subjects — e.g. snow scenes — is liable to mislead the exposure meter and result in wrong exposures. As indicated below (**Corrections in practice**) you allow for that by adjusting the exposure settings. In manual mode that is straightforward. Increase the exposure by 1 EV step either by using the next larger aperture (one f/number step lower) or the next slower shutter speed. Decrease the exposure with a smaller f/stop or faster shutter speed.

In automatic mode the exposure compensation control below the rewind crank can also set the camera to apply this correction automatically.

On the Leica R5 and R4s/2 press down the override lock, that is the button with the ± mark to the left of the finder dome. Either keep it depressed or turn it to make its pointer point inwards to the right. Now move the black lever protruding from the outside rim of the film speed dial to bring the appropriate setting into the window at the left. The uncorrected position is **0**, the dots below (+) indicate increased exposure and the dots above (-) decreased exposure, both in $^1/_3$ EV steps. The maximum in each case is 2 EV.

So with the compensation set to +1, the camera increases all automatic exposure settings by the equivalent of +1 EV step. In aperture-priority mode that means the next slower shutter speed, in **T** mode the next larger f/stop. The red ± triangle at the extreme left below the finder screen blinks rapidly when the exposure compensation is in use; remember to reset it to **0** afterwards.

In the Leica R4 and first R4s (not mod. 2) the override lock is a button, not a lever, and the settings go from −2 to +2 EV in $^1/_2$ EV steps.

The exposure compensation adjustment is mechanically combined with the film speed setting, which increases or decreases the exposure settings in the same way. At the ends of the film speed scale the compensation range is restricted. You can set no underexposure at ISO 3200 and no overexposure at ISO 12. At ISO 1600 the underexposure is limited to − 1 EV, at ISO 25 the overexposure to + 1 EV — rarely a problem. There is no restriction between ISO 800 and ISO 50.

Corrections in practice

Finally, here is a summary of actual exposure corrections you are likely to need in

automatic mode. They apply equally to manual mode (see below) though you would in that case set them not by the exposure compensation but by adjusting the aperture and/or the shutter speed setting.

Subjects of predominantly light tones: If for instance in a snow scene there is no midtone that you can conveniently read, even a selective reading leads to underexposure. So increase the exposure by +1 to 1½ EV, especially with slide film.

Subjects of predominantly dark tones: These need the opposite treatment to avoid overexposure. Apply a −1 EV compensation, again especially with slide film. (You can usually ignore −EV compensation with colour print film where overexposure by 1 EV does no harm.)

In both these cases it is the predominant subject tones that count, the exposure meter automatically allows for the general lighting level. But a subject of mainly dark tones appears too light in a colour slide without such correction. And underexposed snow can easily look like soot.

Very contrasty scenes where both highlight and shadow detail are important: switch to manual mode (which always involves selective readings), read important lightest and darkest areas separately, then use a mean value for the exposure. If for instance the brightest subject area needs f/16 and a shadow reading (with the same shutter speed) on a dark area f/4, this is a difference of four f/stops. The mean would be two f/stops from each end, i.e. f/8. Still more contrasty subjects (more than 5 f/stops difference) rarely reproduce well in prints, though you may get away with it on slide film. So either fill in deep shadows with flash or select a correct exposure for the main subject and sacrifice perfect rendering for the extremes of the range.

If you shoot such scenes with the short-focus setting of a zoom lens, zoom to the longest focus to read the selected subject portions within the reduced measuring angle. Set the exposure accordingly, then zoom back for the picture itself. If you are using a wide-angle or normal lens of fixed focal length you can switch to a tele lens for a more restricted selective reading — but this is of course more involved and needs some leisure.

Extreme low contrast: Landscapes in the rain and other dull-weather subjects are rendered rather dark on slide film. So overexpose by +½ to +1 EV to bring out the mood without burying the image in impenetrable gloom.

Sunsets, night shots etc: For direct sunsets take a selective reading on the sky right next to the sun but don't include the sun itself in the metering area. That usually yields an optimum compromise between some foreground detail and a just visible disc of the sun in the sky. If you measure the foreground, the sun becomes indistinguishable against the sky; if you read the sun itself, everything else becomes too dark. Try bracketing (see below) with a series of exposures at different settings and select the one you like best.

Similar considerations apply to night scenes, especially with street lighting and

large dark areas. When exposure times run into several seconds, increase the exposure by a further +1 to +3 EV (manually beyond +2 EV) for at very low lighting levels the film behaves as if it had dropped in effective speed. Apart from that, different exposures yield a different balance between night and light and it becomes a matter of taste which combination you prefer.

Bracketing exposures

The exposure override lock on the Leica R5 and R4s/2 is particularly easy to disengage for making series of bracketing exposures — a favourite professional way of making sure of at least one correct exposure in tricky light conditions.

To make a bracketing series — in the **A**, **P** or **T** auto exposure modes — select first the bracketing interval. Usually a ⅔ EV step is most suitable with colour slide film or a full EV step with negative film. Depress the override lock and turn it (pointing at the finder dome) to keep it unlocked. Fully push forward the compensation lever protruding from the rim of the dial. That sets +2 EV overexposure.

Expose the first frame, then bring the compensation lever back through two clicks (for a ⅔ EV interval) or three clicks (a full EV step) and make the next exposure. Repeat until the compensation lever has reached its farthest rear position. With ⅔ EV intervals this yields a series of seven exposures, with full EV steps five exposures. (You can restrict a series to fewer exposures.) The middle shot is the meter-set 'correct' exposure; for this exposure the compensation signal should also disappear in the finder.

This procedure is even more convenient with the motor winder or drive on the camera.

Bracketing sequences are also possible in manual mode. Establish the right exposure, preselect an aperture/speed combination for whatever overexposure you want to start with, and then adjust the aperture ring on the lens or the shutter speed dial step by step for the complete series. Here aperture correction can go in half-stop intervals, shutter speed correction only in full EV steps.

Manual mode is also best for bracketing exposures with the Leica R4 and the first R4s. For on these cameras you have to keep the override lock depressed manually — not so convenient for a bracketing sequence.

Meter sensitivity

A second function of the ± exposure compensation signal is to indicate the lower metering limit. If the light is too weak for the meter to measure at all (too weak even for an extended slow exposure up to 30 sec), the ± signal in the triangle lights up and stays steady (without blinking).

With an f/1.4 lens the lower meter sensitivity limit in terms of subject luminance is 0.25 cd/m² for full-area centre-weighted readings. It is 1 cd/m² for selective readings since the cell here receives less light. The reading limit with slower lenses does not go as low, since the lens again passes less light to the silicon photodiode inside the camera.

With an ISO 100 film an average subject luminance of 0.25 cd/m² corresponds to

an exposure of 1 sec at f/1.4 or EV +1. At full aperture and with this film speed setting 1 sec is thus the longest exposure time the Leica R5 or R4 models can yield. For anything that would need longer, the ± signal lights up. The R5 does set longer times up to 15 sec (in aperture-priority AE mode) at smaller apertures — down to f/5.6. (During the reading the lens is at full aperture; the aperture selection only simulates smaller stops, so these do not affect the meter sensitivity.)

The LEDs of the Leica R5 indicate meter-set times up to $^1/_2$ sec; for anything longer '2' lights up at the bottom of the scale together with a downward-pointing arrowhead or triangle.

According to Leitz the longest time with the R4 models is 8 sec; in fact some cameras yield longer times up to 30 sec but these are no longer reliable settings. The longest time indicated by the LEDs is 1 sec; the downward pointing arrowhead next to this also serves for all longer times.

You can get longer times at full aperture also with slower film speed settings — up to 8 sec with ISO 12. Conversely, the longest possible exposure at full aperture becomes shorter with faster films: $^1/_4$ sec with ISO 400 and only $^1/_{30}$ at ISO 3200. The LEDs at the right of the finder may indicate longer times, but the ± sign at the left will light, too, to signal that you are outside the camera's measuring range.

With selective readings these limiting times become shorter by two steps. At ISO 3200 the longest exposure at full aperture (before the out-of-range ± signal appears) is $^1/_{125}$ sec!

With low-light scenes just below the selective measuring limit you can sometimes get around this limit. Set the exposure compensation to +2 EV and take a selective reading on a brightest subject portion. The setting compensates the exposure for the fact that this highlight reading registers a luminance usually four times higher than a midtone.

There is an upper meter limit, too, but that depends more on the smallest aperture/shortest time combination that the camera can set. With the f/1.4 standard lens on the Leica R5 that is $^1/_{2000}$ sec at f/16, equivalent to EV 19 or — with ISO 100 film — to about 66 000 cd/m². With a lens capable of stopping down to f/22 the limit would even be EV +20. It is academic, though, as these limits are well beyond anything you are likely to come across. The average luminance of the brightest outdoor scene in brilliant summer sunlight rarely exceeds 8000 cd/m².

Long time exposures

If a required exposure time is likely to exceed 8 sec or so, e.g. with night shots out of doors or other subjects below the camera's measuring limit, use a long time exposure. Turn the shutter speed dial to B (marked in red), screw a cable release (to avoid camera shake by pressing directly on the camera) into the socket in the release button. Press the release plunger and hold it depressed while you count off the seconds of the exposure time. A cable release with lock is handy if the exposure time is longer than about half a minute. The Leica R must of course be mounted on a tripod or other firm support.

Remote control with the motor winder or drive (see Chapter 10) is another way of releasing the tripod-mounted camera.

The B setting is one of the two mechanical shutter settings (see below) — it does not depend on battery power. That's just as well, for that way keeping the shutter open at B for seconds (or even minutes) on end does not drain the camera battery.

Mechanical fallback

One problem with electronic automation is that such a system depends on battery power. I always carry at least one set of spare silver oxide batteries for the camera's exposure system. But in case you are caught out (and also in case of — hopefully rare — electrical failure) the Leica R models have a fallback mechanical shutter setting: the red 100 (1/$_{100}$ sec) on the dial. (On the Leica R3 the X setting — 1/$_{90}$ sec — serves the same purpose.)

For such mechanical operation select an exposure combination of a suitable lens aperture to match a time of 1/$_{100}$ sec. For the correct exposure consult the instruction leaflet packed with the film or printed on the inside of the film carton. This includes a summary — but surprisingly reliable — exposure table for outdoor subjects. Use the lens stops specified for 1/$_{125}$ sec (or one stop smaller than indicated for 1/$_{250}$ sec). The 1/$_{100}$ sec setting is also a mechanical flash synch speed.

The electromechanical shutter release of the Leica R5 and R4 models has a mechanical fallback too. Just depress the release button further. If the first pressure does not trigger the shutter, the second will (at 1/$_{100}$ sec of course).

The selftimer

To switch on this delayed-action release, traditionally associated with self-portraiture, check that the shutter is tensioned and turn the selftimer button clockwise through 30° to engage. That is the button with the two halves of a vertical bar, on the camera front next to the lens release. (It won't engage if the shutter is not tensioned.) Slightly depress the release button, as for switching on the meter circuit. This lights an LED in the window above the 'C' of the Leica name on the camera front and releases the shutter 8 sec later. During the first 6 sec the LED blinks twice a second to signal that the selftimer is running; during the last 2 sec the LED is steady.

If you fully depress the release button, it releases the shutter straightaway. To switch off the selftimer before an exposure simply turn back its button.

The selftimer is most useful when you want to eliminate any vibration risk during releasing. That might be the case with the camera mounted on a not very steady tripod, when pressing the Leica with table stand against a wall or when you need both hands to support a combination with a heavy lens. For self-portraits the remote-controlled motor drive or winder is much more practical — especially as you then control the exact moment of release.

The eyepiece shutter

Light can pass into the finder system through the eyepiece when you don't have your eye close behind the eyepiece. In extreme cases (strong sun from behind) it can then

filter through the finder optics and mirror right down to the meter cell in the camera base and interfere with correct exposure control.

So whenever you use the Leica R on a tripod, stand or otherwise leave it to its own devices during the exposure (e.g. with the selftimer or remote control), close the eyepiece shutter after you have finished focusing. Turn the black button (to the left of the finder eyepiece) anticlockwise to set its bars horizontal. You see a white triangle (in the Leica R5) or circle (R4 models) inside the eyepiece when this shutter is closed.

Multiple exposures

Normally the winding lever advances the film after every exposure and so prevents accidental superimposition of two images on the same frame. But you can do so deliberately by disengaging the film transport after an exposure.

After the first exposure of such a multi-series, and before advancing the film, fully depress the rewind release in the camera base. It should stay depressed. Operate the winding lever. Now it only retensions the shutter but does not move the film inside the camera.

At the end of the lever movement the rewind release springs out again. Repeat the process to make a third exposure (and further ones) on the same frame. The frame counter does not advance during a mere tensioning cycle that does not move the film — it therefore continues to count correctly the number of frames exposed.

The motor winder and drive have provision for keeping the rewind release depressed all the time for motorised multi-exposure sequences. (See Chapter 10.)

For straight superimpositions of subjects of similar brightness, reduce each part exposure to half (1 f/stop smaller or − 1 EV underexposure) with a double exposure, to one-third with a triple exposure and so on. This avoids overexposure. If one of the exposures is meant to yield a weaker ghost effect, reduce its exposure time further still. But aim to keep that image against a dark background, otherwise it may get lost altogether.

Use the full exposure for each part shot when photographing motion studies against a black background. (See **Stroboscopic effects** in Chapter 10.)

The signals summed up

As explained in the previous pages, the multiplicity of exposure and metering modes give rise to numerous LED and other signals in the finder. The table below sums up these for quick reference, distinguishing also between information and warning signals.

TABLE 1 **Viewfinder signals**

Signal	Type	Meaning	Action
Exp. LED: Steady upper arrow head only, does not change with light	Warn	Speed dial set to mechanical speed (X, B or 100)	Set speed dial to one of white speed figures

Signal	Type	Meaning	Action
As above, T symbol blinks below finder at right	Warn	Lens not set to smallest aperture	Turn lens aperture ring to smallest stop
As above, but other exp. LEDs appear as light changes	Warn	Overexposure risk	Select smaller aperture (A mode) if available
As above, in T mode	Info	Automatic override is setting faster shutter speed	
Exp. LED: Slowly blinking upper arrow head only (with dedicated flash in hot shoe — see Chapter 6)	Info	Flash charged ready to fire	Take flash shot
As above, immediately after flash exposure	Info	Correct automatic flash exposure	
Exp. LED: Fast blinking upper arrow head (immediately after flash exposure)	Info	Correct automatic flash exposure	
No upper arrow head immediately after automatic mode flash	Warn	Insufficient automatic flash exposure (or flash in manual mode)	Repeat exposure at larger lens aperture or nearer distance
Exp. LED: Lower arrow head only; A and P modes	Info	Camera is setting longer time than $\frac{1}{2}$ sec (R5) or 1 sec (R4)	
As above, in T mode	Info	Automatic override is setting slower shutter speed	
Exp. LED: Numerical indication	Info	Aperture (T mode) or shutter speed (other modes) set by camera or suggested for correct exp. (m mode)	
Exp. LED: Two LEDs light together	Info	Intermediate meter-set aperture or speed	
Mode LED: m, A, T or P	Info	Indicates exposure mode in use	
Mode LED: T or P symbol blinks below screen at left	Warn	Lens not set to smallest aperture for T or P mode	Turn lens aperture ring to smallest stop

Signal	Type	Meaning	Action
Mode LED: ± symbol blinks below screen at left	Warn	Exposure compensation setting in use	Reset exposure compensation to 0 after current exposures
Mode LED: ± symbol steady below screen at left	Warn	Subject brightness level outside camera measuring range	Try highlight reading
Shutter speed window below screen: No shutter speed	Info	Leica R5 in A mode; R4 in A or P mode	
Aperture window below screen: No aperture	Info	Non-automatic lens on camera (PA Curtagon, longer Telyt, extension tube or bellows)	Set or stop down aperture manually — read exposure at working aperture

Exp. LED = Speed/aperture LED signals to right of finder image
Mode LED = Mode indications below finder image (bottom left)
Info = Information signal
Warn = Warning signal

The above signals may appear in combination. However, only one exposure LED (or two neighbouring ones) can appear together. Also, only one of the mode LEDs is visible at a time, except that the ± LED can appear together with any one of the other mode LEDs.

To flash or not to flash? The flashless shot (top) conveys the impression you get as you enter this Wat Phra Singh shrine (Chiang Mai, Thailand) — but it needed $^1/_{30}$ sec at nearly the full aperture of the 50 mm Summilux-R to do it. With flash (at f/8 — bottom) you see more detail, depth of field covers everything from the near flowers to the background, but the atmosphere is lost.

(Photos: Andrew Matheson)

Visitors were not allowed up this stairway in the Royal Palace complex in Bangkok (above — taken with 50 mm Summilux-R). A closer view of the demon guard (right) therefore needed the 180 mm Elmarit-R. For the five-headed snake (far right) I used the 90 mm lens to keep the image large from far enough away for moderate perspective. (I temporarily unhooked the chain which was in the way — see above.) Kodachrome 200 film.

(Photo: Andrew Matheson)

For the row of these golden Buddha statues in a museum in Pagan, Burma, I needed a a smallish aperture for depth of field, yet short enough time for a hand-held exposure by the fairly weak available light. (Flash was out of question.) The eventual compromise was $^1/_{30}$ sec at f/4 — which just failed to get the nearest statue absolutely sharp. 28 mm Elmarit-R lens, Kodachrome 200 film.

(Photo: Andrew Matheson)

6 Flash and the Leica R5

The Leica R5 can automatically control flash exposures, too. A second TTL photodiode inside the camera measures the light during a flash shot. A control circuit inside the flash unit registers this measurement and switches off the flash when the film has received sufficient light for a correct exposure.

Obviously this requires a flash with a suitable control circuit. Leitz does not make electronic flash units but has designed its flash control to work with all flashes compatible with the dedicated SCA 300 system sponsored by Metz. These flashes, marketed by several European electronics firms, take dedicated SCA (*Special Camera Adapter*) interfaces. Through these the Leica R5 controls the exposure with the flash unit and the latter transmits certain signalling information to the camera.

Flashes and interfaces

Flash units usable in this fashion are the shoe-mounted Regula 742 SCA or the

Dedicated contacts in the Leica R5 hot shoe, surrounding the large synch contact. Signals through the lower left contact set the shutter to its synch speed and indicate flash readiness and correct exposure, the other two contacts carry flash terminating signals. The Leica R4 lacks the two right-hand contacts.

Mecablitz 32 CT and 36 CT models from Metz, as well as the professional Mecablitz 45 CT-3, 45 CT-4 and 60 CT-4 handle-and-bracket types. Also associated with the SCA system are flashes by Cullmann and Wotan (German Osram), plus some discontinued Bosch/Braun and Agfa models.

The interface required for TTL flash control with the Leica R5 is the SCA 351 adapter. This is a small box with a foot that fits in the camera's hot shoe. It carries the main synchronising contact as well as additional control contacts that mate with similar contacts in the hot shoe. The adapter in turn takes the flash unit itself. Shoe-mountable flash units thus sit directly on top of the camera. For bracket-mounted flashes (or when a shoe-mounted flash is used on a bracket and grip such as the Metz G15) a further SCA 300A or SCA 307A cable connects the flash with the SCA 351 adapter. The latter then sits on its own in the camera's hot shoe.

With the Leica R4 models the same flashes and interface provide a more limited control range. (See **Leica R4 flash dedication** below.)

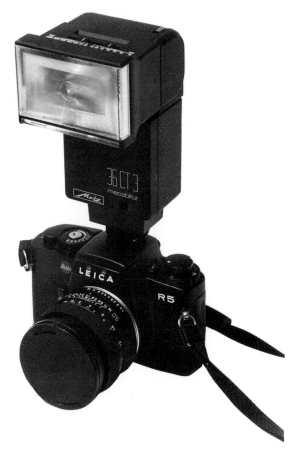

Flash units compatible with the SCA 300 system permit TTL flash exposure control with the Leica R5.

Regula 742-2 SCA flashgun. Another flash unit which couples to the Leica R5 via the 351 adapter, or to the R4 and R4s via the 350 adapter. The sub-flash is detachable, as shown, and can be used as a slave flash which is triggered by the main flash; no connecting cable is required.

TTL with Leica R5

The TTL flash metering photodiode sits alongside the cell for normal full-area and selective metering. It points at the film gate and during the exposure, while the shutter is open, measures the light reflected from the film surface. This is a measure of the flash light reflected from the subject. The cell records the light quantity rather than intensity; it thus yields a real-time exposure measurement, at the working aperture of the lens. (Inevitably, as the lens is stopped down during the exposure.)

The flash control circuit compares the signal output for the accumulated quantity of light with its correct exposure program. When the two match, the circuit terminates the flash. In so-called thyristor-controlled flash units the residual flash energy remains stored (for a while) in the unit's power capacitor and under suitable conditions permits very short recycling times. That residual energy also controls an auto check signal to confirm a correct exposure.

Reliable functioning of such exposure control depends on a standard degree of light reflection from the film. In fact, the emulsion surface reflectivity of most film types is sufficiently consistent to yield correct exposures by this method. The only exceptions are a few specialised films not normally used for flash exposures, and

Polaroid instant-picture materials. Use non-TTL flash control with these (see below).

Flash synchronisation only involves exposure times where the focal plane shutter fully uncovers the film. The flash metering cell therefore takes in the light from the whole film area. The reading characteristic is fairly similar to normal full-area centre-weighted measurement.

Dedication functions

In addition to flash duration, the dedicated SCA 351 interface and the Leica R5's own circuits control the following functions:

Synch speed: As soon as the flash unit connected to the camera is charged up ready to flash (or as soon as it has recycled from a previous flash) the shutter speed switches automatically to its synchronising speed. This is an electronically controlled $1/100$ sec, the same as the $1/100$ sec you can set manually with the X setting on the dial (but not the mechanical 100 on the dial). This switching takes place in all exposure control modes (**m, A, P** or **T**) and irrespectively of the user-selected shutter speed.

Ready flash signal: Simultaneously with the synch setting the upper arrow head of the LEDs at the right lights up and blinks twice a second. You are ready to shoot.

Auto check signal: This appears immediately after an automatic flash exposure — controlled either by the TTL sensor of the Leica R5 or the flash's own sensor. If the flash output was adequate for a correct exposure, the upper arrow head lights up. This is the case if there was still undischarged energy left in the power capacitor when the sensor's control circuit switched the flash off.

Depending on the amount of energy left over, the auto check signal may appear in one of two ways. If the flash used up most of the capacitor power, the arrow head blinks rapidly (8 blinks/sec) for one or two seconds, and is then replaced — possibly after a short interval — by the slow 'flash ready' blink. If the flash used only a little energy (e.g. with near subjects or at a large aperture), recycling is almost instantaneous and the arrow head blinks slowly (without a fast flashing stage) immediately after the exposure. Both the fast and the immediate slow blink confirm a correct exposure.

TTL shooting procedure

Here are the preparatory steps for setting up the camera and flash:
(1) Mount the flash unit — with SCA 351 adapter foot — in the camera's hot shoe. With a grip type unit mount the SCA adapter in the hot shoe and connect the flash to the adapter via an SCA 300A or 307A cable.
(2) Set the flash to TTL operating mode. (On some flashes manual mode covers also TTL operation.)
(3) Check the correct film speed setting on the Leica R5. (The film speed setting on the flash unit is irrelevant for TTL operation.)

(4) Check the approximate subject distance — e.g. from the lens distance scale after focusing. On the flash unit's calculator find the lens aperture needed to cover at least this distance. Check the instructions for the flash unit on how to do this.
(5) Set the camera lens to that aperture.
(6) Switch on the flash.

Shooting involves just two steps:
(7) Expose once the ready light starts to blink.
(8) After the shot look for the auto check signal to confirm a correct exposure.
Repeat steps (4) and (5) if the subject distance changes significantly.
 The exposure compensation setting on the camera controls effective exposure in the same way as with normal shots.

Leica R4 dedication

The Leica R4, R4s and R4s/2 do not measure flash exposure through the lens.
 The SCA 351 interface here only sets the camera shutter to the $^1/_{100}$ sec synch speed. It also signals:
(a) flash readiness in the finder by the upward-pointing arrow head LED at the right of the screen, and
(b) correct exposure as recorded by the flash in its own (non-TTL) automatic mode.

After an exposure the flash-ready and auto check signals do not appear if you keep the release button of the R4 depressed. Therefore after a flash shot let go of the button completely, then depress it slightly to see the LED signals.
 The SCA 350 adapter provides the same dedication functions with the Leica R4 models as does the SCA 351. So does the SCA 550 adapter with flash units designed for the earlier SCA 500 interface system (e.g. the professional Mecablitz 45 CT 5 and 60 CT2 handle/bracket models).
 With the Leica R5 the SCA 350 and 550 interfaces provide the same limited dedication as they do with the R4; only the SCA 351 permits TTL flash control.

Non-TTL computer flash use

Most current flash units (other than the smallest ones) are computer flashes with a built-in sensor to control exposure automatically. Even if they are not SCA-dedicated you can still use them with the Leica R cameras — with all models including the R3. Here all settings (other than shutter speed and lens aperture) are on the flash unit and that is where you also watch the flash ready and auto check signals. On some flashes audible beeps supplement LED signals — handy, as you don't then have to remove the camera from your eye.
 Mount the flash in the camera's hot shoe or — if a grip type unit — connect the synch lead to the synch socket on the camera body. (Plug into the X socket on the Leica R3.) The settings and steps are then:
(1) On the flash unit set the speed of the film in the camera. (The camera's speed

setting is irrelevant for flash without TTL control.)
(2) Set the flash to auto mode. Check the subject distance and on the unit's calculator or other display read off the required lens aperture for that (or the nearest greater) maximum distance. This may involve switching output levels.
(3) Set that aperture on the lens (camera preferably in manual mode).
(4) Set the shutter speed on the Leica to X or $^1/_{100}$ sec. Switch on the flash unit. Then:
(5) Wait for the ready signal on the flash unit.
(6) Expose and check the auto check signal (on the flash) for correct exposure.

If no available aperture option in auto mode covers the subject distance, switch the flash to manual operation. Check its guide number (e.g. from the instruction leaflet) and divide the distance into that. The result is the required f/number setting on the lens. (Often a calculator on the flash unit provides this information.) Such a manual flash exposure is correct however only for that particular distance, with no automatic flash output control and no auto check signal.

Straight and bounce flash

Flash shots are easy with the flash mounted on the camera. But the resulting flat front lighting — the typical newspaper flash effect — is not particularly attractive. Results often look better either with bounce flash or with flash off the camera.

For bounce flash — if the flash unit has a tiltable reflector — point the reflector up so that it lights the ceiling and the latter bounces the light back as soft even illumination. That needs a suitable light ceiling, neutral in colour and not too high. The longer light path via the ceiling and the latter's diffusing action waste a lot of light. For this you need a sufficiently powerful flash — guide number of at least 35 (metric) — and usually the largest lens aperture. A near wall can also bounce the light — provided that the flash reflector can swing sideways.

TTL flash exposure control takes care of all the exposure variables introduced by bounce lighting. Even without TTL control the flash should be an automatic type. Keep the sensor pointed at the subject (not at the ceiling). If the ceiling is too high, attach a bounce reflector to the flash. This is a smaller reflecting screen fitted or held above the upward pointing flash to redirect the light forward again, but much more spread out.

While direct flash is harsh, bounce flash tends to the other extreme with excessive softness. Some frontal fill-in light helps matters and there are flash units that automatically divert about 10% or so of the bounce lighting directly forward at the subject. A subflash (a small second flash tube in its own reflector) has the same effect.

Off-camera flash can yield more versatile effects (side, top etc lighting) and involves setting up the camera and flash (even several units) like lights in a studio. Synch leads link the camera with the flash units, or better still use a slave flash on the camera to trigger the other flashes. Correct exposure becomes more complicated in such setups and you may need to establish it in manual mode with a separate flash exposure meter.

Fill-in flash

Flash is important for auxiliary lighting, too. It balances difficult illumination, for instance outdoors in the shade, under trees etc where faces of people and other detail tends to appear dark and flat. When you shoot into the light the shadows facing the camera are also very dark and benefit from being filled in with flash.

The aim with fill-in flash is to support, but not to compete with, the prevailing illumination, e.g. daylight. In practice that means that the flash intensity (flash exposure) should at most amount to half the level of the existing ambient light. But the flash should also remain correctly synchronised with the camera. This is easiest with an automatic flash unit controlled by its own (not the Leica R5's TTL) sensor.

Do it this way:

(1) In manual mode establish the required exposure for the subject areas lit by the prevailing light. For back-lit setups base this exposure on a selective reading of brightly lit subject parts, not the shadows.

(2) Set the shutter speed dial to $^1/_{125}$ sec if you are using an SCA dedicated flash, or to $^1/_{60}$ sec if you are not. Adjust the lens aperture till the LEDs at the right also indicate 125 or 60.

(3) Either: Set the flash unit to double the speed of the film in the camera and the aperture option selector to the aperture already set on the lens.
Or: With the film speed set normally, select the aperture option or range on the flash unit at one f/stop larger (next lower f/number) than the aperture setting on the lens. For instance if you are shooting at f/5.6, set the flash to a power level equivalent to f/4.

(4) Check that the subject is within the indicated distance range for automatic mode, then expose. The flash should now have filled in the shadows to a level a little below that of the main lighting for a luminous natural result.

If the flash has no setting for a sufficiently low light output or small aperture, reduce the flash power by attaching a wide-angle diffuser (where available); this usually reduces the exposure by the equivalent of one f/stop. Or tie a white pocket handkerchief (single layer thickness) over the flash reflector.

A normal full flash exposure with the flash set to the same film speed and aperture as the camera would expose the shadows normally and overpower the prevailing daylight. The effect is not very natural but sometimes called for in press and feature photos which should never show faces in shadow. On the other hand you can restrict the fill-in effect further by setting the flash to 1 or even 2 f/stops larger than the lens aperture. This more dramatic lighting is often effective in colour slides; on prints it tends to make shadows appear too dark.

Matching the light colour is important with such combinations. Electronic flash and daylight (other than possibly late afternoon sunlight near sunset) should pose no problems. Tungsten light is however much too reddish to go with the flash. Depending on the film type and correction filter used, that gives either a correctly lamp-lit picture with bluish fill-in, or correct rendering in the filled-in areas but very reddish colours everywhere else. You may just have to put up with that.

7 Lenses and optics

We are told often enough that the camera sees differently from the way we do. That difference is more psychological than optical. In fact the optical performance of the average human eye — definition, resolution etc — is quite poor compared with even a mediocre camera lens. We compensate for that by our sequential way of seeing. We concentrate on a succession of small object details and we scan over larger areas. The visual memory is the sum of these single stimuli, weighted by our interest and attention and translated into a spatial impression of what we looked at.

The beady camera eye

The camera lens neither concentrates nor scans: it simply takes in, quite unselectively, everything within its field of view. To some extent we can control how sharply (or unsharply) the camera should record the view (see Chapter 9). But the photograph is still an optical slice of time, not an accumulation of impressions.

To re-create the visual impact we have to selectively manipulate the camera's coverage too. The temptation is to record a whole view and sort out later what interests us in it. But unless we can then recall just what it was that attracted us in the first place, the impact is lost. To help such recall, the photograph must select the attention-getting aspect of the original subject at the time of taking.

Getting close to the subject, using different lenses to take in more or less of a view, and cropping are the classical methods of such selection.

With a set of interchangeable lenses we can control the angle of view and image scale by different focal lengths, and perspective with various combinations of subject distance and lens. The two vital characteristics are the focal length and the angle of view.

In the camera the focal length of the lens controls the scale (as of course does the subject distance) at which a subject appears on the film. If the head of a person 6-7 ft away appears 5 mm high on the film with a 50 mm lens, the 90 mm lens projects the same head from the same viewpoint 9 mm high. With the 35 mm lens you would get a 3.5 mm head, and with the ultra wide-angle 19 mm just under 2 mm. If you want the head 9 mm high with the 50 mm lens you have to come closer, to say 3 ft. So, changing lenses saves some legwork.

When an object appears smaller in the picture at a given distance, there is more space around it. A shorter focal length can thus cover a larger angle of view on the film format. (But the lens design must be capable of covering the wider view.)

Visually we take in a horizontal angle of view of some 70°, or almost 140° in the total sweep of both eyes (without moving the head). Compared with that, the standard 50 mm lens on the Leica R covers about 39° horizontally. This rather blinkered view is regarded as normal for a 35 mm camera.

To include in a picture what you can take in with both eyes — say the breadth of rolling hills and mountains, or the height of city skyscrapers looming above you — you need a wide-angle lens. For the Leica R such lenses cover focal lengths from 15 to 35 mm, and (not counting fisheye optics) horizontal angles from nearly 110° to 54°.

To narrow down the view selectively, an extended focal length range from 80 mm to 800 mm covers horizontal angles from 25° down to $2^1/2°$. Relative magnifications, compared with 50 mm, range from 1.6x to 16x. (The wide-angle scales run from 0.7x down to 0.3x.)

Wide-angle photography

In practical photography, a wide-angle lens is useful primarily when you cannot move back sufficiently from a subject to include all of it with the standard lens. Pictorially, the wider view conveys depth and breadth.

As such wide-angle shots take in what we cover visually only by scanning over the view, the picture ought to be viewed at a distance at which the eyes are again obliged to scan across the image. To do that you can either make a really big enlargement and look at it from close up, or project slides on a large screen and again watch from very near. With for instance a 50 mm lens on a 35 mm slide projector, this resembles wide-screen movie projection. So does the impact of the pictures. (Today we get nearest to that impression with multiscreen projection in AV presentations. But thanks to our preoccupation with television, wide-screen viewing has become a much rarer experience than it used to be.)

This of course means looking at wide-angle pictures from much closer than we would normally do. At the usual viewing distance for a normal shot the wide-angle image appears unnaturally compressed and distorted in perspective. To a large extent the reputation of perspective distortion with wide-angle lenses is due to the fact that the extended view covers more in depth, too, from far to very near.

Thanks to this exaggeration, interiors of small spaces photographed with extreme wide-angle lenses (e.g. 15, 19 or 21 mm) appear greatly expanded. That's how in a charter brochure a tiny boat cabin can look like a stateroom. The camera doesn't lie, but it is good at deceiving. The advertising world makes extensive use of that.

Another kind of wide-angle distortion is geometric. People's heads and faces look egg-shaped when they appear at the edges (and especially corners) of wide-angle pictures. This is increasingly pronounced with the 24 mm and shorter lenses but visible even with 28 mm. So preferably keep such familiar shapes away from the corners and edges of the view. (Deliberate distortion of this kind can on the other hand again add pictorial impact.)

Connected with wide-angle distortion is the extensive exaggeration of the effect even of slight camera tilts. Familiar in everyday photography is the effect of converging verticals when you tilt the camera up to take in the top of a tall building. The structure appears to fall over backwards. With the more extreme wide-angle lenses the falling-over effect becomes rather more radical. Pointing the wide-angle lens down can similarly spread vertical lines (and shapes) into unfamiliar forms.

The secret of creative wide-angle photography is to use such distortion pictorially

without making it look too contrived. But always keep the camera carefully levelled when using a wide-angle lens for an architectural or other record where accurate representation counts. If necessary mount the Leica R on a tripod and level it with the aid of a spirit level. The grid of the No. 4 all-matt screen (see **Alternative screens** in Chapter 9) helps to show up the effect of any camera tilt and inclination in the finder. With a shift lens (see below) you can in some cases avoid the need for pointing the camera up (or down) for such views.

The fisheye view

A special case of distortion is that of the fisheye lens. Across the image diagonal it covers a 180° view and does so by relying on a reducing scale of reproduction from the centre outwards. As a result all straight lines in the picture that do not go through the image centre curve towards that centre. (The 'fisheye' tag may come from the way the view resembles a scene as seen reflected in a goldfish bowl.)

This curvilinear rendering can again be used for deliberate pictorial effect. It needs a little experience and readiness to experiment. Fisheye views are effective with subjects that have a near foreground close to the edges of the field. The distortion here subdues the otherwise exaggerated perspective of such near elements but enhances the perspective rendering of items in the centre.

With fisheye pictures you have to take care to keep your own feet out of the picture, so for preference set up the camera on a tripod. (Tripod leg ends look less obvious than disembodied human feet.) With the other ultrawide-angle lenses, too, watch for possibly intrusive detail near the image edges.

Another wide-angle problem is light fall-off towards the image edges. This effect of geometric optics leads to underexposure of the edge and corner areas of a picture and becomes more marked the wider the angle. There is no cure, other than special graduated neutral density filters. You have to put up with it or compensate by local exposure control when enlarging such negatives. (The distortion of the fisheye lens largely counteracts the effect.)

The PA-Curtagon-R shift lens

Large-format view cameras get over the problem of converging verticals when pointing up at buildings etc. You keep the camera back (film plane) vertical but shift the lens upwards. A similar effect is possible with the PA-Curtagon-R shift lens which permits a lateral displacement of the lens axis through up to 7 mm.

Unshifted, the lens yields a semiwide-angle view like any of the other 35 mm Leica R lenses. Photograph a tall building from far enough away to take it all in, and you also have to include much unwanted foreground. With the shift lens you can go nearer — for less foreground — and still include the whole structure by shifting the lens upwards. That shift removes even more unwanted foreground.

The PA-Curtagon is designed to cover a larger image circle than the regular 35 mm lenses — with a total diagonal angle of 78° instead of 63°. With upright shots and a 7 mm shift the upper half-angle of view covered (which is what counts in shots of tall objects) is about 35°, only slightly less than the coverage of a 24 mm lens. The lower

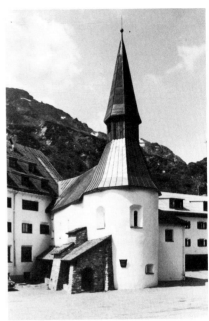

The most obvious application of the PA-Curtagon shift is to include more of the top of a subject in the picture, without risking converging verticals by pointing the camera upwards.

half-angle (which determines the foreground) is equivalent to some 18°, or less than that of a 50 mm lens. You could thus regard the upward shifted Curtagon as taking in the upper half of the view of a 25 mm, and the lower half of a 55 mm lens.

Other applications of this lens include interiors that are to include square-on views of pictures, windows and the like but where other objects or reflections (e.g. with mirrors) obstruct a square-on camera position. So set up the camera to one side of the ideal viewpoint but with the film plane parallel to the object plane. Then shift the lens sideways to bring the intended item into the picture.

Practical points of using the PA-Curtagon-R:

(a) Mechanically the shift displaces the lens in only one direction. But the whole lens and shift movement rotate in the basic mount, so you can effectively shift the lens up, down or to the left or right. The rotating part engages at 90° intervals; in intermediate positions oblique shifts are also possible.

(b) A black/white segmented shift ring controls the movement. It carries segments numbered from 0 to 7, representing shifts from 0 to 7 mm.

(c) The ring also rotates with the whole lens for the alternative shift directions. When the scale on the ring *and* the depth of field scale on the lens face you,

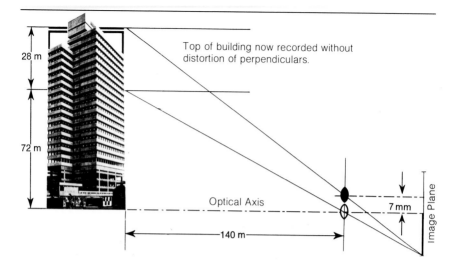

By simple geometry the extra subject height brought in by the shift is equal to one-fifth of the subject distance. In terms of the subject itself, the shift adds about 40% of its height in upright-format shots, and about 60% extra in horizontal shots (where you start with less).

The shift of the PA-Curtagon displaces the lens axis from the film frame centre — equivalent to a (limited) rising front movement on a view camera.

turning the ring shifts the lens towards you (upwards on the camera when the depth of field scale is on top). There is a second shift and aperture scale underneath the lens, but without a depth scale. When you face this, turning the shift ring moves the lens away from you.

(d) The shift is usable with hand-held shots but is easier to assess, and to level, accurately with the camera mounted on a tripod. When you shift the lens upwards, the image in the finder moves down within the fixed finder frame.

The shift ring scale indicates the shift in mm (here 3 mm). With a downward shift a second shift and aperture scale comes into view; however in this case the aperture index is not a correct distance index.

That may seem a little strange at first, as in normal viewing the finder frame moves over the fixed scene when you point the camera in different directions.

(e) Use the No. 4 focusing screen with its grid as an aid to levelling.

The PA-Curtagon has no aperture or stop-down coupling (difficult to link up to a shift lens without making the whole system very bulky). Exposure measurement therefore takes place at the working aperture and you can use the Leica R5 and R4 only in **m** and **A** modes (with either full-area or selective readings), not in **P** or **T** modes. No aperture value is visible in the central (user-selected) aperture window below the screen. For the most convenient procedure with automatic exposures (full-area readings):
(1) Set up or point the camera at the subject and focus at full aperture.
(2) Check whether you need to stop down for depth of field. Operate the lens aperture ring, not the depth preview lever which does not work with this lens. With hand-held shots check also whether the shutter speed (indicated by the LEDs at the right) is fast enough — after stopping down — for a shake-free exposure.
(3) Reset the lens to full aperture and adjust the shift as required. (Shift after focusing; any substantial shift makes accurate focusing difficult in the split-image wedge or microprism screen area.)
(4) Stop down the lens to the previously chosen working aperture and expose.

While this sequence is of course slower than with automatic aperture stop-down, this hardly matters with the comparatively static subjects for which the shift lens is mostly used.

Distance and perspective

The closer you approach an object with the camera, the larger it becomes in the picture. Take a tree, 20 ft tall and 30 ft away. The standard 50 mm lens projects it on the film a little under 1¼ in. — about 30 mm — high. A further tree 60 ft away would appear only 15 mm high. With the 21 mm lens the relative image heights would be 12.6 and 6.3 mm, with one of the 90 mm lenses 54 mm (i.e. no longer all in the frame) and 27 mm. But from the same viewpoint the size relationship of the two trees remains constant irrespective of the actual image sizes.

Let's move back to 90 ft from the first tree. The standard 50 mm lens now projects it only 10 mm high on the film. But the second tree — still 30 ft behind the first one — is no longer twice as far away but only one-third further. Its image on the film is now 7.5 mm high, three-quarters (not half) as high as that of the first one. The 135 mm lens would show the trees 27 mm and about 20 mm high respectively — again in the same proportion. With this lens the first tree looks almost as big on the film as from 30 ft with the 50 mm lens. *But the second tree has become much bigger!*

These are the size relationships that control perspective in an image. The greater the difference in scale of nearer and farther objects, the more perspective appears

The viewpoint (subject distance) and the lens can control the perspective in a picture. A near viewpoint (above) makes the subject dwarf its surroundings; with a distant view (right) and longer focal length (to maintain the same scale) the background becomes dominant; a standard lens (upper right) gives us a 'normal' perspective as we might see with our own eyes. The clock in all three pictures appears the same size. In the picture above the Old Observatory building at Greenwich appears totally dwarfed and distant, whereas in the picture bottom right it looms large, apparently immediately behind the railings. Above: 19mm f/2.8 Elmarit at 19 paces, Upper right: 60mm f/2.8 Macro Elmarit at 60 paces, Lower right: 180mm f/3.4 Apo-Telyt at 180 paces. Photos: Dennis Laney.

enhanced, and the greater the impression of depth in the view. The nearer you go to a subject extending in depth, the more exaggerated this depth becomes. That applies as much to trees (or a whole avenue) as to portraits. From close up, the nose and chin appear overlarge compared with the ears or the neck. The effect may not be attractive, but in terms of geometric optics it is perfectly correct.

Perspective is determined exclusively by the camera viewpoint — but the lens is responsible for scale of reproduction. The pictorial effect usually depends on a combination of the two. By going close you separate the foreground from the middle distance and background to emphasise the effect of depth. But to take in what you lost of the width of the scene by going close, you have to reduce the image scale again by using a shorter focal length (i.e. a wide-angle lens). This holds not only for broad landscapes; for instance, an automobile may look like a dashing sports car in a near wide-angle picture. But when taken with a tele lens from further away it becomes a modest family saloon. (That is very familiar ground to motor publicity departments.)

So keep your distance to render facial proportions correctly in a portrait, at least 7-10 ft, and make the face appear larger with a longer-focus lens.

For perspective alone you don't need the longer focal length. Enlarge the centre of the view taken from the same viewpoint with a shorter-focus lens: the perspective rendering is identical. But the more highly enlarged print loses some quality — it may appear more grainy and slightly less sharp. The alternative image scales and coverage of the various lenses make the most of the small film area every time.

Telephoto perspective is the exact opposite of wide-angle perspective. It compresses depth and distance. That is the familiar binoculars effect which becomes quite dramatic with the longer Telyt-R lenses. What you record with the 400 mm lens corresponds closely to what you see through a pair of 8x binoculars.

Lens types and automation

Most of the more than thirty current lenses for the Leica R models have standard aperture simulation and stopdown coupling features.

When you adjust the aperture ring, a lever in the rear of the lens engages and moves along a ring inside the camera mount. This adjusts the electric input to the exposure control circuit which thus takes note that you have selected a working aperture a given number of steps below the lens's full aperture. Such an aperture input simulation allows the camera to measure light at the full lens opening (and so utilise the maximum meter senstivity) yet compute accurate exposures.

Immediately before the exposure itself, as the mirror swings up, a further coupling in the camera mount allows another spring-loaded lever to stop down the lens to the intended working aperture you preselected. In time-priority and programmed AE modes the camera electronics determine how far that lever can stop down the lens. This takes place in the fraction of a second of the whole exposure cycle; you are hardly aware of it while you expose.

A few lenses do not provide stop-down simulation and automatic stop-down and cannot therefore be used with time-priority or programmed AE modes that rely on these aperture actions. They do however work perfectly in aperture-priority AE and of course manual mode, both of which involve user-selected apertures. The lenses in question are:

(a) **The Telyt-R lenses of 400 to 800 mm:** the mechanical aperture coupling is difficult to carry through the long lens barrel efficiently;

(b) **The 500 mm MR-Telyt-R f/8** has a fixed aperture with no adjustment;

(c) **The 35 mm PA-Curtagon:** It is not practical to link the aperture coupling with the shift movement;

(d) **The 2x Extender-R** has auto stop-down coupling but does not function effectively in time-priority or programmed mode;

(e) **The Bellows-R and extension tubes for closeups** involve manual or semi-coupled stopping down. Some macro lenses used on the bellows permit only manual stopping down;

(f) **Some extreme wide-angle lenses** (16 mm fisheye and 19 mm f/2.8) have an unusual stopdown problem. The aperture control cam configuration always keeps the **T** and **P** symbols in the finder blinking in time-priority or programmed AE mode respectively of the Leica R5 and R4. The symbols blink even with the lens set to its smallest f/16 stop, though the camera correctly operates in these modes. Avoid using these exposure modes if you find that blinking confusing.

Control cams and levers

In addition to the aperture coupling and stop-down levers, most Leica R lenses have a couple of smooth cams in the rear of the mount. These are aperture coupling cams for the earlier Leicaflex models. They are redundant as far as the Leica R cameras are concerned, though they are not in the way. The most recent versions of the current R lenses are produced without these cams — which slightly cuts cost and weight. The lens table lists the alternative versions with and without Leicaflex cams. Leitz can add the cams if you want to use such a lens on an old Leicaflex model.

R lenses made prior to 1976 may lack the aperture coupling and stop-down levers required for the Leica R5, R4 and R3 cameras. Again Leitz servicing workshops can add these levers. Don't use a lens without the R coupling levers on an R camera model.

View of rear lens mount showing all three cams. Arrow indicating third cam for Leica R models (current lenses may only have third cam).

Leica lens names

A couple of generations ago lens names (such as Elmar, Super-Angulon, Tessar etc) indicated famous lens designs. With a growing flood of new lens systems, lens producers ran out of individual names and used only a maker's name. Leitz also simplified lens labelling but used its traditional names to signify maximum apertures and broad lens groups. The -R suffix indicates a Leica R mount:

Summilux-R = Lenses of maximum aperture f/1.4;
Summicron-R = Maximum aperture f/2;
Elmarit-R = Maximum aperture f/2.8;
Elmar-R = Maximum aperture f/3.5 or f/4;
Telyt-R = Tele lenses, generally of 250 mm and longer focal lengths.

There are also prefixes (Macro-, Vario-) and a few exceptions (e.g. Super-Angulon).

Further lens specifications

The table on page 173 compares data for the various Leica-R lenses. Here are some more general explanations to complement that table's footnotes and remarks:

The angle of view is in theory the angle that the image subtends on the film but in practice the angle covered in the subject space. In their literature lens makers usually quote diagonal angles of view — which look more impressive with wide-angle lenses. As the side-to-side coverage (across the film frame) is more relevant to normal picture taking, the table lists horizontal angles as well as diagonal ones.

These angles are based on the 24 x 36 mm film gate size, on the nominal focal length and on the lens focused at infinity (the angle of view narrows at nearer distances). The values are rounded down — there is little point in being more precise than the permissible tolerances. Also, the opening of standard slide frames (about 23 x 35 mm) and negative carrier masks in enlargers slightly reduces the angles.

Configuration (number of lens elements and groups, i.e. assemblies of elements cemented together) is today far less important than a generation ago when the level of optical correction tended to be equated with the amount of glass in a lens. For optimum correction, extreme wide-angle and extreme-speed lenses (also zoom lenses) need more elements. All lenses are coated: the glass/air interfaces carry special ultra thin layers that absorb parasitic reflections and improve light transmission as well as image contrast.

Leitz from time to time updates designs and may replace existing lenses by more compact or otherwise improved versions. Order codes are changed only with more fundamental modifications but also distinguish between versions with and without Leicaflex cams. The table data refer to the latest models (1987).

The near limit is the nearest distance setting on the lens, measured from the subject to the film plane (marked to the right of the finder dome on the top cover). The scale indicated (as 1:xx reduction) is the largest reproduction scale at the near limit.

Nominal and actual focal length: Generally we specify a lens by the nominal focal length as marked on it — e.g. 50 mm. In fact, thanks to permissible production tolerances, the actual focal length of a 50 mm lens could be anywhere between 48 and 52 mm (and longer focal lengths in proportion). You won't notice such deviations in practice but by a long tradition Leitz considers them relevant in specialised scientific applications.

German-made Leica-R lenses of 50 mm and longer focal lengths also carry the actual focal length value. This is encoded in two small figures engraved sideways next to the 'm' of the metric distance scale. They are the last two significant digits of the focal length expressed in tenths of a mm. Thus '19' on a 50 mm lens stands for an actual focal length of 51.9 mm — and '80' on a 180 mm lens for 178.0 mm. Leica lenses made in Canada or Japan do not carry this information.

Ultrawide and wide-angle optics

The 16 mm Fisheye Elmarit-R f/2.8 has a large protruding front lens surface that easily attracts dust and fingerprints, so take special care not to touch it. The 'stub' wings act more as a mechanical protection (against scratching when you put the lens with the front down on a table) than as a lens hood. This is one of the two lenses with confusing mode signals in **T** and **P** exposure control modes (see **Lens types and automation** above).

An extra control ring forward of the focusing/distance ring selects one of the four built-in filters. Pull this ring back towards the camera body, uncovering a red strip underneath, and rotate in either direction. It engages at the filter selection points, with the filter code opposite the white dot on the front rim. No filter is in the light path with the ring halfway between two settings.

The 15 mm Super-Elmar-R f/3.5 covers the widest undistorted angle (100° horizontally, 77° vertically) of any Leica R lens. Its bulk (for a wide-angle lens) derives from the need for a great deal of glass to correct the lens over this extended angle. So-called floating elements maintain optimum optical correction during focusing on near distances. The stub wings at the front again protect the prominently bulging front element. Like the 16 mm fisheye, this lens has four built-in filters selected by a control ring.

The 19 mm Elmarit-R f/2.8 is the fastest of the ultra wide-angle lenses. The 82 mm front screw thread is among the largest in Leica R lenses (only the 280 mm Apo-Telyt-R is larger). Leitz advises against using filters; they are liable to cause vignetting. The lens comes with a clip-on rectangular hood (12 529). The push-on lens cap clips over the studs that hold the lens hood in place. This lens gives rise to **T** and **P** mode signal problems similar to those of the 16 mm fisheye.

The 21 mm Super-Angulon-R f/4 is the most compact ultra wide-angle system. It is thus a handy alternative to the 19 mm Elmarit to which it concedes only 4° in angular coverage and one lens stop in speed. It comes with a separate rectangular clip-on lens hood.

The 24 mm Elmarit-R f/2.8 is a less extreme but still very versatile ultrawide-angle lens. It incoporates floating elements for near focusing and takes a rectangular clip-on hood.

The 28 mm Elmarit-R f/2.8 is my preferred wide-angle lens for general use as it does not yet produce noticeable wide-angle distortion and covers wide views without excessive compression. It, too, takes a separate rectangular clip-on lens hood.

The 35 mm Elmarit-R f/2.8 is the slowest but also the most compact of the three medium wide-angle lenses for the Leica R range. Like the 35 mm Summicron-R and Summilux-R it is more of an extended standard lens than a real wide angle.

The 35 mm Summicron-R f/2 is with its one f/stop advantage a little more versatile than the 35 mm Elmarit-R but otherwise has the same applications.

The 35 mm Summilux-R f/1.4 is an extreme-speed medium wide-angle system with floating elements. This speed necessarily means bulk — the 35 mm Summilux-R weighs over twice as much as the 35 mm Elmarit-R.

The 35 mm PA-Curtagon-R f/4 is the special wide-angle shift lens, already described.

Standard lenses

The 50 mm Summicron-R f/2 is the bread-and-butter standard lens for the Leica R cameras. The focusing range (maximum 1:7.5 scale) may be extended with Elpro closeup lenses (see Chapter 11).

The 50 mm Summilux-R f/1.4 offers an extra lens stop in speed over the Summicron, at the usual price of extra size and weight. In all other facilities and specifications it closely matches the 50 mm Summicron, though Leitz do not recommend it for closeups with Elpro lenses.

The 60 mm Macro-Elmarit-R f/2.8 can also count as a standard lens in terms of focal length. Its main feature is the extended continuous focusing range with which the lens on its own reaches a 1:2 scale (and even to 1:1 with a matched extender). The front element of the 60 mm Macro-Elmarit is deeply recessed in the mount so that the latter acts as a permanently extended lens hood. The macro applications are covered in detail in Chapter 11.

Medium tele systems

The extensive range of tele lenses can be divided into medium and long tele systems to reflect major differences in application as well as handling. In this respect the medium tele systems cover focal lengths up to 180 mm and lenses sufficiently handy for straightforward hand-held shooting. Long tele optics are primarily the Telyt-R

systems of 250 mm and over, intended for use at least with the hand grip and shoulder support, and usually with a more manual form of aperture control.

This distinction is not quite strict. The shorter Telyt-R lenses still include auto aperture coupling for full AE control in all modes of the Leica R5 and R4. And the longer medium tele types (e.g. 180 mm) can certainly benefit from the steadier camera hold with the grip.

The 80 mm Summilux-R f/1.4 is really a short tele system, matching the extreme lens speed of the 35 and 50 mm Summilux-R lenses.

The 90 mm Elmarit-R f/2.8 and the **90 mm Summicron-R f/2** again offer two alternative trade-offs of lens speed and bulk in this focal length. Though slightly shorter in focal length, the 80 mm Summilux-R can really count as the third member of this group. The 90 mm lenses are ideal for portraits and pictures of people, yielding reasonably large heads and shoulders from far enough away not to raise distortion problems.

The 100 mm Macro-Elmar-R f/4 and the **100 mm Apo-Macro-Elmarit-R f/2.8** resemble the 60 mm Macro-Elmarit-R in having an extended continuous focusing range from infinity to 1:3 and 1:2 respectively. Further accessories — a macro adapter for the Macro-Elmar-R and a specially matched Elpro attachment for the Apo-Macro-Elmarit-R can extend this to 1:1.6 and 1:1 .

The Apo-Macro-Elmarit offers high chromatic correction over an extended spectral range. During focusing only the front group of six elements moves while the rear two elements remain stationary. This optimises optical correction at different subject distances. One result of this is that the focal length varies slightly — from 100 mm at infinity to 92 mm at the 1:2 setting. You can ignore this in practice. The Apo-Macro-Elmarit-R is a comparatively heavy lens and is best used with the camera mounted on a tripod. An STA 1 tripod mount (14 636) fits over the rearmost fixed ring of this lens for better tripod balance. The macro applications are described further in Chapter 11.

The 135 mm Elmarit-R f/2.8 is a medium tele lens for frame-filling head-only portraits and for unobtrusive 'stolen' shots of people in the street and other public places. With this longer focal length you can shoot from a distance without attracting attention.

The 180 mm Elmar-R f/4 and the **180 mm Elmarit-R f/2.8** are yet again alternative-speed versions of lenses with similar applications — namely magnified views of distant architectural and landscape detail. The extra speed of the 180 mm Elmarit-R is usually worth the extra cost and weight, especially with action subjects, as the faster shutter speed made possible can significantly reduce camera shake risk.

Zoom lenses

The great merit of a variable-focus or zoom lens is that it can replace several lenses of

fixed focal length. Thus the 70-210 mm Vario-Elmar-R combines the roles of a 70 mm, 90 mm, 135 mm, 180 mm and 210 mm lens as well as a continuous range of all in-between values. A reflex finder screen is essential to keep track of the changing angle of view during zooming; hence zoom lenses only make sense with the modern SLR camera.

Zoom lenses have some limitations too. They are slower than lenses of fixed focal length and therefore less suited to low-light photography. Their optical performance also tends to be slightly below that of fixed lenses.

In practice the advantages usually far outweigh the drawbacks — being able to replace three bulky lenses by a single lens that is no bigger is an immense convenience. Two zoom lenses could then cover the whole focal length range you are likely to need for travel, general shooting etc.

There are at present two zoom lenses for the Leica R models. Their combined coverage of focal lengths from 35 to 210 mm is useful, though still sparse by the standards of other SLR cameras. Further zoom systems for the Leica R are under consideration. Lenses zooming from 28 mm to 85 mm or longer would be useful (nowadays they exist up to 28-200 mm) and tele zooms covering continuous ranges between 100 and 300 or 500 mm. The dilemma is that such extended zoom ranges are difficult to achieve at present at competitive cost without some performance compromises that Leitz considers incompatible with the Leica reputation.

Camera operation with a zoom lens is much the same as with a lens of fixed focal length. The Leica R zooms are compatible with all AE modes, including **P** and **T** of the Leica R5 and R4. If you have the leisure, focus with the lens set to its longest focal length — it's most accurate there — and then zoom to cover the field you want. The zoom lens stays in constant focus at the different focal lengths.

Depth of field varies with focal length; such variation is difficult to allow for in a single depth of field indicator. These zoom lenses therefore have no depth indicator. (Use the depth preview for a visual check.)

The 35-70 mm Vario-Elmar-R f/3.5 with its 2:1 zooming ratio is more of an extended standard lens, with the facility of precisely narrowing down or widening its coverage. An additional zoom ring between the aperture and focusing rings adjusts the focal length. The markings indicate approximate intermediate focal lengths as a guide; normally you set a zoom lens by the appearance of the finder image, not by focal length.

The 70-210 mm Vario-Elmar-R f/4 with its 3:1 zooming range covers all the medium tele focal lengths listed earlier. For most outdoor shooting the maximum f/4 aperture is adequate, especially with faster films. This is a so-called single-touch zoom. A main control sleeve zooms when you push it forward (for shorter focal lengths) or back (for the tele end of the range). The barrel carries approximate intermediate focal length markings. The same sleeve rotates to focus the lens. So when using this control normally, take care not to turn it while zooming once you have focused. Single-touch zooming is useful for fast shooting in action photography, etc. You can both zoom and focus while keeping the subject in view in the finder.

The Telyt-R range

The 250 mm Telyt-R f/4 has a nearly 40% longer focal length than the 180 mm Elmarit-R, is a full f/stop slower and weighs half as much again. It does however focus closer — almost approaching a macro range with a 1:5 reproduction ratio. That makes it specially suitable for near-range telephotography (see the Chapter 11). The lens has a tripod mounting ring and the whole lens (with camera) rotates in the ring when you press the black button in the left side. The extending lens hood (40 mm deep) surrounds the front barrel. The lens comes complete with a leather case (14 578).

The longer configuration of the Telyt-R lenses, involving spaced out elements and extended barrels, is sensitive to ambient temperature variations. These can lead to slight changes in focal length and hence of the infinity focus position. To allow for this the focusing movement goes a little beyond infinity. (You focus by the screen image, anyway.)

The 350 mm Telyt-R f/4.8 is the longest focal length with automatic aperture and stop-down coupling. Its tripod mounting ring has two tripod bushes: use the rear one to balance the camera with motor and lens, the forward one without motor. The extending lens hood is 43 mm deep. The lens comes with a plastic 98 mm push-on cap (14 295) and stiff leather case (14 579).

The 500 mm MR-Telyt-R f/8 is a specially compact mirror lens (no longer than the 135 mm Elmarit-R), suitable for hand-held shooting. It differs in several practical respects from the other Leica R lenses:

(a) There is no aperture ring. The aperture is fixed at an optical f/8; the effective light transmission is however equivalent to f/10. TTL exposure readings (**A** and **m** modes) automatically allow for that. The lack of aperture adjustment precludes **T** and **P** mode operation.

(b) The optical configuration calls for the presence of a filter element in the 32 mm screw mount inside the rear of the MR-Telyt-R. Normally that should be the colourless ultraviolet-absorbing UVa. The top compartment of the leather lens case holds alternative filters supplied with the lens (yellow, orange and red for black-and-white film; neutral density for any film).

(c) Use the 4x neutral density (ND) filter if the light is strong enough to risk overexposure at even the fastest shutter speed. It is equivalent to stopping down the lens to f/20.

(d) The lens hood (supplied with the lens) screws into the 77 mm front thread. Always keep this in position — for protection not only against stray light but also against accidentally touching the front lens surface. The lens cap pushes on over the hood.

(e) After focusing, hold the lens by the fixed sleeve (with the window for the

distance scale) to avoid upsetting the focus. Brilliant out-of-focus image points not only appear unsharp, but also take on a doughnut-ring shape — particularly obvious in the innumerable reflections when you shoot into the light over water.

The follow-focus Telyts

The 400 mm Telyt-R f/6.8 is only slightly longer than the 350 mm Telyt-R, and comparatively slow. This is acceptable for outdoor wildlife shots on fast film. It also weighs rather less. Its follow-focus mount permits fast focusing and hand-held shooting with the universal handgrip and shoulder stock.

For easier transport the 400 mm Telyt-R splits up into the lens unit itself with iris diaphragm and follow-focus mount, and a mounting tube. The hand grip (see **The universal handgrip** in Chapter 3) is an essential part of the outfit. You can use the lens/camera assembly on a tripod instead, but the follow-focus movement is less convenient there.

The 560 mm Telyt-R f/6.8 uses the same mounting tube (and handgrip) as the 400 mm Telyt-R. If you already have a complete 400 mm lens outfit you only need to get the 560 mm lens unit itself for the second focal length. But with a mere 60% focal length difference there seems little point in having both lenses. The choice is a matter of assessing relative sizes and bulk. That extra 60% in focal length costs only 25% more in weight and 40% more in overall length. Yet the 400 mm lens is noticeably handier.

Assemble either lens as follows:

(1) Push the front end of the mounting tube (with bayonet mount and tripod mounting block) into the rear of the lens unit, aligning the two so that the chrome screw head on the tube engages the small notch at the rear of the lens.
(2) Push forward the screw-over ring on the tube and screw firmly over the thread on the lens unit.
(3) Screw the universal hand grip with shoulder stock into the rear tripod bush of the tripod mounting block.
(4) Attach the Leica-R to the bayonet mount at the rear of the mounting tube.
(5) Either fit the twin cable release in the handgrip (screwing the other end of one of the cables into the release button) or attach the motor winder to the camera, connecting it to the remote release (14 237) and fitting the latter in the handgrip.
(6) Line up the whole assembly for comfortable holding, so that the right hand holding the grip pushes the shoulder stock into the right shoulder and you can at the same time look comfortably through the camera finder.
(7) For upright shots depress the chrome latch at the rear of the mounting tube and rotate the camera through 90°; it engages in both end positions.

For shooting hold the grip with the right hand, with the thumb or index finger on the cable release plunger or remote release. Grip the front lens tube with the left hand, the thumb on the focus release button at the left of the tube. On pressing this

button you can move the whole tube forward and back for quick focusing. For a smoother sliding movement on the 560 mm lens, support the front of the main lens barrel (where it flares out) with the left index finger.

Focus at full aperture, stop down to the required working aperture for a manual meter reading, and set an exposure combination with a fast enough shutter speed to avoid camera shake. If you are going to shoot at full aperture (which is likely most of the time) you can also use aperture-priority AE mode. Expose by pressing the remote release switch or the cable release plunger.

Neither lens has a focusing scale but the instruction leaflet with the lens includes a printed scale. Cut it out and with transparent adhesive tape attach to the focusing barrel just in front of the aperture ring. This is just a rough guide to the distance setting — these lenses also focus beyond the infinity position.

Both these Telyt-R lenses can take a 60 mm extension tube (14 182) between the lens unit and mounting tube to extend the near focusing range. On the 400 mm lens it brings the near limit down from 3.6 m to 2.3 m ($7^{1}/_{2}$ ft) with a maximum 1:3.3 scale, on the 560 mm lens from 6.4 to 4 m (13 ft) for a 1:4.7 scale.

A filter slot in the mounting tube takes 2 in. diameter Series 7 filters. Pull back the spring-loaded ring just behind the screw-over ring to expose the slot and insert the filter.

An older version of the hand grip and shoulder support (14 188) is somewhat less convenient than the current model (14 239).

Special Telyt-R systems

The Leica R lens range includes a few types for specialised applications well outside the range (in need as well as price) of advanced amateur or general professional photography. Two of these are the Apo-Telyt-R lenses with apochromatic colour correction that extends into the infrared range and eliminates the need for special focusing in infrared photography.

The 180 mm Apo-Telyt-R f/3.4 is slightly larger than the 180 mm Elmarit but is handled in the same way.

The 280 mm Apo-Telyt-R f/2.8 is the fastest of the Telyt lenses (and apart from the 800 mm below, the heaviest). The high speed makes it useful for poor-light sports photography. It focuses internally (by movement of lens elements inside the lens) and beyond the infinity point. It has a built-in tripod mounting ring and eyelets for a carrying strap — the latter for more balanced carrying of the lens on the camera.

The Apo-Extender-R 1.4x (see below) is specially matched to this lens to turn it into a 400 mm f/4 unit.

The 800 mm Telyt-S f/6.8 is a giant system consisting mainly of the five-part lens barrel with focusing movement and iris for the single 3-element lens group. As it is hardly a portable unit it depends on a fixed camera viewpoint in long-range sports and wildlife etc. photography. Even a sturdy single tripod is not enough to hold the camera and lens assembly solidly, so the 800 mm Telyt-S has two tripod support

rings: a main one with both $^1/_4$ and $^3/_8$ in. bushes, plus a second $^1/_4$ in. forward one for additional support with a second tripod or at least a monopod. The lens takes Series 7 filters in a filter slot. A carrying handle on the centre barrel section incorporates a sports frame finder for preliminary aiming. For transport you can dismantle the barrel into five sections to pack into a metal equipment case.

The main reason for bothering with such a monstrous item is optical perfectionism. For focal lengths beyond 500 mm most camera and lens makers provide more compact and convenient mirror optics (such as the 500 mm MR-Telyt-R). Leitz at one time even supplied an adapter to fit an 800 mm Minolta mirror lens on the Leica R. However, in definition, and especially brilliance, the image of the 800 mm Telyt-S is significantly superior to that of any comparable mirror lens.

Tripod mounts

The 250 mm, 280 mm and 350 mm Telyt-R lenses have their own tripod mounts — a platform attached to a ring in which the lens can rotate. The platform has a standard $^1/_4$ in. tripod bush which supports the camera/lens assembly more or less below its centre of gravity. The 350 mm lens has two bushes: a forward one for the camera/lens combination and just behind that a second bush for the shifted centre of gravity when the motor winder or drive is attached to the camera. (This balancing also helps to hold the camera steadier with the universal hand grip and shoulder stock.)

To switch from horizontal to upright shots, press in the side of the tripod support bracket. The lens and camera can then rotate through 90° in either direction and click into position at the end points.

The tripod mount for the 400 mm and 560 mm Telyt-R f/6.8 is on the (11 906) lens tube and carries both a normal $^1/_4$ in. and a larger $^3/_8$ in. bush. Just the rear part of the mount rotates for upright/horizontal format switching. Depress the sprung chrome latch and rotate the camera about its optical axis. The mount engages at 90 ° intervals all round.

Tele-extenders

Placing a diverging lens group at the rear of a normal lens yields a combination of longer focal length. Tele-extenders use this principle as a low-cost (and low-weight) way of achieving tele focal lengths. Thus a 2x tele-extender instantly converts a 180 mm into one of 360 mm while adding only 30 mm to the overall length. The new lens combination retains the same focusing range — and so yields twice as large a reproduction scale at the near focusing limit.

You pay for this in lens speed because the extender also doubles the f/number of the maximum aperture: an f/2.8 lens becomes f/5.6. Tele-extenders slightly reduce optical performance (definition), though with modern types this is not serious. Dedicated or lens-matched extenders (such as the Apo-Extender-R) are best in this respect.

The aperture loss is inevitable but may still be worth it. Thus the 300 mm f/5.6 combination obtained from the 180 mm Elmarit-R and 2x Extender-R is just over half as long as the 350 mm Telyt-R, only half an f/stop slower and weighs about 35 oz

compared with 64 oz for the 350 mm lens. Generally a medium tele lens of larger aperture gains most from an extender. So, on paper, does a zoom lens, but the speed loss (and hence the inability to focus with the split-image wedge or microprism) is often unacceptable.

There are two tele-extenders in the Leica R range:

The 2x Extender-R (11 236) is usable with focal lengths over 50 mm and with aperture-priority AE. It does not have the right auto aperture coupling for time-priority and program modes of the Leica R5 and R4. Image corners are slightly vignetted with the 400 and 560 mm Telyt-R lenses. The (11 236) extender has no Leicaflex cams but an earlier version (11 237) has. This latter has no aperture coupling.

The 1.4x Apo-Extender-R (11 249) is specially matched to the 280 mm Apo-Telyt-R f/2.8 and converts it to a 400 mm f/4 system — faster (and heavier) than the 400 mm Telyt-R f/6.8. The combination is usable with all AE modes of the Leica R5 and R4. Using the 1.4x Apo-Extender-R with other lenses is risky as the protruding lenses on the extender may foul rear elements on the prime lens. It is safe with the 100 mm Macro-Elmar f/4, the 180 mm Elmarit-R f/2.8 and the longest Telyt-R systems (400 mm f/6.8, 560 mm f/6.8 and 800 mm f/6.3).

Lens quality and performance

One of the priorities in producing the Leica cameras and lenses is maintaining high mechanical and optical quality. As noted before, this policy tends to delay progress in marketing new product types, however useful, until their quality meets Leitz's self-imposed levels. However, Leitz has good reason to be proud of its reputation here, as Leica lens performance is often regarded as an industry standard against which other lens makes are compared in popular testing.

Popular testing is a favorite (and circulation-boosting) feature of photographic periodicals which sometimes invest in elaborate optical laboratory facilities. These involve measuring modulation transfer functions (MTF) and other complex optical parameters that are a help in comparing performance of different lenses but may be less relevant to how lenses are used in practice.

In looking at such test results — and at accompanying test pictures — remember one individual lens only is tested. Different specimens of nominally the same lens may vary slightly in test performance. Also, the results usually reflect the rendering of flat test targets. Except in copying, most objects extend in depth. Hence such aspects as ultimate flatness of field is not as vital as tests sometimes make out.

A last word on optimum apertures. One compromise of lens design is that most lenses yield their best performance when stopped down by one f/stop or two from their maximum aperture. Lens makers' literature (including Leitz's) sometimes dwells on this at length. By all means note the fact, but then forget it. While shooting, you don't have time to to remember optimum apertures and performance variations of each lens. It is the subject conditions (light, shutter speed requirements etc) that determine the aperture. If you need to use a lens at full aperture, use it —

otherwise you would miss the shot altogether. In a modern high-quality lens such as the systems for the Leica-R, differences are comparatively slight, anyway.

Lens hoods

To see better when looking into the sun you usually shield your eyes with your hand. A lens hood similarly enables the lens to see more clearly. It does so especially when bright lights not actually in the picture shine directly at the lens, such as the sun, or powerful lamps in low-light situations. (What counts is the intensity of the source relative to the general lighting level.)

Ideally you should use a lens hood for every exposure. With most Leica R lenses you can pull forward the front lens rim so that the extending tube forms a lens hood. The only bother is that you must push back the hood to refit the lens cap.

Present-day lens coating, especially multicoating, largely limits one problem that a lens hood was called on to cure, namely scattered light within the lens which reduces image contrast on the film. Such flare becomes troublesome when the sun or other very bright points of light are actually within the field of view of the lens. (But no lens hood can help in that case anyway.)

A separate hood is supplied with the 19, 21, 24 and 28 mm wide-angle lenses. Here the hood must be very short so as not to intrude in the field of view. For most effective shading, such hoods are rectangular to match the image frame — unpractical with an extending hood. A bayonet mount on these hoods ensures

The wheel in the side of most wide-angle lens hoods is for turning a polarising Series filter held between the hood and lens.

correct alignment. To remove the hood, pull it *forward* on the lens, then turn anticlockwise.

There is a similar hood, but round, for the 35 mm PA-Curtagon-R shift lens.

Between the lens front and the hood the latter forms a recess that can take loose Series filters. On the hoods for the 21, 24, 28 and 35 mm shift lens a small wheel protrudes into this recess. When you mount a polarising filter in this way, you can rotate it by the wheel.

8 Outfit choice and care

On its own the Leica R5 (or R4) with a standard lens is fine for straightforward picture-taking. But its versatility relies on the equipment system and it is worth planning the further items you propose to add to the basic camera.

Choosing lenses

The obvious priority is the lens range. You will want alternative focal lengths to tackle wide-angle and tele subjects. The classical approach of starting with the standard lens and adding others as needs and means dictate is not necessarily the best: zoom lenses are more flexible.

The most useful initial outfit thus consists of the 35-70 mm and the 70-210 mm Vario-Elmar-R lenses. These cover everything from medium wide-angle to the longest tele likely to be needed for general shooting — and do so with not too much lens changing.

For me 35 mm does not really count as a wide-angle lens; I would prefer 28 mm and look forward to the day when the Leica R lens assortment includes a 28-85 mm zoom as a more useful alternative to the 35-70 mm. Meanwhile a separate 28 mm or 24 mm lens will hold up the wide-angle end.

With present-day high-quality fast films, the medium speed of the Leica zoom lenses is not too much of a handicap. Sports and feature photographers, like other professionals who need every half-stop of lens speed, will add a large-aperture lens or two to the zooms. If you want such a lens for its speed, it is hardly worth stopping short of the Summilux-R f/1.4 systems in the focal length you need most (35, 50 or 80 mm). The 50 mm is probably the most useful all round for this particular purpose, and it is also the lightest of the three Summilux-R lenses.

If you need highest lens speed in other focal lengths, the Elmarit-R units (135 and 180 mm) may be worth their keep — but they are of fixed focal length.

The selection of most of the other Leica R lenses depends on individual (and often special) requirements: the ultrawide-angle and fisheye lenses for more extreme coverage and effects, the PA-Curtagon-R for architectural photography, the macrofocusing lenses (Macro-Elmarit-R and Macro-Elmar-R) for closeups and product shots and the Telyts for long-range tele and sports photography.

Guidance and more detailed information to assist choice of lenses will be found in the companion volume to this, ''Leica Lens Practice — Choosing and Using Leica Lenses'', also published by Hove Foto Books.

Flash choices

A flash unit should be the next priority. Preferably get a System SCA 300 dedicated

computer flash with SCA 351 adapter to benefit from the R5's TTL flash metering control (see Chapter 6) — or from the automatic signalling facilities with the Leica R4 models. Here are some basic selection criteria from the available flash range:
— For a hot-shoe-mounted flash the guide number should be at least 30-35 (metric, ISO 100). Lower-power units will do for fill-in flash but are otherwise of too limited use.

— The flash reflector should be able to tilt up (and possibly sideways too) for bounce flash effects. A downward tilt of 5-10° helps to point the flash most effectively at closeup subjects. Also useful is a subflash or other system that directs a small portion of the flash light forward in bounce mode.

— The flash reflector should cover at least a horizontal 55° lighting angle, or about the field of a 35 mm lens. A diffuser can extend this for wide-angle shots (at the expense of some light loss). Zoom reflectors can cover a variable angle equivalent to that of lenses from about 35 to 90 mm and make best use of the light output.

— For a Leica R4 (or R3) without TTL control, the flash should also have two or more switchable power levels (usual in flashes of a 30-35 guide number, anyway). These levels are generally indicated as apertures required for different distance ranges with automatic (computer mode) operation. The apertures should remain the same for different film speeds — the flash should provide a greater operating range with faster film, not compensate higher film speed by requiring a smaller aperture.

— Get a flash that takes size AA batteries, the same as used in the motor winder or drive. That simplifies battery buying and stocking.

— Handle or grip type flashes are usually more powerful but also heavier — which is why you cannot mount them directly in the camera's hot shoe. This relocation of the flash even slightly away from the camera often improves light modelling. You can get handgrips for some shoe-mountable flashes, too.

— Finally, elaborate LCD displays are often more impressive than helpful. Much of their information is again irrelevant with TTL flash control.

The rest of the outfit

You may want a winder for the convenience of motorised film transport and possibly remote control, or even the motor-drive for fast sequencing. The choice between them will depend on your ideas about the desirable trade-off between bulk and sequencing speed. (More about that in Chapter 10.)

 The combined hand grip and shoulder stock is worth having for its multiple uses (including as a table tripod) — see **The universal handgrip** in Chapter 3. The Leitz table tripod is a more compact alternative.

A second camera body sounds an extravagance if you have invested much hard-earned savings in a Leica-R outfit. Professionals often find they need to carry a second body, either for shooting on two different film types at the same time (e.g. colour slide and colour print), or to save time over lens changing which can make you miss important shots on press or similar assignments. (A wide-range zoom lens is the other answer to this problem.) The additional body need not be an R5 — an R4s/2 is still a useful second string.

Finally, an outfit is best carried in a camera bag where the items are easily accessible. That bag will also accommodate other small bits and pieces you may want to take. (See **Holdall cases** in Chapter 3).

Camera care

The Leica R cameras are photographic tools for heavy-duty use. They are designed to stand up to climatic extremes and to hard handling. While the chrome finish (of the bright as well as the black versions) is normally quite abrasion resistant, knocks, scraping against sharp edges etc in time leave their tracks. So when not actually using the camera, I prefer to keep it either in a holdall case or in a soft leather case for protection.

Protect the camera against dust, moisture and fine sand. On the beach and especially in the desert, sand dust penetrates everywhere — even inside the camera. If you have no case, store the camera on such travels in a waterproof and dustproof plastic container.

Dust on the camera looks neglectful; dust inside can interfere with the precision mechanism and it shows up in the pictures. So dedust the camera regularly. Small battery-powered vacuum cleaners are good for that — better even than the popular blower brushes that just blow the dust somewhere else. (But a blower brush is better than nothing.) Dedust also the film chambers and the space between the lens mount and the shutter. But do not poke a pointed nozzle into the shutter blinds.

Avoid handling a camera with greasy hands. Clean grease and other soiling carefully off the Leica with a soft rag — but not solvents (which can cause trouble if they get inside the camera).

If you have the misfortune to drop the camera into water (especially salt water) the biggest risk is corrosion. One first-aid measure suggested for such a case is to remove the batteries, rinse the camera thoroughly in fresh (non-salt) water straightaway, dry it out in a slow oven (lowest possible setting, below 100° C) and get it to a repair service as soon as possible. That may not save the electronic circuitry but the latter will probably need replacing anyway.

A basic rule for all mechanical camera components: items that should move must do so freely or engage positively. There are not many adjustments that a Leica user can carry out. So in case of malfunction never use force, but let a Leitz service agency handle it. The same applies to failures of the electronic system.

Lens care

As mentioned before, keeping the lens capped when not actually shooting saves

much time that you could waste on lens cleaning. Also keep the rear cap on when the lens is off the camera.

The rear lens cap (14 162) is the same for all Leica R lenses that attach directly to the camera. The front caps of most lenses clip into the 55, 60 or 67 mm filter thread. Press together the two spring-loaded keys on the outer rim and push on the cap to engage. Such caps are quick to remove and fairly easy to lose; it is a good idea to carry a spare such cap for each lens size you take with you. (I also carry a spare rear cap.) Large-diameter lenses may have slip-over front caps — less likely to drop off or get lost.

When storing the camera without a lens remember to fit the front camera body cap to protect the mirror and other camera innards.

If a lens surface does collect a fingerprint, remove by carefully wiping it off the glass with a piece of chamois leather. Preferably dab it off (never rub over the whole lens surface); help by very gently breathing on it if necessary. Failing chamois leather, use a clean and well washed handkerchief. Avoid cleaning fluids and impregnated cleaning tissues unless they are specially designed for *photographic* lens cleaning. (Avoid cleaning tissues for spectacles.)

Remove dust and other foreign matter by blowing it off — wiping can scratch the glass. A small blower brush is again useful; keep it or carry it in the camera bag inside a dustproof plastic bag. If it is not absolutely clean, a blower brush (or a chamois leather) can apply more dirt to the lens than it removes. Store chamois leather patches in a dust-free plastic container, for instance a film can. Don't blow dust away by mouth; that can easily blow tiny splashes onto the lens surface.

Dealing with batteries

The battery check shows when the silver oxide or lithium button cells in the camera are exhausted. But during use, and especially during prolonged storage, small amounts of chemical matter may leak out of the cell and affect the contacts in the battery compartment. If a cell appears to fail prematurely, first clean the battery compartment contacts and the cell itself — it may then continue working for weeks or even months.

Replace a pair of silver oxide cells together; do not combine a fresh and partly used cell.

9 Creative sharpness

It is a popular half-truth that a photographic imahe should be as sharp as possible. Pictorially, sharpness is often enhanced when set against something unsharp. Sharpness is thus variable in nature and effect.

In photographs we have two kinds of sharpness variation, involving focus and movement. Both are connected with exposure parameters, though in quite different ways. The factor affecting focused sharpness is the control of depth of field by the lens aperture. The shutter speed on the other hand determines how sharply the camera will freeze movement blur.

More about depth of field

Apart from the lens aperture, the focused distance and the focal length of the lens employed affect depth of field. The sharp zone gets shallower as you get closer to the subject. For instance, with a 90 mm lens focused at 4 m, the depth-of-field indicator at f/22 shows a sharp zone from just over 3 m to about 6 m — a total depth of 3 m. At 2 m distance the sharp zone extends from about 1.75 m to 2.45 m (as closely as one can estimate it from the scale) or a mere 0.7 m overall.

Looking at the depth indicator of a 180 mm lens, the depth at f/22 and 4 m covers from some 3.7 m to 4.4 m — again 0.7 m altogether instead of the 3 m zone of the 90 mm lens.

Incidentally, doubling the focal length has the same effect on the image scale as halving the subject distance; it here has a similar effect on the actual depth of the sharp zone. The extent of the latter thus appears to depend mainly on the image scale: the larger the scale, the shallower the depth of field, irrespective of whether this is achieved by reducing the subject distance or increasing the focal length of the lens. (The depth is however proportional not to the image scale, but rather to its square).

This relationship is approximately valid at medium to larger scales (better than 1:100) and with standard to long-focus lenses. It means in practice that with nearer subjects you can depend on the aperture for depth control and manipulative distance and focal length exclusively for perspective effect. At greater distances and with wide-angle lenses you get more depth by using a shorter focal length and going closer.

On the other hand, with negative film you can also increase the subject distance and afterwards enlarge a cropped image to a great degree. You then lose some sharpness by the higher print magnification (depth-of-field sharpness standards are based on comparisons of film using images enlarged to similar degrees) but you lose less sharpness in depth than by using a longer-focus lens.

A few more general guidelines to sharpness control in depth:

Selective unsharpness by deliberately restricted depth of field concentrates attention on the sharp portions of an image. For an extreme degree of such differential focusing, go really close to the subject and use the largest available aperture. Check the approximate zone covered on the depth of field indicator, to keep unwanted detail outside that zone. The further such detail is outside the depth zone markings the more blurred it will appear in the picture.

If on the other hand you need sharpness in depth (for instance people in the foreground of a scene together with an extended view behind) and the light is not good enough for a small stop, the approach depends on the subject:

— If it is the people or other foreground objects that matter, the background can be less sharp. So focus on the foreground and use as large an aperture as the light demands.

— If the foreground just provides human interest (scenics with figures) but must be sharp together with the background, go further away from the nearest item you want sharp. Or use a wide-angle lens; both ways yield sufficient depth of field even at a medium aperture.

— You may really need maximum depth from very near to fairly far, for instance in large interiors. Here use the smallest lens stop and put up with the long exposure time which that entails. (Remember to mount the camera on a stand.)

Freezing movement

If any part of the image that the lens projects on the film moves during the instant that the shutter is open, that image portion will be blurred in the picture. The most obvious blur factor is an unsteady camera hold: if the whole camera shakes, the whole image is unsharp. A short exposure time counteracts this by reducing effective image movement on the film. Hence the recommendation of $1/60$ sec — or preferably shorter still — for hand-held shots.

A fast shutter speed also reduces the unsharpness where part of the subject moves during the exposure. The image movement that has to be arrested depends on the scale of reproduction (subject distance and focal length of the lens used — shades of depth of field, above) and on how fast the subject is moving. The limiting shutter speed rquired for this may be calculated or derived from more or less complex tables.

Here is a simpe mnemonic:- With a 50 mm lens, a subject 50 m away and moving at 50 km/h, a shutter speed of $1/250$ sec would yield a sufficiently sharp image. That is the limit — the exposure can be shorter but it should not be longer. It applies to movement at right angles to the camera direction (camera axis).

From this 'triple fifty' rule you can derive limiting shutter speeds for other conditions too. Thus a longer-focus lens would need a shorter exposure time to arrest the same movement — around $1/500$ sec with 90 mm — while with the 28 mm lens you could get away with $1/125$ sec. (For intermediate focal lengths use the next faster speed, e.g. $1/1000$ sec with 135 mm, or put up with slightly more movement blur at the next slower speed.)

Faster or slower movement involves corresponding corrections. Other factors being equal, you can arrest something moving at 25 km/h with $^1/_{125}$ sec. If you go nearer, you need a faster speed, for instance $^1/_{500}$ sec at 25 m. (Like a longer focal length, nearer distance magnifies the image and hence its movement on the film). If the object moves obliquely towards the camera, you can again double the limiting time ($^1/_{125}$ instead of $^1/_{250}$), and double it once more (to $^1/_{60}$) for movement directly approaching, or receding from, the camera.

You can set up and memorise similar ready rules for specific subjects — for instance 17/135/100 for football shots (17 m distance, 135 mm lens, $^1/_{1000}$ sec), assuming the arms and legs of a running player to move at roughly 25 km/h. Of course 17 m is not meant to be an exact value, rather a range between 15 and 20 m. Or a rule for general movement in feet and miles: 50/50/15/500 for a 50 mm lens, 50 ft subject distance, 15 mph and $^1/_{500}$ sec exposure.

You can also use slower shutter speeds by catching movement at a 'dead point' — for instance a highjumper at the top of his or her leap. Be sure to release at the right moment, and possibly anticipate that a little.

Finer points of movement blur

Two points before we leave this topic.

First, not all movement blur looks equally blurred. The impression of sharpness also depends on the subject itself. A solid shape, for instance an airliner just rising from the runway, needs a fair degree of blur before it really looks unsharp. Yet much slighter blurring can be disturbing in distinct detail — say fine writing on the side of a passing van or truck.

The same, incidentally, applies to focusing unsharpness. An almost detailless outline of a building in mist or fog does not have to be pinsharp. Brightly lit architectural texture does.

Secondly, like differential focusing for selective unsharpness, deliberate movement blur can reinforce pictorial impact. Take a child waiting at the edge of the road with traffice rushing past. Expose the stationary child at $^1/_{30}$ sec and you enhance the impression of the busy rush around it. You can also have creative movement blur if you swing the camera to follow a moving object and keep it centered in the finder while you expose at a fairly slow shutter speed. The object then appears sharp against a laterally blurred background — for instance a car on a race track.

One rule serves for all this. Pictorial unsharpness is a means to an end and should be a deliberate effect, not a by-product of sloppy technique.

Alternative screens

The split-image wedge and microprism ring of the universal focusing screen supplied with the Leica R5 and R4 are the most useful focusing aids for nearly all occasions. In a few cases certain alternatives, provided by interchangeable screens, are better.

The universal screen is the No. 1 screen (14 303). The others are:

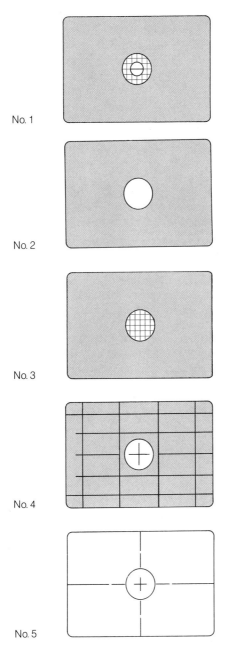

No. 1

No. 2

No. 3

No. 4

No. 5

Leica R5 and R4 screens. From top to bottom: Universal screen No. 1 with split-image wedge and microprism ring in centre of matt area; No. 2 all-matt screen; No. 3 screen with microprism circle in matt area; No. 4 all-matt screen with line grid; No. 5 clear screen with hairline cross.

No. 2: This all-matt screen (14 304) with neither wedge nor microprism is preferable for telephotography with the 400 mm and longer Telyt-R lenses. One reason is that at their f/6.8 (or smaller) maximum apertures neither the wedge nor the microprisms are usable. Also, when photographing wildlife at a distance the subject is easier to observe if the finder centre is not cluttered up with focusing aids. For the same reason the all-matt screen is preferable for portraiture where you want to closely watch facial expressions.

No. 3: The microprism screen (14 305) is similar to the universal screen No. 1 but without the central wedge. The microprism area covers the whole of the 7 mm circle. If you prefer microprism focusing to using the split-image wedge, that becomes easier on the larger circle than in the ring. This is however a matter of taste.

No. 4: this is also an all-matt screen but with a superimposed rectangular grid (14 306). That helps in keeping the camera correctly levelled — for instance in architectural photography or copying. (The gird immediately shows up any tilt or converging verticals in the view.) Two vertical index lines just outside the 7 mm circle are exactly 10 mm apart and permit convenient checking of the image scale — if you include a ruler or something of the sort in the picture. I find the grid a help in telephotography, too, and really prefer this screen to No. 2.

No. 5: This specialist clear screen (14 307) with hairline cross is intended for macrophotography where even the fine grain of the matt screen is disturbing in focusing. You focus on the aerial image (see Chapter 11). The clear screen also shows a brighter image with small-aperture tele lenses and is useful in certain scientific applications (e.g. endoscopic photography) where no focusing is involved, anyway. On all screens the central 7 mm circle marks the approximate target area for selective exposure readings.

Screen changing

This is a little fiddly — as with most cameras where the screen is accessible only through the lens mount. Leitz supplies alternative screens in a plastic box complete with a screen holding tool. You need both the box and the tool to handle the screen change.

Remove the lens from the camera. Inside the lens flange, at the top, the transparent tab of the plastic screen is visible in a rectangular cutout. Take the small handling tool from the box of the alternative screen. Push the lip at the end of the tool against the edge of the tab protruding into the cutout inside the lens flange. Depress the tool plunger — the tool should slip down to grip the screen tab.

With the tool firmly attached to the tab in this way, lever the screen down to release it from its seating and lift out of the camera. Place the screen in the upright grooves of the screen box for the moment, then press the tool plunger to release the tool from the screen. Use the tool to pick up the other screen from its seating in the box and introduce it into the camera through the lens mount. The shiny side of the screen

To remove the screen, first attach the handling tool to the screen tab, then lever downwards.

must face the mirror. The screen tab is slightly off centre, so you cannot insert the screen the wrong way round.

Carefully put the screen — still attched to the tool — in position, with its edge against the tiny leaf spring in the rear groove in the camera. Then swing the screen (by the tool) up towards the finder prism so that the tab engages the small spring in its recess. Finally release the tool from the screen (by again pressing the plunger). Pick up the first screen (the one just removed from the camera) from the parking groove in the screen box and place it properly in the box.

The tab carries the embossed screen number in the form 'R Nr. 1' ('R4 Nr. 1' on earlier versions, which are otherwise identical). The screen box also contains a small brush to dust the mirror if necessary. Keep the brush always in the screen box — otherwise you may smear more dust onto the mirror than you remove.

The interchangeable screens are intended for protracted applictions where the alternative types are more useful. Screen changing through the lens flange is however too cumbersome for constant switching in everyday use.

10 **Motorised shooting**

Professionals specially value the fast shooting capability of 35 mm cameras. So it was logical to develop motor drives to advance the film (and wind the shutter) automatically after every exposure. Many compact 35 mm models — and some SLRs — today feature built-in motors; most SLR cameras have provision to take attachable drives.

There are arguments for and against integral motorisation. In favour is the fact that the motor is always there, and that it is more efficient engineering to instal motive power right where it is used, rather than link it up via longer gear transmissions. On the other hand, separate motors offer more power, especially if they have to operate at faster shooting speeds — which is what professionals expect of a camera system such as the Leica R.

The Leica system uses a separate motor which you can leave at home when luggage weight counts and shooting rate is a lower priority. Further, the system offers two options: The smaller motor *winder* where the convenience of the automatic film advance is more important than fast sequencing, and the more powerful (and bulkier) motor *drive* for greater speed. The two are similar in design and — apart from shooting rate and power supplies details — almost identical in handling. So where descriptions refer to the 'motor', they apply to both the motor winder and the motor drive.

The Motor Winder R

This unit matches the Leica R5 and R4 in length (about 140 mm or 5¹/₂ in.), protrudes a little behind and in front of the camera when fitted, and adds about 40 mm or a little over 1¹/₂ in. to its height. With batteries it also adds a not exactly negligible 400 g or 14 oz to the camera weight. The camera and winder do form a unit that is reasonably convenient to hold — particularly with the special hand grip (see below).

The front carries a release button, a tripod bush for fitting the tripod bracket and the release key of the battery holder. In the base is the folding key for the screw shaft that screws the winder to the camera, another tripod bush and the rewind release. A small black screw cap at the right covers the remote control outlet.

Like other equipment, the Leica Motor Winder has undergone improvements over the years. The latest version (14 208), officially known as the Motor Winder R, has this designation engraved on the battery holder latch on the front. This model also carries three small gold-plated contacts on the panel between the release button and the front tripod bush, to link up with the electric hand grip.

The previous version (14 282) has no contacts and is engraved MOTOR WINDER R4, but is otherwise the same unit.

The Leica Motor Drive R

This higher-power unit is about 5 mm higher than the winder, protrudes rather more at the back (which matters little) and weighs 620 g, or just under 22 oz. Much of this extra weight is that of the additional batteries (10 instead of 6). The controls are virtually the same as on the winder, though the rewind release (and double exposure latch) is relocated.

An extra control is a sliding three-position speed selector switch on the front.

Like the latest winder, the current Motor Drive R (14 310) carries three contacts for the electric hand grip. Its immediate predecessor (14 309), labelled MOTOR DRIVE R4, has no contacts. There is however a small blank panel between the front tripod bush and release button for subsequent installation of such contacts — possible on models of serial Nos. above 63 000.

The (14 309) drive is in turn an improved version of the original Motor Drive R4 (14 292), with redesigned gears for quieter running. SLR camera motor drives, especially fast ones, are never particularly silent — but the Motor Drive R is among the less noisy. (It does not however come anywhere near the quiet operation of the winder for current Leica M rangefinder cameras.)

Fitting the winder and drive

Both the winder and the drive come with a protective plastic cover over the contacts and coupling elements, held in place by the tripod screw. Keep this cover on when you carry the winder or drive on its own in your camera bag. To remove, raise the key

Matching coupling elements in the camera base (left) and motor drive (centre): Three contacts at the top, tripod bush and tripod screw, a fourth contact (matching that below the lens mount on the camera), rewind release and the drive coupling. The underside of the winder (right) carries a tripod bush, the tripod screw key to secure the unit to the camera and the multiple-exposure lever.

of the screw in the winder or drive base and unscrew anticlockwise to release this cover. A new Leica R5 or R4 may have a similar cover to protect the base — or a stuck-on piece of plastic. Obviously remove this, too (but there is no point in putting it back).

Before fitting the winder or drive, preferably advance the film manually (if not already advanced after the last shot) and pull the winding lever out to its start position. (If you forget this, the motor will advance the film while you are attaching it to the camera.) Also be sure that the multiple-exposure lever in the motor base — see **Multiple exposures** below — is in the single-exposure position (one white dot).

Raise the key of the screw shaft in the base and position the motor winder or drive against the camera base so that the contact and coupling shaft locations match up. Engage the two pins at the ends of the motor top in the corresponding locating holes of the camera base and press the motor against the base. The screw shaft should engage in the camera's tripod bush; turn the shaft by its key to secure the motor to the camera.

Push the camera's winding lever back into its rest position (almost flush against the camera top); this switches on the motor system, ready to run.

When removing the winder or drive, pull out the camera's winding lever to its start position first; this stops the motor from cycling as you take it off (but that does not really do any harm).

Batteries

Sets of batteries, housed in a quick-change battery holder, power the motors. To remove the holder, press the release key near its inner end, press your left thumb against the ribbing on the back of the holder and slide the holder out from the left. (The release key is the long key at the front with the engraved name.) To fit the

The quick-change battery holder is instantly removable from the winder.

holder, slide in from the left and push fully home. You can get spare MW-R battery holders (14 280) for the winder or MD-R holders (14 322) for the drive.

If you are going on extended motorised shooting sessions it is a good idea to take a spare holder with extra batteries for instant changing when required. (Changing batteries in the holder itself is fiddly — see below.) And if you are shooting in very cold weather, keep the spare holder in a warm pocket for better battery efficiency.

The battery holder of the winder takes six size AA cells, that of the drive ten cells to provide the extra power for faster sequencing. Use either alkaline batteries (international designation LR6) or rechargeable nicad accumulators. Both are available from numerous makers with similar (or different) type designations. (Ignore ordinary zinc carbon cell torch batteries, except for emergencies; their capacity is too low and output too variable.)

Alkaline cells (e.g. Mn 1500, AM-3, Varta 4006, Eveready E 91 etc) yield 1.5 volts per cell — 9 volts for a set of six in the winder or 15 volts for the ten cells in the drive. They are available everywhere and hence convenient. Nicads may cost four to eight times as much but can be recharged several hundred times. For nicads you also need a mains charger (see below).

Makers' specifications for alkaline batteries often quote twice as high a capacity as for nicads. But the latter have a more uniform output and fail only when fully discharged. So in applications involving high current drain (such as motors) the effective capacity of both types is in fact about the same. Based on its own test conditions, Leitz quotes a capacity (at 20° C) of about 150 films of 36 exposures for both battery types — a set of fresh alkaline or freshly recharged nicads. It is also the same for both the winder and the drive; the extra batteries in the latter make up for the greater current taken. As the batteries run low, the motor gets slower or (with nicads) cuts out abruptly.

Remove alkaline batteries if the winder is not in use for a week or more.

Loading the battery holder

To open the battery holder, use a coin to unscrew the milled screw in the end and take apart. (If not tightened too firmly you can even unscrew it with your fingers.) If the holder already contains batteries, open the holder carefully — otherwise the batteries spill all over the place.

In the winder's holder insert four cells in the fat square section and two cells in the thinner part. Be sure to insert the batteries the correct way round; watch for the polarity signs (+ or −) marked on the contacts in the holder. The negative end of a cell should always contact a spring, the positive end (the cap) a plain contact. When correctly oriented, cells sit with alternate poles (+ and −) next to each other. In the thinner section the polarity of the battery end visible on top should be the same as marked on the contact next to it.

To reassemble the holder of the winder, put the two halves together (without spilling out any cells) with the white dots on the housing facing each other. Push together and screw in the screw — finger-tight is sufficient.

The ten cells for the motor drive are a little more involved. The square section of the shorter half again takes four cells with alternating polarity. The compartment

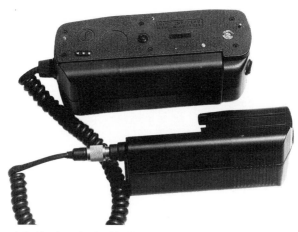

The external supply holder (here for the drive) is a dummy battery holder that you can connect to an external 15 volt power supply or even to a regular battery holder that you keep in a warm pocket in cold weather.

next to this takes three cells — check correct orientation — while the longer half takes another three. Then assemble and screw the two halves together.

Once the motor winder or drive is attached to the camera, the motor batteries also supply the power to the camera's meter and shutter circuits. So the Leica R5 and R4 can function even if the silver oxide or lithium cells in the camera are exhausted. To check the battery function in this case press both the battery check button and the mode selector release key (or half depress the shutter release on either the camera or the motor). If the camera's red battery check LED fails to light, this means that the motor batteries have failed (or you haven't fitted the battery holder or the latter contains no batteries). This check shows only whether the batteries are good enough for the metering circuits, not necessarily whether they still have enough capacity to power the motor. (If they don't, the motor simply cuts out.) To check the camera's own cells, remove the motor before pressing the check button.

Winder operation

Pushing in the camera's winding lever to its rest position, flush against the body, switches on the winder. Pressing either the camera's or the winder's release button (on the front) makes the exposure and advances the film for the next shot.

There is a functional difference between the two releases. With the camera release you have to press and let go before the winder advances the film; you cannot press again until the transport cycle is finished. The release on the winder front is only an electric switch; you can keep this depressed and the camera then shoots and recycles automatically at up to 2 frames/sec. The shooting rate depends of course on the preselected (or meter-set) shutter speed, for the transport cycle cannot start until the shutter has closed at the end of an exposure. Nearly exhausted alkaline batteries also

slow down the shooting rate. (Exhausted nicads cut out abruptly without previous slowing down.)

Pulling the winding lever out to its start position switches the motor off. You now release and wind manually with the lever as if no motor were fitted. However, the release button on the motor is still operative, but as a single-exposure release.

The winder keeps recycling until either the camera's frame counter reaches No. 36 or the film is finished (e.g. with less than 36 exposures). In the latter case the winder hunts and 'chatters' a few times, then cuts out. You can switch it on again only by rewinding the film and opening the camera back (which resets the frame counter) — so there is no risk of tearing the film by wrong handling.

You can load the camera with the winder (or drive) attached and use the motor to advance the film to the first frame. If the motor does not appear to work, perhaps after it got stopped by a film shorter than 36 exposures, remove it from the camera and refit. Preferably load full 36-exposure films when using the winder or drive because you will want the maximum film reserve when shooting sequences.

Faster drive sequences

In most respects the motor drive functions like the winder but has an additional shooting rate setting. With this sliding switch in the top position (marked '4'; depress the button on the switch to move it), the Leica R5 or R4 models can cycle at up to 4 frames/sec. Again, this depends on the selected or meter-set shutter speed; the latter should be $1/60$ sec or faster for a top shooting rate.

In the middle '2' position the switch slows down the cycling rate. The camera now shoots at up to 2 frames/sec. Use this setting when you specifically *don't* want the 4 frames/sec rate, e.g. to keep enough film for a longer shooting period.

With the switch in the bottom '1' position the motor drive makes one exposure (followed by a film advance) every time you press the motor's release. You have to let go and press again to take another shot, just as you have to when exposing with the camera's release button (irrespective of the shooting range setting).

Multiple exposures

For deliberate double exposures proceed as without a motor (see **Multiple exposures** in Chapter 5), depressing the rewind release button in the motor base before the *first* of the two exposures to be superimposed. Then make the second exposure by releasing normally.

For more than two exposures you can lock down the rewind release by depressing the button and swinging the lever surrounding it to the right — the position marked by two white dots. The motor then superimposes exposure after exposure automatically. Swing back the lever before the penultimate exposure of a series, e.g. before No. 5 of a series of 6. If this is not practical (for instance if you want to keep the camera precisely aimed during such a motorised sequence), make all the multi-exposures you need under direct motor control, then unlock the lever, cap the lens and press the camera's shutter release twice more. That advances the film to the next clear frame.

To signal this locked multiple exposure mode, the winder or drive beeps (4 beeps/sec) whenever the meter circuit is switched on. That is, when you partly depress the release button (on the winder/drive or on the camera) or when you press the release key of the mode selector lever. On the Leica R5 the winder or drive then keeps bleeping for 10 sec, on the R4 models it bleeps only while you actually press the relevant control. If you should use the selftimer in double exposure mode, the unit will bleep (on the R5 and also the R4 models) while the selftimer runs down.

Stroboscopic effects

A special motorised multi-exposure technique is stroboscopic action studies. Successive superimposed flash-lit images of motion phases. This can resolve the movement flow of dancers or gymnasts into separate images, or analyse the motion of hands, etc., while operating industrial machinery.

The usual way is to light the subject with a repeating stroboscopic flash and expose by opening the shutter (at the B setting) for the period covered by the motion to be analysed. You can also do it with a regular electronic flash provided it has a fast-recycling reduced power level. Some flashes have a 'W' or winder setting that permits operation at 2 flashes/sec; in a few a motor drive (MD) setting can even flash 4-5 times a second.

Set up the Leica R5 or R4 with the winder or drive front of a black background and arrange for the subject to go through its movement within the area taken in by the camera. (With dancers that may need rehearsing.) Then expose a sequence at 2 or 4 frames/sec, depending on what the flash can provide. Unless you want to deliberately slow down the movement, 2 frames/sec is usually too slow.

Try to spread out faster movement to avoid too confusing superimposition. (But close superimposition of slower movement can be pictorially interesting) The winder or motor drive setting of the flash is a manual mode, so work out the required lens aperture from the flash guide number and distance. As the flash power is very reduced at these settings (typical metric guide No. about 5-10) use high-speed film.

Even at this low power, avoid overheating the flash tube. Restrict winder sequences to about 8-10 flashes, then allow at least a minute for cooling down.

Handgrip and tripod bracket

The handgrip R (14 308) provides a more convenient right-hand hold on the camera with motor. It has a removable leather strap and two release buttons, on the top and front, for comfortable releasing with the camera held horizontally or upright. The releases are electric switches acting through the contacts of the current (14 208) and (14 310) winder and drive respectively. This handgrip is therefore only usable with these latest motor versions — serial Nos. from 84011 and from 95001 respectively. (Older winders and drives need an earlier handgrip — see below.)

To fit the handgrip, screw it into the tripod bush on the front of the motor, just below the front release button. Use a coin to screw the retaining screw in tight, so that the grip does not wobble on the motor. Slack off the strap of the grip so that you can comfortably get your hand through it, or tighten as needed for firm support

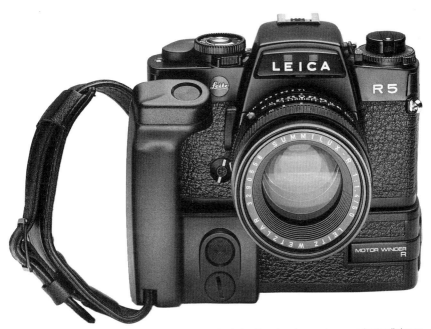

The handgrip provides a more convenient hold for the Leica R and motor; a release on the top links up electrically (mechanically on an earlier version) with the motor.

across the back of the right hand. With the camera held horizontally, the right index finger rests on the release button on top of the grip. For an upright hold get all the fingers of the right hand to curl around the grip and release with the right ring finger on the front release button.

The earlier handgrip R4 (14 283) fits both the older and current motors; it has only one release (on top) which acts mechanically on the button on the motor front. A slight inconvenience with this grip is that you have to disengage the camera strap from the right-hand strap eyelet before you can fit the grip. Then attach that end of the camera strap to the eyelet on top of the grip.

For a horizontal hold with this grip push the whole right hand through the grip strap and let the thumb rest on top. The right index finger then naturally rests on the release lever. Press this inwards (towards the camera body) to shoot. For upright shots raise the right hand; the hold of the fingers remains the same.

A ribbed sliding latch next to the release lever locks the latter against inadvertent releasing. To lock, slide this latch to the left (towards the camera lens).

The tripod bush underneath the motor winder or drive is intended not so much for balanced support of the camera assembly (which it does not give) but as an anchoring point for a more substantial tripod bracket (14 284). The latter has two shorter arms with tripod screws, and a longer plate with a standard $^1/_4$ in. tripod bush. Attach the bracket to the motor so that each tripod screw screws into one of the

bushes (front and base) of the motor; the longer plate should then protrude forward. Its bush can now be mounted on a tripod, or even on the universal handgrip.

Remote control

One of the most useful facilities of the winder and drive is remote operation via control units that plug into the motor's remote outlet. This is the five-pin socket at the rear right of the motor, marked with a white dot and normally closed by a plastic screw-in dust cap.

There are several straightforward and also some more sophisticated remote control units. All work equally with the motor winder and the motor drive, subject to the available shooting rate limitations.

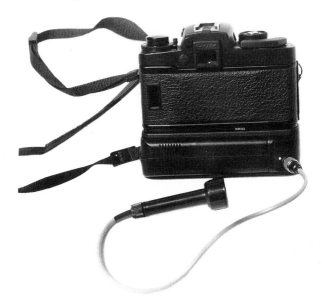

For remote operation plug the release switch into the motor's remote outlet. Long release cables and extensions can increase the range up to 100 m or 300 ft.

The remote release switch (14 237) is a simple push-button switch at the end of a tubular handle, with a 30 cm (12 in.) lead. Plug it into the motor's remote outlet, lining up the small groove in the side of the plug with the white dot at the side of the outlet, then screw in the milled sleeve to secure against accidental pulling out.

The universal handgrip (14 239) also comes into its own with the motor winder or drive. The tubular handle of the release switch (14 237) fits in the hole through the top of the grip. Connect the plug to the motor's remote control outlet and you can conveniently shoot and advance the film with the hand holding the grip. The universal handgrip/motor combination is specially handy with the longer lenses that

There is no 'correct' exposure for a scene like this. It all depends on how you wish to interpret it. A little less exposure could have been equally valid: it would have produced more saturated colours and given a different mood to the picture. The photographer wanted to convey the ethereal atmosphere he felt by this lake in the Derbyshire Peak District. (Photo: John Robert Young)

Top left: The light-weight and very rapid sliding focusing movement of the 400mm and 560mm "follow focus" Telyt R lenses make them ideal for occasions such as the Calgary stampede. The horses can be kept in sharp focus as they race towards the camera and the shutter release pressed at the right moment. 400mm lens. (Photo: John Robert Young)

Bottom left: The light from the open doorway of the Taunggyi (Burma) cheroot factory made this cigar roller a very contrasty subject. Aperture priority AE (with selective metering) is the best bet here. Kodachrome 200 film. (Photo: Andrew Matheson)

Above: An average reading of a scene of mainly dark tones (not necessarily low light) tends to lead to overexposure. The intention in this picture was to preserve the delicate colour of the Lilac-Burmese cat and keep the background dark to emphasise the face and whiskers. With slide film one generally needs to use a −1 f/stop or EV underexposure compensation. 60mm macro Elmarit-R. (Photo: John Robert Young)

Fish eye lenses, through mis-use, have acquired a reputation for being gimmicky, but they can make shots possible which would otherwise be unobtainable and they add an extra quality of their own. However the alignment and precise positioning of the camera is all important in the picture composition: moving the camera an inch or so up or down could have distroyed the picture. 16mm Fisheye-Elmarit-R.

(Photo: John Robert Young)

attach directly to the grip through their own tripod bush. Here you can attach the motor to the camera base (or remove it) without interfering with the rest of the setup.

The remote release cable (14 238) is essentially a remote release switch with a 5 m lead.

The 25 m extension lead (14 274) extends the range of the remote release cable or of the RC Leica R unit (below). You can link up to four 25 m leads together. (Beyond 100 m the cable resistance can make operation less reliable.)

Other remote control equipment produced at various times includes a radio remote release with a range up to about a mile in the open, infrared light barriers, large mains-operated interval timers and control units. This is essentially laboratory equipment.

The 5-pin remote-control plugs are also available on their own from Leitz (item 302-013.154-004) and may be wired up with other remote-control items (e.g. infrared remote releases) capable of closing a circuit. When you look at the male plug end-on, the pins are numbered 1 to 5, going anticlockwise from the locating groove. To release the camera and winder, connect the circuit-closing device to pins 1 and 2.

The RC Leica R unit

This multipurpose control unit triggers the camera's exposure and transport sequence, counts exposures and can time sequence intervals from about $^1/_2$ sec to 10

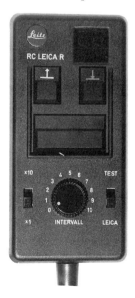

The knob selects exposure intervals (the numbers are arbitrary non-linear units), the switch at the left selects ranges. The wide central key triggers exposures, the smaller keys above it recall the digital frame number display at the top and program frame numbers.

min. It can thus control anything from action to time lapse sequences, regular record shots etc.

The RC Leica R is in a plastic box about 30 x 60 x 120 mm (1.2 x 2.4 x 4.7 in.), weighs 220 g or 7¾ oz and has an 8 ft lead and plug to connect to the motor's remote outlet. The front of the unit carries three keys, a digital readout, two switches and an interval dial. The rear carries moulded into the plastic a summary of the functions in German, English and French. Seven internal C-MOS circuits control it all.

You can also connect the unit via (14 274) extension leads (see above).

Once the RC Leica R is plugged into the motor, you have a choice of two main operating modes: direct releasing and interval control. For both the camera's winding lever must be fully pushed in against the body (rest position).

For direct releasing set the interval dial to 0 (bottom left — the dial engages in this position) and the lower righthand switch (TEST/LEICA) to LEICA. Pressing the wide bar-shaped *release key* now triggers an exposure cycle (release and transport). Continued pressure keeps cycling the camera in the same way as continued pressure on the motor's release, and at the shooting rate to which the drive (when used) is set.

The 9 mm high LED numbers of the digital readout at the top right indicate the number of exposures made. The numbers light up for 2 sec, then go out to save battery power. (The motor's batteries or external power supply power the remote control.) You can recall the readout — for 2 sec at a time — by pressing the *recall key* with the white upward pointing arrow (the lefthand key above the release key).

The digital readout starts from 00 when you plug the RC unit into the motor. While the RC unit stops operating the camera when the latter's frame counter has reached No. 36, you can at this point unload and reload the camera. The digital counter will then continue beyond 36 up to (after further film changes) 99 to return to 00. It is the RC unit that controls the readout; it advances with every shot, also — unlike the camera's frame counter — with every exposure of a multiple exposure.

To reset the readout to 00, either unplug and replug the RC unit, or press the recall key together with the *correction key* — the righthand key with the red downward pointing arrow. To advance the readout, for instance to match its number to that of the camera's frame counter, move the lower right switch to TEST and keep pressing the correction key till the readout shows the required value.

For interval control turn the interval dial away from 0. There are two timing ranges, controlled by the x10/x1 switch at the bottom left. In the x1 range the intervals run from about 0.5 to 60 sec. However the scale is not linear; for instance 3 is about 1 sec, 5 is 4-5 sec, 7 is about ¼ min. Hence the numbers are mainly for orientation. In the x10 range the intervals run from 5 sec to 10 min.

In interval mode a red dot stays on all the time below the lefthand digit of the display (even when that digit goes out). A second red dot lights up below the righthand digit when the control triggers an exposure. This stays on for a few seconds, depending on the interval set.

To set an exact time interval, move the righthand switch to TEST and observe the righthand dot. With a stop watch (or the seconds hand of a watch) check the intervals between successive instants when the righthand dot first lights. Adjust the dial to get

the required interval. You can do this in either timing range and convert to the other range if convenient — the 10:1 conversion is sufficiently accurate.

In TEST mode the RC control does not operate the camera but starts to do so as soon as you switch back to LEICA. It then releases the camera at the precise intervals set in test mode. The digital readout now lights again with every exposure. The intervals are the delay between the end of one transport cycle and the next release. With longer exposure times you have to add the exposure time itself to the test-set interval.

External power and nicad charging

There are several alternatives to the batteries in the battery holder. All involve the use of an external supply holder, of the same size and shape as the battery holder, but with a coiled 1.5 m (5 ft) connecting lead and plug. The external supply holder for the winder (14 278) fits into the winder in place of the MW-R battery holder, while the supply holder for the motor drive (14 323) replaces the MD-R battery holder in the drive.

An obvious use of the external supply holders is in cold weather. You keep the external supply holder on the motor and connect it to the battery holder which remains warm in your pocket for optimum battery performance. (Battery power and capacity is liable to drop at low temperatures.) The plug on the supply holder for the motor drive plugs directly into a socket on the battery holder itself. Alternatively, link the two via a 5 m (15 ft) MD-R extension lead (14 325).

The MW-R battery holder of the winder has no matching plug. Instead, fit the holder in an intermediate holder or cradle (14 279) and plug the lead from the supply holder into that. Again, there is an MW-R extension lead (14 293).

The NL3 mains unit provides a steady external DC supply for the motor and for other control equipment. It also incorporates a charger for nicad batteries. Other mains adapters can be used, provided they supply 8.5 volts DC for the winder or 15 volts DC (maximum) for the motor drive. They need to be suitably wired up through appropriate sockets or female plugs to match those on the external supply holder. (See also below.)

Various nicad chargers can be used to recharge nicad batteries without removing them from either battery holder. The charger should be yield 45 milliamps when connected through either 6 nicads (for the winder) or 10 cells (for the drive). For the outlet you need a pair of 2 mm single-pin plugs to fit the plus and minus sockets on the drive's MD-R battery holder. The same pins fit similar sockets on the (14 279) cradle for the MW-R battery holder.

Note that there are different connecting plugs for different voltages. The plug for 9 volts (MW-R) has two pins, that for 15 volts (MD-R) has three — none located in the same positions as the two 9-volt pins. That should stop you from connecting the wrong supply to the wrong motor. The extension leads have a matching pin configuration in their plugs: two-pin plugs at the ends of the lead (14 293) for the winder supply holder, and three-pin plugs on the lead (14 325) for the motor drive's supply holder.

The remote control items all have five-pin plugs. Externally, all are similar and all

Don't confuse connecting plugs and sockets: the two-pin plug connects the winder's power supply holder to an external 9-volt supply. The three-pin plug does the same for the drive's holder and a 15-volt supply. (The configuration difference prevents feeding too high a voltage into the winder.) The five-pin plug connects release switches and other remote control devices to both the winder and the drive.

have the same screw-over sleeve that secures the plug against being pulled out.

Leitz also supplies connectors and sockets for installing in chargers and other external supply adapters. Be sure to wire up the right kind for the supply voltage.

Motor philosophy

A manufacturer may feel obliged to offer the slower winder for camera owners who do not want to carry (or buy) the motor drive. To me, practical user priorities look different. I would choose the motor and not the winder. For the bulk of the winder is not worth a mere automatic winding convenience at a couple of frames a second. But the 4 fps of the drive tips the scale. When you need fast sequencing, you want it fast — even with the drive that is 50% bulkier and heavier than the winder. Nevertheless it is more use than ballast. But that is of course a personal decision.

In either case, motorised shooting poses an obvious temptation to use more film. Press, feature and sports photographers do that deliberately. Film stock is the least expensive commodity of professional picture taking. Not getting the right picture wastes other costly resources involved in the photographer's mere presence on the scene. So shooting dozens of rolls of films is more of an insurance policy; even if you don't get a perfect picture there should still be a few acceptable very near misses. But you also get more outstanding shots that way. Sports cameramen have been known to set up a Leica reflex on a stand, with a long tele lens and motor, and to leave it running to record, for instance, the complete sequence of a gymnastics display at Olympic Games.

The best shots are then selected afterwards, and selection is the key. You need some experience and a critical eye to pick out good images from the mass of mediocre ones, often on sheets of small contact prints of a whole film at a time. If you want to follow this technique, start by looking at small (say $3^1/_2$ x 5 inch) enlargements mass-printed from the whole film (not that expensive). After a while, with a magnifier you will manage to pick winners from contacts too.

The winder for the Leica R3

Leitz developed the motor winder system before the Leica R4. The functions and

operation of the Motor Winder R3 for the Leica R3 MOT are virtually the same as for the Winder R4. The latter was merely modified to match the slightly different body dimensions and contact layout of the Leica R4 (and R5). Even the accessories — remote switches, the RC Leica R unit and battery housings — are the same, or at least the same current ones will fit. The slightly different earlier switches are the remote release switch (14 275), equivalent to the (14 237) switch, and the longer 5 m cable (14 272) which corresponds to the current (14 238) release cable. The 25 m (14 274) extension cable fits them all.

The winder for the R3 also takes the same battery holder (14 280) and external supply holder (14 278) as the current Winder R. The Winder R3 takes a different handgrip (14 271) — without release lock but otherwise of similar operation to the handgrip (14 283) — and different tripod bracket (14 276).

The Winder R3 does of course need the motor-compatible R3 MOT version of the Leica R3. To attach it, proceed as for the Winder R. The only difference in use is that for multiple exposures you set the multi-exposure lever of the camera. This stays in the multi-exposure position during winder operation and is then reset manually.

Data in pictures

In scientific and medical photography, laboratory records, etc., it is often desirable to include identifying data in each film frame. Nearly 25 years ago a Leica provided one of the earliest ways of doing this by locating data strips within the film frame. Nowadays a data back replaces the regular camera back and imprints alphanumeric characters in a small data field near the bottom right-hand corner of the (horizontal) frame.

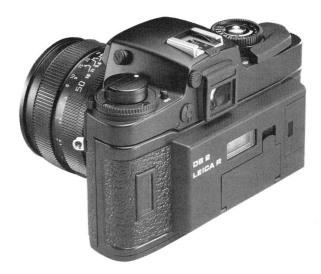

The databack imprints the date or clock time on selected frames. The LCD shows the information to be imprinted.

Data backs have become a popular way of recording the date in snapshots. It's a matter of taste whether you like to have this indelible intrusion in every exposure. Data numbering, especially with automatic incrementing, however is a useful way of identifying individual frames in long action or other sequences (e.g. portraiture sessions or wedding assignments). Plan such pictures so that the data area can be cropped away in the final prints selected from the session proofs.

The DB 2 Leica R data back is the latest type of imprinting back. There are two versions, for the Leica R5 (14 216) and for the R4 range (14 230). Closure of the camera's flash contact triggers imprinting — in the R5 version via two contacts below the film gate inside the camera and in the R4 version by an external cable.

To fit the back, remove the regular camera back. After opening the camera disengage the back by pushing down the small screw in the hinge slot. Insert the lower hinge end of the data back in the hinge bearing, push down the screw and engage the hinge. Load the film, close the back and — with the R4 version — plug the cable into the camera's PC flash socket alongside the lens. The back can remain permanently on the camera; it does however add about 1 cm to the camera depth.

The back takes two 1.5 volt silver oxide batteries (same type as used in the camera) which fit side by side in the battery compartment at the left. (You cannot use 3 volt lithium cells.) The batteries power a small microprocessor with built-in quartz-controlled clock and also the internal LEDs that imprint the data. The latter consist of three blocks of two numerals each, occupying a line 0.65 mm high and 4.6 mm long on the film.

The microprocessor is programmed to run a calendar until the end of the year 2099 (!), automatically allowing for different month lengths, leap years etc. Like most quartz clocks, the internal clock is claimed to be accurate within \pm 15 sec a month. Data alternatives are:

(a) Time: The three blocks indicate day of month, hour and minute.

(b) Date: The three blocks show day, month and year (dd mm yy) with a choice of alternative mm dd yy or yy mm dd sequences.

(c) Preset number up to 99 99 99. You can suppress any one of the blocks or replace it by --.

(d) Frame numbering, incremented or decremented automatically with each successive exposure. You can adjust the imprinting LED intensity for medium speed (ISO 100) or high-speed (ISO 400 and over) films. The LED impression may be too weak for slower films. Also, as the imprinting takes place through the film back, it may not record too well on films with a very dark backing layer. Imprinting can of course be switched off altogether.

Three buttons underneath the large bottom-hinged flap set the imprinting mode and the data. Select the mode with the MODE button: the LCD in the centre panel runs through the above displays in turn. Depressing the SET key in the appropriate

mode makes part of the display blink; change that by pressing the ADJ key. Set the time, date, reference and initial frame number in this way.

The data visible in the LCD panel are imprinted during the film exposure. Imprinting does not depend on the shutter speed or aperture, but do not use too fast a shutter speed with the motor drive or winder. Otherwise the motor may start advancing the film during the imprint and thus blur the latter. Leitz recommends an exposure time of $^1/_{125}$ or longer with the winder and $^1/_{30}$ sec or longer with the drive. (This would slightly slow down the sequencing rate.) The LCD panel briefly displays 'PRINT' for every imprinting exposure.

The DB Leica R4 data back is an earlier non-electronic version that sets alphanumeric characters in a small window in the pressure plate, to be exposed on the film by transillumination from an LED. There are three setting dials:- the first with numerals from 1 to 31, the second with numerals from 1 to 12 and letters from A to G, and the third with numerals from 79 to 99 and letters from A to I. All three dials also have non-imprinting blanks. In addition to dates you can of course use any of the available letter and numeral combinations for reference codes.

Two silver oxide cells (underneath the lid with the slotted screw) power the imprinting light. A selector button sets the light intensity for different film speeds (or switches it off); an LED flashes when imprinting takes place.

Fit the back in the same way as the R4 version of the DB 2 Leica R back, plugging the lead into the camera's flash socket.

As the back of the Leica R3 is not removable, it cannot take a data back.

11 Close-up and macro

At their nearest focusing distance of 0.5 m, or some 20 in, the standard 50 mm Summilux-R and Summicron-R lenses record objects reduced to about 1:7.5, or 0.13 times natural size. (This limiting scale may vary — mostly between 1:6 and 1:9 — with other lenses.) For a really close look at things we would however want to get much nearer. We can conveniently split up such a near range in terms of scales of reproduction:

(a) From a 1:9 scale or similar regular near focusing limit to about 1:2
(b) From 1:2 to 1:1 or same-size;
(c) From same-size to around 3x magnification (macro proper);
(d) From 3x to 15x and even beyond (high macro).

Different macro optics and accessories, from simple to elaborate, approximately match the above groups:
(1) Elpro close-up attachments on the standard (and some other) lenses.
(2) Special close-focusing macro lenses.
— these cover range (a) above.
(3) Extension tubes, especially in combination with macro lenses, cover range (b).
(4) Focusing bellows with normal camera lenses advance into range (c).
(5) Focusing bellows with special short-focus macro lenses can cope with range (d). (This is more specialised.)

The Elpro attachments

A converging lens in front of the camera lens allows the latter to focus on closer distances — just as we can look at nearer objects with a magnifying lens. The Elpro closeup lenses are optically corrected versions of such magnifiers. There are four of them, all screwing into the 55 mm front filter thread of the lens:

The Elpro 1 (16 541) and Elpro 2 (16 542) are for the 50 mm Summicron-R f/2 lens. With the latter focused on infinity, the Elpro 1 yields a close-up scale of about 1:7.7 (the scale at the normal near focusing limit); with the focusing movement you then get to a new near limit equivalent to a 1:3.8 scale. With the Elpro 2 the range covers scales from 1:3.9 to 1:2.6 or nearly quarter natural size.

The Elpro 3 (16 543) is intended for the 90 mm lenses and, together with the Elpro 4 (16 544), also for the 135 mm Elmarit-R. (They are usable with the macro-focusing lenses too — see below.) Depending on the camera lens, they cover various ranges between 1:10 and 1:2.

The Elpro attachments do somewhat affect image quality and you should stop down the camera lens to about f/5.6.

The converging powers of the four Elpro lenses do not progress in numerical order but were chosen to provide in each case a range (or two ranges) of reproduction scales following onto the largest scale at the normal near focusing limit. In fact, the Elpro 2 is more powerful than the Elpro 1 but the Elpro 4 weaker than the Elpro 3 (and the latter weaker than the Elpro 1). With the 50 mm lens the Elpro 3 and 4 would overlap the normal focusing range. The Elpro 1 and 2 are not recommended with the 90 and 135 mm lenses as you would then have to stop down too far for adequate image quality.

Table 2 shows the reproduction scales, distances and subject fields with the recommended Elpro combinations.

TABLE 2 **Closeups with Elpro attachments**

Lens	Elpro lens attachment*	Camera lens focus**	Scale of reprod. decim.	1:	Subject distance† (cm)	Subject field (cm)
50 mm f/2 Summicron-R	EL 1 (16 541)	infin.	0.13	7.7	41	18 × 27
		near	0.26	3.8	21	9 × 14
	EL 2 (16 542)	infin.	0.26	3.9	21	9 × 14
		near	0.38	2.6	14	6 × 9
90 mm (Summicron-R & Elmarit-R)	EL 3 (16 543)	infin.	0.15	6.7	61	16 × 24
		near	0.33	3.0	30	7 × 11
135 mm f/2.8 Elmarit-R	EL 4 (16 544)	infin.	0.1	9.9	135	23 × 35
		near	0.23	4.4	68	11 × 16
	EL 3 (16 543)	infin.	0.22	4.5	61	11 × 16
		near	0.36	2.8	42	6.6 × 10
100 mm Macro-Elmar-R f/4	EL 3 (16 543)	infin.	0.16	6	61	14 × 21
		near	0.5	2	24	5 × 7
100 mm Apo-Macro-Elmarit f/2.8	EL 16 545	infin.	0.5		16	5 × 7
		near	1.1x		10	2.2 × 3.3

*EL 1 (16 541) = Elpro 1 (also Elpro VIa with older 50 mm Summicron-R)
EL 2 (16 542) = Elpro 2 (also Elpro VIb with older 50 mm Summicron-R)
EL 3 (16 543) = Elpro 3 (also Elpro VIIa for 54 mm filter fitting)
EL 4 (16 544) = Elpro 4 (also Elpro VIIb for 54 mm filter fitting)
EL 16 545 = Elpro 1:2-1:1 attachment (specifically for this lens)
**Near = nearest focusing distance.
† Clear space between front of lens and subject.
Subject distances and field sizes are approximate.

Macro-focusing lenses

The most logical way of focusing very close is to extend the focusing movement that varies the lens-to-film distance. Macrofocusing lenses solve the mechanical and

optical problems of doing just that, covering a continuous focusing range from infinity down to a 1:3 or 1:2 scale. (Accessories can extend this further.) Hence such lenses are particularly versatile for covering large to small objects, for instance in commercial photography, nature shots of flowers and small animals etc. Thanks to optimised optical near-range correction, macro lenses yield slightly better image quality than normal lenses in the close range. Camera holds and handling with the macrofocusing lenses is virtually the same as with normal lenses.

There are three such macrofocusing lenses for the Leica R, already mentioned in Chapter 7:

The most compact is the 60 mm Macro-Elmarit-R. Less than one full turn of the focusing mount brings its continuous range down to 1:2 scale. This extends the lens itself (housed in the tubular front part) by some 32 mm.

The 100 mm Macro-Elmar has a similar extension movement, but in view of the longer focal length this only yields a 1:3 scale at the nearest setting. This lens is one

For their macro ranges the 60 mm and 100 mm macro lenses, such as the 100 mm Macro-Elmar-R (above) rely on a deep focusing mount (above right) and on an additional extender (below right).

The somewhat involved focusing scales of the Macro-Elmar lens shows distances in ft and m, and also reproduction scales (here 1:5). The second topmost reproduction scale figures (e.g. 1:1.5) refer to the lens combination with the macro extender.

stop slower than the 60 mm. However, for very near subjects 100 mm is a better focal length because at any given reproduction scale it leaves a greater clear working distance between the subject and the lens front. This is important for setting up lighting. Also, close-ups of small animals are easier if you don't have to approach them too near — see **Tele close-ups**.

The Macro Adapter R (see below) further extends the near range of the above lenses to a scale of 1:1 and 1:1.6 respectively.

In addition to the regular distance scales in metres and feet, two further sets of figures indicate reproduction scales. A white one, from 1:10 to 1:2 (on the 60 mm lens) or from 1:20 to 1:4 (on the 100 mm Macro-Elmar-R) applies to the extended focusing movement of the lens itself and starts at distances below 3 m or 10 ft. A second scale in green shows reproduction scales with the macro adapter.

The 100 mm Apo-Macro-Elmarit has a still more extended focusing movement down to 1:2 reproduction. At this scale the clear subject distance is 26 cm. This lens, too, shows reproduction ratios (between 1:5 and 1:2) on its distance scale.

For still larger close-ups a specially matched Elpro 1:2-1:1 attachment (16 545) screws into the recessed front of the Apo-Macro-Elmarit-R and covers a continuous focusing range from 1:2 reduction to just over same-size reproduction. The clear subject distance in this case ranges between 16 and 10 cm — almost the same as with the 60 mm Macro-Elmarit. The (16 545) attachment is thus useful if you already

have the 100 mm Apo-Macro; unless you need the latter lens for its other qualities (e.g. infrared photography) it is however an expensive alternative to the 60 mm lens with macro adapter.

It is also possible to use the 100 mm Macro-Elmar-R with an Elpro 3 close-up lens, in this case to cover a range down to a 1:2 scale, overlapping part of the lens's own focusing range. The macro adapter (see below) however is a better alternative as it extends the near range down to a 0.63x magnification, or 1:1.6.

The macro adapter and extension tubes

You can also extend the focusing movement by inserting a piece of lens barrel — an extension tube — between the lens and the camera body. The Macro Adapter R (14 256) adds 30 mm to the focusing travel, doubling the latter for the 60 mm Macro-Elmarit-R and the 100 mm Macro-Elmar-R. The macro adapter also links up the aperture input and stop-down mechanism between the camera and lens to permit full-aperture metering and aperture-priority AE operation. Leitz does not recommend **T** and **P** mode automation (on the Leica R5 and R4) with the macro adapter — the stop-down coupling across the adapter is apparently not sufficiently accurate for this. Aperture priority mode is preferable for close-up work, anyway.

TABLE 3 Closeups with the Macro Adapter R and extension tubes

Lens	Macro adapter or extension tube combin.*	Camera lens focus**	Scale of reprod. decim.	1:	Subject distance† (cm)	Subject field (mm)
Macro-focusing lenses with macro adapter						
60 mm Macro-Elmarit-R f/2.8	None	near	0.5	2	15	48 × 72
	MA 14 256	infin.	0.5	2	16	48 × 72
		near	1.0x		10	24 × 36
100 mm Macro-Elmar-R f/4	None	near	0.3	3.3	39	72 × 108
	MA 14 256	infin.	0.3	3.3	39	72 × 108
		near	0.63	1.6	25	38 × 57
	MA 14 256 + Elpro 3	infin.	0.5	2	24	49 × 73
		near	0.83	1.2	17	29 × 44
100 mm Apo-Macro-Elmarit	None	near	0.5	2	26	48 × 72
Other lenses with macro adapter						
50 mm f/2 Summicron-R	MA 14 256	infin.	0.57	1.75	11.6	42 × 63
		near	0.7	1.42	9.9	34 × 51

Lens	Macro adapter or extension tube combin.*	Camera lens focus**	Scale of reprod. decim.	1:	Subject distance† (cm)	Subject field (mm)
90 mm	MA 14 256	infin.	0.33	3	32	72 × 108
Elmarit-R &		near	0.5	2	23	48 × 72
Summicron-R						
135 mm f/2.8	MA 14 256	infin.	0.22	4.5	75	108 × 162
Elmarit-R		near	0.33	3	55	72 × 108

Other lenses with extension tubes

Lens	Macro adapter or extension tube combin.*	Camera lens focus**	Scale of reprod. decim.	1:	Subject distance† (cm)	Subject field (mm)
50 mm f/2	EX 14 158	infin.	0.48	2.1	13.5	50 × 75
Summicron-R		near	0.63	1.6	11.2	38 × 58
	EX 14 158	infin.	0.96	1.04	8.1	25 × 37
	+ 14 135	near	1.09x		7.5	22 × 33
90 mm	EX 14 158	infin.	0.28	3.6	38	86 × 130
Elmarit-R &		near	0.45	2.2	25	53 × 79
Summicron-R						
	EX 14 158	infin.	0.56	1.8	21	43 × 65
	+ 14 135	near	0.7	1.4	18	34 × 50
135 mm f/2.8	EX 14 158	infin.	0.19	5.4	87	130 × 195
Elmarit-R		near	0.29	3.4	60	81 × 121
	EX 14 158	infin.	0.37	2.7	50	65 × 97
	+ 14 135	near	0.48	2.1	42	50 × 75

*MA 14 256 = Macro Adapter R
EX 14 158 = 25 mm 2-part extension tube
14 135 = 25 mm centre insert to extension tube
**Near = nearest focusing distance.
† Clear space between front of lens and subject.
Subject distances and field sizes are approximate.

Table 3 lists the relevant data for recommended combinations. The macro adapter can also extend the focusing range of longer tele lenses for near-range telephotography (see **Tele close-ups** below).

An alternative is an earlier extension tube set. It provides two extensions of 25 and 50 mm but does not couple aperture controls between the camera and lens. This therefore involves more cumbersome exposure handling (see **Working-aperture metering**).

The extension tube set consists of a two-part ring (14 158) altogether 25 mm deep. The front part carries a cable release socket for triggering a semi-automatic stop-down mechanism. The two rings screw apart to take a 25 mm tube (14 135) in-between them for a total 50 mm extension. This permits slightly better reproduction scales than the macro adapter but this hardly makes up for the inconvenience of the tube set.

The Focusing Bellows R

An adjustable bellows overcomes the drawback of the fixed extension (and therefore restricted range) of tube systems. The Focusing Bellows R (16 860) adds an extension variable from 42 to 142 mm between the camera and lens. With the 50 and 60 mm lenses that yields real magnifications up to nearly 3x, with special short-focus macro lenses up to 15x or so. The bellows also extends still further the near focusing range of the longer tele lenses.

The bellows consists of a base rail connected to a rear plate carrying a lens mount to fit the camera's lens flange. A knob-operated rack-and-pinion gear moves the front standard; the latter's bayonet flange takes Leica R lenses. Along one side of the base rail a scale bar indicates the bellows extension from 0 to 100 mm. At the zero setting the unit is already equivalent to a 42 mm extension tube; for actual extensions therefore add 42 to the scale value.

The scale bar rotates and can indicate reproduction scales (as decimal magnification) with 90 mm, 135 mm and 100 mm lenses. The 90 and 135 mm are the regular Summicron-R and Elmarit-R systems; the 100 mm is a Macro-Elmar f/4 — a special version of the Macro-Elmar-R without focusing mount or distance scale. The missing -R suffix means that the lens is not directly usable on a Leica R camera; it does however have an R bayonet mount to fit the front flange of the bellows. The latter thus serves as this lens's continuous focusing mechanism — from infinity to same-size reproduction.

Underneath the bellows is a tripod mounting block with ¹/₄ and ³/₈ in. tripod bushes. A further knob moves the block within the bellows rail; when you mount the bellows with camera on a tripod, this movement shifts the whole assembly forward and back. It permits precision focusing — which in macrophotography

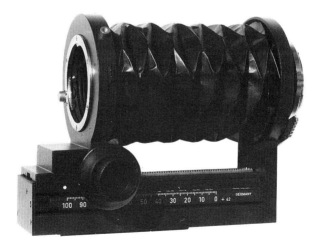

The Focusing Bellows R provides a variable extension from 42 to 142 mm, shown on the scale. The lever on the lens standard locks the lens iris fully open; the lever behind the rear standard allows the camera to rotate between upright and horizontal shots.

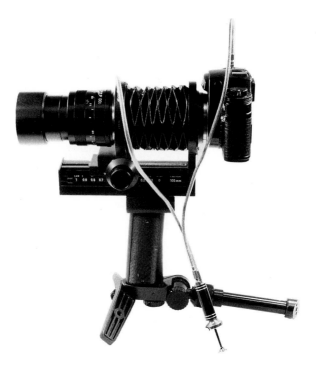

In a closeup assembly with bellows a twin cable release automatically stops down the lens just before triggering the camera release. With the assembly mounted on the shoulder stock hand-held close macro shots are possible.

should always adjust the subject-to-lens distance rather than the lens-to-film distance. That focusing travel is 67.5 mm and can be locked with a clamping lever on the knob.

To set up the bellows for closeups, mount it on a tripod — or a copying stand with column for shooting straight down onto a baseboard. Attach the camera at the rear and the lens at the front. The camera rotates in its fitting for upright and horizontal shots. Press in the large chrome lever on the rear bellows panel and turn the camera body in either direction. The mount engages at 90° intervals.

When you fit the lens on the bellows, its iris closes down to whatever working aperture it was set at. To open to full aperture, push the collar of the focusing knob (on the lens standard) inwards on its axis and at the same time pull down the small lever in the side of the lens panel. Depressing the collar once more lets the aperture close down for the exposure.

Twin-cable releasing

A twin cable release (16 494) with one fixed and one adjustable release cable is

An extreme wide-angle shot distorts shapes near the image edges and corners, as is demonstrated by these square floor tiles. This is due to the geometry of image formation, not to any aberration of the lens. Indeed, if one were to view this picture taken with the 19mm Elmarit-R from sufficiently close range, so that the angle subtended by the frame at the eye was the same as that of the scene to the lens, the shapes would appear quite normal. (Photo: John Robert Young)

Above: Cross light is the most difficult to deal with, particularly late evening sunlight, especially to obtain good skin tones. As a good general rule one should measure the highlighs and shadows, average them, and then give about half a stop less exposure than average. Panning the 180mm Elmarit-R lens has given a slight blurring to the waves, which give a better feeling of movement to the runner. *(Photo: John Robert Young)*

Top right: For portrait heads the 80mm f/1.4 Summilux-R is ideal. At full aperture the background can become sufficiently blurred so as not to distract, even here where it is close behind the subject. The wide aperture and high contrast of this lens has coped with the poor weather and resulting dull light on this occasion. *(Photo: John Robert Young)*

Bottom right: The 60mm Macro Elmarit is a most versatile lens and the one that is most rewarding to keep on the camera the whole time. When out on a walk with no particular photographic intentions, one can use it for landscapes, close-ups, and extreme close-ups, as in this example. The trick here is to extend the lens fully to 1:2 ratio and then move in on the prey, pressing the shutter release as soon as it is in focus. *(Photo: Dennis Laney)*

The 90 mm Summicron-R focuses close enough for a 1:6 scale — just right for these orchids. You can get still closer with macro lenses and attachments. Kodachrome 200 film.

(Photo: Andrew Matheson)

TABLE 4 **Closeups with the Bellows-R**

Lens	Bellows extension (mm scale)	Scale of reprod. decim.	1:	Subject distance* (cm)	Subject field (mm)
50 mm Summicron-R f/2	0	0.83	1.2	9	29 × 44
	100†	2.9x		4.5	8.4 × 12.5
60 mm Macro-Elmarit-R f/2.8	0	0.67	1.5	12.5	35 × 53
	100†	2.8x		5.7	8.5 × 12.8
90 mm Elmarit-R f/2.8 and	0	0.48	2.1	24	51 × 76
Summicron-R f/2	100†	1.8x		10	13 × 20
100 mm Macro-Elmar f/4	0	0	inf.	inf.	inf.
(lens only)	100	1.0x		18	24 × 36
100 mm Macro-Elmar-R f/4	0	0.42	2.4	32	57 × 85
(in focusing mount)	100†	1.7x		14	14 × 21
135 mm Elmarit-R f/2.8	0	0.31	3.2	57	77 × 115
	100†	1.2x		26	20 × 30
Extreme macro:					
50 mm Photar f/4**	0	1.2x		9	20 × 30
	100	3.2x		6	7.5 × 11
25 mm Photar f/2**	0	3x		2	8 × 12
	100	7x		1.7	3.4 × 5.1
12.5 mm Photar f/2.4**	0	7.5x		0.8	3.2 × 4.8
	100	15.5x		0.7	1.5 × 2.2

*Clear space between front of lens and subject.
†And with lens focused on nearest distance.
**Fitted in Photar Adapter R (14 259).
Subject distances and field sizes are approximate (usually rounded down).

convenient for controlling this stop-down action when exposing. Screw the adjustable release cable into the cable release socket on the bellows and the fixed one into the camera's release button. Adjust the length of the first cable by its screw collar until pressing the cable release plunger triggers the stop-down action of the lens just before it releases the shutter. The more the release pin protrudes from this cable end the sooner the lens is stopped down.

The twin cable release is also useful with the (14 158) extension tube. When you mount a Leica R lens in this tube, the iris remains closed down to whatever stop was preset. Open the iris by turning the aperture ring to the largest f/stop; if you then turn the ring back, the iris stays fully open. Pressing the chrome release button on the tube stops down the lens again; so does a cable release screwed into the button's socket.

On the other hand with static subjects and a rigidly mounted camera adjust the releases so that the lens stops down well before the release triggers the camera. You

can then pause for a second once the lens is stopped down to let any vibration die down, and only then press further to release the shutter.

Working-aperture metering

When you use the (14 158) extension tube or the bellows, there is no aperture input from the lens to the camera. (No aperture figure appears in the central window below the screen, either.) The TTL meter therefore reads the exposure at the lens's preselected working aperture and you can use neither the **T** nor the **P** auto exposure modes of the Leica R5 and R4. You can use aperture-priority AE (the **A** modes), and the reading still allows automatically for closeup exposure factors.

There are two ways of managing the switch between full aperture for focusing (otherwise the image is too dark for reliable assessment of sharpness) and working aperture for meter readings and for the exposure itself. For the first, start with exposure measurement:
(1) Set the lens to the stop to be used and check (or, in manual mode, select) the shutter speed.
(2) Open the lens: on the extension tube turn the lens's aperture ring to its maximum opening, then back to the previously selected working aperture. This keeps the iris itself open. On the bellows open the iris with the collar on the focusing knob as described above.
(3) Focus the image carefully. To check depth of field, close down the lens by depressing the release button on the extension tube or the collar on the bellows focusing knob — then open the lens once more.
(4) Observe the image and (especially if the subject moves) refocus, then expose with the twin cable release to automatically close down the aperture just before releasing the shutter.

The second way is quicker. Set the camera to **A** mode, open the lens aperture, focus and shoot — again with the twin cable release. However, you don't see the meter-set shutter speed in the finder; at best you can allow for it mentally. Thus if the working aperture is two stops below full aperture (e.g. f/5.6 with an f/2.8 lens), the effective shutter speed will be two steps slower than the value shown by the LEDs in the finder.

Close-up technique

Certain technical aspects of closeups differ from general shooting procedure:

In focusing use the lens's focusing movement and/or the bellows extension for selecting the reproduction scale and coarse focus. Fine focus by adjusting the lens-to-subject distance, for instance with the knob that controls the movement of the tripod mounting block on the focusing bellows. If the camera and bellows are mounted on the universal handgrip (see below), move the whole assembly forward and back till the image appears sharpest on the screen.

Depth of field is very limited at close range — down to about 1 mm overall at 1:1

scale and f/8, and a little over 2 mm at f/16. However, image sharpness deteriorates with excessive stopping down. At normal distances this is negligible even at the smallest available lens stop, but does become significant in the macro range. Don't stop down beyond f/16 at 1:1 reproduction; between 1.5x and 2.5x the limiting aperture is f/11. It becomes f/8 at 3x, f/5.6 at 4-5x, comes down to f/4 at 8x and f/2.8 at 15x in the extreme macro range (see below).

Scale of reproduction: Most of the time the magnification scales on the macro-focusing lenses and on the bellows rail are an adequate guide. If you need to know the exact magnification, place a small mm-scaled ruler in the subject centre to run across the middle of the finder screen's 7 mm circle. Count the mm divisions across the circle and divide into 7. E.g., if the circle measures 5 mm across the ruler the scale of reproduction is $7 \div 5 = 1.4x$.

Close-up and macro exposures need to be longer at the same nominal f/number than for other subjects — for instance four times as long (2 f/stops larger) at 1:1 scale. The TTL metering automatically allows for this exposure factor, but check the meter-set exposure time and avoid running into too slow shutter speeds that can lead to camera shake.

A rigid support is desirable for close-ups at scales larger than about 0.5x. For quite apart from camera shake risk, hand-held focusing becomes difficult. You must keep the camera steady enough not to drift out of the sharp zone of only a mm or two. Release with a cable release or by electric remote control with the winder or drive.

Flash — especially with TTL flash-duration control — is an ideal light source for close-ups and solves most movement and exposure problems. At close range the duration of a sensor-controlled flash can become near $^1/_{10,000}$ sec or less, which is ideal for close-ups of insects and other tiny moving creatures. Flash off the camera, at least on a grip-type bracket to one side of the camera, yields better modelling than a flash mounted in the hot-shoe. With very near subjects point the flash inwards and down at the subject area actually taken in by the lens. Bounce flash, with a small bounce reflector mounted directly on the flash unit, is good for softer illumination which macro subjects often demand.

For product shots and other macro subjects you can also use general tungsten lighting plus one or two miniature spotlights (microscope illuminators) for highlighting. Still more effective are macro lighting units using fibre optical light guides for highly localised light control.

Extreme macro

Macrophotography at magnifications beyond about 3x (the limit with the 60 mm Macro-Elmarit-R on the bellows) requires more specialised macro lenses such as the Photar range. This currently covers three lenses: 50 mm f/4, 25 mm f/2 and 12.5 mm f/2.4. All three are optically corrected for optimum performance at higher magnifications; even the 50 mm Photar is better above 1:1 scale than, for example, the 50 mm Summicron-R.

The shorter the focal length, the greater the magnification possible with a given lens-to-film distance or bellows extension. That is how with a total extension of around 190 mm (142 mm of the bellows plus 47 mm optical register of the camera) the 12.5 mm Photar can reach about 15x magnification. If you add a macro adapter or extension tube, each extra focal length equivalent of extension adds 1 to the magnification. Thus 50 mm (= 4 x 12.5 mm) of the (14 158) plus (14 135) tubes would increase the maximum magnification to some 19x.

For mounting on the bellows, screw the Photar lenses into a Photar Adapter R (14 259); the standard R bayonet mount then fits the bellows. There is no stop-down or aperture coupling (not even the semi-automatic bellows stop-down is operative); you must stop down the lens by hand before the exposure.

The W 0.8″ x $^1/_{36}$″ screw thread in the front of the Photar Adapter R is a standard microscope objective thread and similar macro lenses of other makes (Zeiss Luminar, Olympus etc) are usable. This is virtually the only Leitz interface with optical systems of other makes. Unlike most camera firms, Leitz has firmly resisted all attempts by independent lens makers to produce lenses to fit Leica R cameras. Very few such other-brand lenses have ever reached the market.

Needless to say, focusing at these high magnifications is particularly critical, as is a rigid camera support — during focusing as well as during exposure. The matt screen texture can be intrusive; the alternative No. 5 clear screen (14 307) makes focusing easier, especially in conjunction with the right-angle finder attachment (14 300) set to 2x visual magnification.

Leica M lenses for close-ups

When the first Leica SLR cameras appeared, Leitz introduced adapters for using M-lenses for the Leica M rangefinder cameras with Leicaflex (and eventually Leica R) close-up equipment. These adapters still exist and carry a rear bayonet mount to fit the front of the Bellows R:

The (16 863) ring takes the 65 mm Elmar-V f/3.5 or the lens unit of the discontinued 90 mm Elmarit-M f/2.8 or of the 135 mm Tele-Elmar-M f/4. Maximum magnifications are 1.5x, 1.1x and 0.75x respectively, or more with extension tubes.

The (14 167) ring with a Leica M front bayonet mount takes Leica M lenses.

These adaptations are possibly of interest to an owner of a rangefinder Leica M camera outfit who has also acquired a Leica R5 or R4. There would be no other grounds for using Leica M rather than Leica R on the bellows R.

Tele close-ups

An interesting aspect of the long-focus Telyt lenses is the comparatively long subject distance, even with reasonably large scales of reproduction, when you combine them with the Macro Adapter R. With the 250 mm Telyt-R this yields a near limit scale of 1:2.9, yet the subject is over 3 ft away from the front of the lens. The 350 mm Telyt-R gets down to about 1:4 with the macro adapter, but with a clear distance of 1.78 m or just short of 6 ft.

Still more flexible is the combination of these lenses with the Focusing Bellows R. With the 250 mm lens that covers reproduction scales from 1:6 to nearly same-size (including the Telyt's own focusing movement) and clear subject distances from nearly 2 m ($6^1/_2$ ft) down to 0.6 m or 2 ft. The 350 mm Telyt-R here ranges from around 1:8 to 1:1.6 and distances from just under 12 ft to $3^1/_2$ ft.

There are similar long-range near limits with the 400 and 560 mm Telyt-R lenses when combined with a 60 mm extension tube (14 182). This screws between the lens unit and mounting tube and with the 400 mm Telyt-R yields a largest scale of 1:3.3 at a little over 5 ft. With the 560 mm Telyt-R the range then runs from 1:9.3 at a clear 5.8 m (19 ft) distance or 1:4.5 at 3.4 m (11 ft) away. Table 5 shows detailed tele near ranges and distances.

This is ideal for close-ups of small creatures. You can thus optically approach larger insects, bugs etc without getting close enough to scare them away. Butterflies, lizards or frogs tend to stay put for a camera with tele lens (and a photographer well behind) that comes no nearer than 6-7 ft.

Such shots however involve considerable risk of camera shake, so make sure of good light for fast shutter speeds or use fast film and/or flash. Depth of field at this range again depends exclusively on image scale. The sharp zone on a caterpillar

TABLE 5 Macro Adapter R and extension tubes for tele closeups

Lens	Macro adapter or extension tube combin.*	Camera lens focus**	Scale of reprod. decim.	1:	Subject distance† m	ft	Subject field (cm)
180 mm f/2.8	MA 14 256	inf.	0.16	6	1.24	4	14 × 21
Elmarit-R		near	0.3	3.4	0.8	2¾	8 × 12
180 mm f/3.4	MA 14 256	inf.	0.16	6	1.3	4¼	14 × 21
Apo-Telyt-R		near	0.26	3.9	0.96	3	9.5 × 14
250 mm	MA 14 256	inf.	0.12	8.4	2.6	8¼	20 × 30
Telyt-R f/4		near	0.34	2.9	1.0	3¼	7 × 10.5
350 mm f/4.8	MA 14 256	inf.	0.09	12	4.7	15½	27 × 41
Telyt-R		near	0.24	4.1	1.8	6	9.5 × 14
400 mm f/6.8	EX 14 182	inf.	0.15	6.7	3.2	10½	15 × 23
Telyt-R		near	0.3	3.3	1.9	6¼	8 × 12
560 mm f/6.8	EX 14 182	inf.	0.11	9	5.8	19	22 × 33
Telyt-R		near	0.22	4.5	3.4	11	11 × 16

*MA 14 256 = Macro Adapter R. The (14 158) and (14 135) extension tube combination yields somewhat larger reproduction scales but with its lack of stop-down coupling is less convenient for tele closeups.

EX 14 182 = 60 mm extension tube (fits between lens unit and mounting tube)

**Near = nearest focusing distance.

† Clear space between front of lens and subject.

Subject distances and field sizes are approximate (usually rounded down).

TABLE 6 Tele closeups with the Bellows-R

Lens	Bellows extension (mm scale)	Scale of reprod. decim.	1:	Subject distance* m	ft	Subject field (mm)
180 mm Elmarit-R f/2.8	0	0.23	4.3	0.9	3	10 × 15
	100†	0.92	1.09	0.36	14″	2.6 × 3.9
180 mm Apo-Telyt-R f/3.4	0	0.23	4.3	1	3¼	10 × 15
	100†	0.9	1.14	0.45	1½	2.7 × 4.1
250 mm Telyt-R f/4	0	0.16	6	1.9	6¼	14 × 21
	100†	0.9	1.1	0.6	2	2.7 × 4.1
350 mm Telyt-R f/4.8	0	0.12	8.3	3.6	11¾	20 × 30
	100†	0.63	1.6	1	3¼	3.8 × 5.7

*Clear space between front of lens and subject.
†And with lens focused on nearest distance.
Subject distances and field sizes are approximate (usually rounded down).

taken at 1:5 from 13 ft away with the 560 mm lens is about 16 mm or just over ½ in. deep at f/8. That is the same as when you photograph it at the same scale and aperture with the 60 mm Macro-Elmarit-R from a clear 10 in. away.

The bellows and handgrip

For hand-held close-ups and tele close-ups you can also mount the bellows on the universal handgrip. The hand hold tends to be more comfortable if you mount the grip to engage the locating pin in the off-centre locating hole of the bellows tripod mounting block. Fit the twin cable release from the front of the grip. With the right-hand focusing knob move the bellows forward or back on the tripod mounting block for optimum balance on the grip with the lens employed. (It may be best fully back with a heavy tele lens.) Focus coarsely with the left knob; for final sharp focus approach the subject or move back from it. Support a long lens below its barrel at this point of the proceedings for extra steadiness as you release.

The grip is also handy as a table stand with the bellows. Depending on the length and weight of the lens, mount the grip with the arm protruding to the front or back. In the latter case engaging the central locating hole on the tripod mounting block. As with normal table stand use of the grip, adjustment of the camera direction is limited unless you fit a ball head between the hand grip and bellows. That adds height to the setup, but at the expense of stability.

12 The Leica R3

Before the Leica R5 and R4 was the R3. We touched briefly on this forerunner of current Leica reflex engineering in Chapter 2. Here, more specifically, is how it differs in handling from the later models.

The R3 meter system

Like the Leica R5 and R4, the R3 offers full-area and selective metering options. It does however achieve them in a different way.

For selective readings a reflector behind the partially transmitting mirror deflects light to a cadmium sulphide (CdS) photoresistor cell in the camera base. Apart from

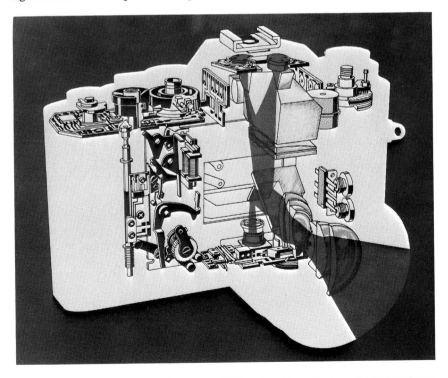

The metering system of the Leica R3 uses two CdS photoresistor cells above the finder prism to measure the brightness of the whole screen image (for full-area readings) and a third cell in the camera base for narrow-angle selective readings. This cell also measures light during full-area readings and provides the centre-weighting.

the different cell type this resembles the selective metering setup of the R5 and R4. Two further CdS cells above the finder prism register the brightness of the focusing screen image. They cover the full screen area. Their measuring circuit reduces the influence of small but very bright image points (e.g. light sources in the picture) as a compensation for certain kinds of subject unbalance. Full-area readings combine the output of these two cells with the bottom selective-reading cell; the latter makes the end result centre-weighted. Both meter modes are usable with either automatic or manual exposure control.

Before any exposure or measurement, switch on the camera by swinging down the main switch in the camera back (to the right of the finder eyepiece) to the 'I' position. At the right of the finder the meter needle swings up to indicate an exposure time. With the main switch set to 'O' the meter needle drops to the bottom of the scale and all circuits, including the shutter release, are switched off – a useful safety feature that also prevents excessive battery drain.

The mode switch – a lever just below the shutter speed dial – sets the reading mode. For selective readings depress the white button in the end of the lever and move the latter to the left to uncover a large dot (white on a black camera). For full-area readings move this lever (again after pressing the white button to unlock it) to the right, uncovering a small rectangle engraved to the left of it.

There are no other reading mode signals in the finder, but the needle action indicates the operation of the memory lock with selective readings in AE mode (see below). The principle of selective and full-area readings with the R3 is the same as for the R5 and R4, as described in Chapter 5.

The meter sensitivity with centre-weighted readings is similar to that of the Leica R5 and R4. The CdS meter may respond more slowly to low-light if you have just measured a very bright subject; in that case it may be better to wait a few seconds first.

Automatic exposure

The Leica R3 has one automatic mode: Aperture-priority AE. To set it, turn the shutter speed dial to AUTOMATIC. An orange 'A' appears in the righthand window above the finder (user-set shutter speed). Select the lens aperture – this appears in the centre window above the screen. At the right side of the finder screen a meter needle swings over a shutter speed scale and indicates the meter-set exposure time. The times are continuous from 4 sec to $^1/_{1000}$ sec.

With selective readings in aperture-priority AE, half depress the release button until the meter needle drops to the bottom of the scale. At this point the reading is stored (as long as you keep the button half depressed) so that you can reframe the view if need be. This drop of the needle is the only signal in the finder that the camera is switched to selective readings; there is no memory store with full-area readings (nor with manual mode and selective readings).

Keep your eye close behind the finder eyepiece during meter readings and especially when storing a selective reading. The cell configuration of the R3 is not as protected against stray light through the eyepiece as in the R5 and R4. For the same reason always close the eyepiece shutter (in much the same place as on the R5 and R4) during an exposure when the camera is on a tripod.

For exposure compensation depress the small lever in the side of the film speed dial and rotate the outer rim of the dial to move the white index marker to one of the values between -2 and $+2$ EV. The rim engages with the white marker opposite '0'. The available exposure compensation is again restricted at the slowest and fastest film speed settings.

Manual exposure

The camera is in manual mode as soon as you turn the shutter speed dial away from AUTOMATIC. You can set only marked speeds (no intermediate values); these appear in the shutter speed window above the finder. The meter needle indicates the speed suggested by the meter reading (either full-area or selective as set).

At the B and X settings the shutter operates mechanically, i.e. without battery power. These settings correspond to B and 100 respectively — not to X — on the R5 (and R4). The actual shutter speed at X on the R3 is a trace slower at 1/90 sec. For shooting with an exhausted battery (or none at all) still switch on the camera's main switch to unblock the shutter release.

Releasing

The camera holds for the Leica R3 are similar to those for the R4. The release action is mechanical all the time. As the release button is here next to the shutter speed dial, rest the right index finger on the cup surrounding the button and squeeze down, against the counter pressure of the palm supporting the righthand camera end. Another way is to use the first finger joint: rest the fingertip on the shutter speed dial and depress the release button by straightening the first finger joint to push down. This way is shakeproof but only comfortable with a horizontal camera hold.

The release travel is about 1.8 mm with increased resistance after a first pressure point at about 1.3 mm. This is the point where the camera stores a selective reading in AE mode.

The selftimer on the R3 is mechanical, too. Check that the camera is switched on and the shutter tensioned, then tension the selftimer by pulling down the lever next to the lens. This uncovers the selftimer's own release button. Press that to start the delay run — about 10 sec if the lever is fully tensioned, or a minimum of about 6 sec when tensioned just over halfway down.

For multiple exposures the Leica R3 has a separate uncoupling lever below the winding lever. For a multi-exposure sequence make the first exposure but don't advance the film. Push this lever to the right, uncovering two dots. Now operate the winding lever. This tensions the shutter without advancing the film, ready for the second exposure on the same frame. The uncoupling lever returns to its single-exposure position, uncovering a single dot on the camera top. For a third exposure on the same frame, move the uncoupling lever to the right again before operating the winding lever.

For multiple exposures with the motor winder, check that the film was advanced

after the previous shot, then move the uncoupling lever as above before the first of the multi-exposures. The lever remains in its multi position until reset by hand at the end of the sequence.

Other details

Many of the other camera handling steps with the R3 differ in only minor respects from those with the R5 or R4. Here is a rundown:

The batteries required are the same as for the Leica R5 and R4 (a pair of 1.5 volt silver oxide cells or a 3 volt lithium cell) and the compartment is similarly located. To check the battery condition press the small button at the rear left corner of the film speed dial (it is also the DIN index). The red light in the camera side just below the test button should come on.

Loading and unloading procedures are virtually the same as with the Leica R5 and R4. The camera back of the R3 is not removable. The film transport indicator in the back, just above the frame counter, is an orange marker that starts at the left and moves across to the right as more film gets wound up on the takeup spool. The frame counter has numbers at larger intervals with more divisions between them.

Flash: The Leica R3 has a hot shoe but no dedicated flash control functions. For flash shots set the shutter speed dial to X (the 1/90 sec synch speed) and mount the flash in the hot shoe or connect it to the upper of the two flash sockets (marked X) at the side of the lens mount. Then proceed as indicated for **Non-TTL computer flash use** in Chapter 6.

Do not use the lower (M) socket. This was for the now obsolete flash bulbs.

Earlier Leica R lenses

Most of the current Leica R lenses have been around for ten years or more. Improved and updated designs have in some cases changed the internal configuration. Most have also undergone changes in the screw thread for filters, in order to simplify and standardise the filter size range. Nearly all current lenses in focal lengths from 35 mm to 250 mm had predecessors of different filter mount dimensions: 44, 48, 54, 59 and 72 mm. Generally these also had different order codes.

Some predecessors of current lenses differ only in still having additional aperture coupling cams for the old Leicaflex models (see **Control cams and levers** in Chapter 7). These alternatives are included in the general lens table at the back of the book.

The different filter threads also require different Elpro close-up attachments. The early range comprised an Elpro VIa and VIb (16 531 and 16 532), effectively Elpro 1 and 2 lenses with a 44 mm screw thread, and an Elpro VIIa (16 533) and VIIb (16 534) — which were same as the current Elpro 3 and 4 attachments, but with a 54 mm screw fitting.

Apart from these variants, a few earlier lenses differed in more significant respects or have become obsolete altogether:

The 21 mm Super-Angulon-R f/3.4 (11 803) was the original ultrawide-angle lens for the first Leicaflex and could only be used on this camera after locking up the mirror.

The 400 mm Telyt-R f/5.6 and 560 mm Telyt-R f/5.6 were forerunners of the present f/6.8 Telyts and were used with a rapid Televit follow-focus system similar to the current type. The f/5.6 Telyt-R outfits however were considerably bulkier (and more expensive) than the present f/6.8 versions — so much so that they were discontinued as not being worth the extra half an f/stop in speed.

The 800 mm RF-Rokkor f/8 was a mirror lens by Minolta made available in a Leica R mount. It was considerably lighter and more compact than the 800 mm Telyt-S f/6.3, though slightly inferior in image contrast. Like the 500 mm MR-Telyt-R f/8 it has a fixed aperture and you can only use it in the **A** and **m** modes of the Leica R5 and R4.

The 45-90 mm Angenieux Zoom f/2.8 was an early, bulky and expensive zoom lens available for the Leica R cameras. The 35-70 mm Vario-Elmar-R at about half the length and weight provides a similar versatility.

The 80-200 mm and 75-200 mm Vario-Elmar-R f/4.5 preceded the 75-210 mm Vario-Elmar-R, which is a trace faster and has a very slightly longer tele limit. Handling and applications are the same as for the current version.

13 Technical glossary

Readers of this book are assumed to know something of the basics of photography, but not necessarily to be experts. Most photographers will be fairly familiar with the terminology. These brief definitions of frequently recurring technical items should clarify those that may occasionally not be obvious.

Acutance or edge sharpness: Measure of sharpness with which a film renders ideal high-contrast edges or outlines (black/white edges). Applies primarily to films but affects also the degree to which a film image can be satisfactorily enlarged. Low-speed films — especially thin-emulsion ones — usually yield images of high acutance.

AE: Shorthand for Automatic Exposure or an automatic exposure mode where the camera on its own sets the required lens aperture or shutter speed (or both) for a correct exposure.

Aperture: Variable opening in the lens, controls light intensity passing through the lens. One of the control parameters of exposure (the other is shutter speed). A control on the lens indicates aperture settings on a scale $(1 - 1.4 - 2 - 2.8 - 4 - 5.6 - 8 - 11 - 16 - 22 - 32)$ where the amount of light passed doubles with each lower aperture value (f/value, usually expressed as f/1.4) or is halved with each higher value. Thus high f/values are small lens openings; they are inversely proportional to the diameter of the opening. They are also relative; with any lens a given f/value (in theory) passes the same amount of light. On Leica R lenses the aperture ring also engages at half-stop settings, i.e. intermediate points on the above scale. With a few lenses the largest aperture may be such an intermediate value (e.g. f/3.5). While you observe the image on the finder screen the lens aperture is always fully open irrespective of the control setting; it automatically closes down to the preselected (or meter-set) aperture in the instant before the exposure.

Aperture-priority AE (**A** mode): Automatic exposure mode in which you preselect a lens aperture; the camera's meter system then sets a suitable shutter speed to ensure a correct exposure.

Apo lens: Lens system with specially uniform (apochromatic) colour correction over the whole spectrum and — in the Leica Apo lenses — usually into the infrared range. Such lenses are suitable for scientific photography on infrared-sensitive film without requiring special focusing corrections.

B setting: Setting on the shutter speed dial for long time exposures (longer than the longest marked time). Pressing the release button opens the first shutter blind; the second blind only closes when you let go of the release. A cable release with locking

screw is convenient for keeping the shutter open for prolonged periods. Is a mechanical setting (i.e. operates without battery power) on the Leica R models.

Cable release: Mechanical release cable that screws into the camera's shutter release button and permits releasing without touching the camera itself. Thus reduces vibration risk with long exposure times when the camera is mounted on a tripod. A twin cable release triggers both the camera's release and the stop-down mechanism of the focusing bellows.

Cadmium sulphide (CdS) cell: Photoresistor type of photocell used in the Leica R3 and the Leicaflex cameras.

Centre-weighted exposure measurement: A modified form of full-area metering (q.v.) to minimise some of the latter's sources of error.

Computer flash: Term sometimes applied to flash units with automatic flash duration control, i.e. where a built-in sensor cell measures the flash light reflected from the subject and adjusts the flash duration (and hence exposure) automatically.

Cropping: Cutting out unwanted picture portions by masking down the negative or print during enlarging. Not very practical in slides (needs masking down the image in the slide frame).

Dedicated flash: Electronic flash unit with special control circuits that can feed status (flash ready) or control signals (synch shutter speed setting) into the camera (Leica R5, R4, R4s, R4s/2) and whose flash exposure may even be controlled by a sensor cell inside the camera (Leica R5).

Depth of field: Zone of distances in front of the camera within which objects still appear acceptably sharp in the picture. Items at the exact distance to which the lens is set are rendered sharpest; definition gradually falls off in front of and behind that distance but this loss of definition is not apparent within the depth of field zone. A depth of field scale on each lens shows the available sharp zone at different distances and with different apertures. The sharp zone increases with smaller apertures and greater distance. Lenses of longer focal length also yield less depth of field. Sometimes confused with depth of focus, an analogous tolerance in sharpness related to the lens-to-film distance.

Depth preview lever: Lever on the camera to stop down the lens to its preselected working aperture (in A and M modes) during viewing, to provide a visual idea of depth of field in the focusing screen image.

Electronic flash: Flash derived from a high-tension discharge between two electrodes in a tube filled with an inert gas. Yields repeatable highly intense flashes of very short duration (typically $1/1000$ sec) which can be further reduced — sometimes down to $1/30000$ sec — by certain types of photocell control (automatic or computer flash). Present-day compact electronic flash units fitted in the camera's flash shoe are a convenient artificial light source for photography.

Emulsion: Image recording layer of a film containing its light-sensitive compounds.

(At certain stages of manufacture these compounds really form an emulsion-like suspension in their gelatine carrier.) More generally applied also to the film as a whole, especially when referring to its image-recording characteristics.

EV: See exposure value.

Exposure: Amount of light required to produce a developable image on the film; controlled in the camera by the lens aperture and shutter speed settings. Hence *underexposure* implies insufficient light for a picture (yields too dark slides); *overexposure* refers to too much light, producing too light slides. With negative film it is possible to compensate for some degree of under- and especially overexposure in enlarging the print. In general photographic terminology "exposure" refers to a combination of an aperture and an exposure time (shutter speed), sometimes also simply to a picture taken in the camera.

Exposure correction (compensation or override): Some subject conditions can mislead the camera's exposure meter, causing excessive or insufficient exposure in the automatic modes. The correction setting (below the rewind crank on the Leica R cameras) allows for this by increasing or decreasing the meter-set exposure by preselected steps.

Exposure value (EV): Simple numerical value for the effective exposure of all equivalent aperture/speed combinations yielding the same effective exposure — e.g. $1/15$ sec at f/11, $1/30$ sec at f/8, $1/60$ sec at f/5.6 all yield the same effective exposure of exposure value or EV 11. Each interval of 1 EV (like an f-stop) doubles or halves the exposure. Hence EV steps are a convenient way of referring to exposure corrections or changes without having to specify exactly how they are achieved. Mathematically, EV is the logarithmic sum (to base 2) of the exposure time reciprocal and of the square of the f-number, i.e. $EV = \log_2(1/t) + \log_2(\text{f-No.})^2$.

Eye relief: Optical location of viewfinder's exit pupil behind the eyepiece. With increased eye relief the eye can be further back behind the finder for comfortable viewing (e.g. when wearing glasses) — but this requires either a lower finder magnification or bulky finder optics. In the Leica R5 a marginally reduced finder magnification yields slightly better eye relief than in the R4 series and earlier models.

Film speed: Response of sensitised film to light, measured by standard procedures. Currently specified in ISO (International Standards Organisation) values, for instance ISO 100/21°. Here the first part (100) is the more commonly used arithmetic value — double the value means double the sensitivity, requiring half the exposure. The degree part (21°) is a logarithmic speed figure where every increase of 3° represents a doubling of sensitivity. The Leica R3 (and Leicaflex models) carry film speed scales marked in ASA and/or DIN scales; these are numerically equal to the present two ISO values.

Filter factor: Indication of the exposure increase required to compensate for light absorbed by a filter. May be a numerical factor (e.g. 2x, 3x) or an exposure value correction (-1 EV,-2 EV). The pale amber or colourless filters for colour slide film

usually need no correction. Filters for black-and-white film may have factors between 2x and 4x (-1 EV to -2 EV), or even more. TTL metering in the Leica R automatically allows for the filter factor in most cases.

Flare: Non-image-forming scattered light within lens, reduces contrast and image quality.

Flash bulb: Single flash produced by chemical combustion of aluminium or magnesium wire or foil, ignited electrically in an oxygen atmosphere within a glass bulb. Nowadays supplanted by electronic flash.

Flash socket: Synch contact mounted on the body of an SLR Leica, in addition to hot-shoe contact.

Flash synchronisation: Method of timing the triggering of a flash so that it lights exactly during the instant of the exposure. Achieved by connecting the flash unit (through the hot shoe or a synch contact) to contacts built into the shutter. Synchronisation with electronic flash is only possible at slower shutter speeds where the shutter fully uncovers the film (e.g. up to 1/100 sec, the flash synch speed on the Leica R5).

Flatness of field: Ability of a lens to render sharply all points of a flat object within the flat film plane. Important in the photography of flat subjects (e.g. copying). Slight lack of this flatness — requiring refocusing between objects in the centre and at the edges of the field — shows up strongly in lens testing but matters less when photographing subjects that are not flat surfaces.

Floating elements: Lens components during focusing that shift their position relative to other components. This helps to maintain optimum optical correction throughout the focusing range. Floating elements are used mainly in wide-angle lenses.

f/number: Numerical value of lens aperture; equal to focal length divided by the optical diameter of the lens opening (in fact the lens's entrance pupil).

Focal length: Distance between a defined plane within the lens and the film plane in the camera when the lens is focused on infinity. (The reference plane can in certain cases even be located in front of or behind the lens.) The focal length determines the scale of reproduction at which a subject at a given distance is rendered on the film — the longer the focal length the larger the image. This way of image scale control is a main reason for using interchangeable lenses. On a given film format lenses of longer focal length take in a smaller angle of view than than those of shorter focal length (wide-angle lenses). A 50 mm lens is regarded as the standard focal length for the 24 x 36 mm format. Most Leica-R lenses carry the nominal focal length engraved (usually in yellow figures) beyond the left end of the depth of field scale.

Focal plane shutter: Shutter system consisting of two blinds (each a train of blades on the Leica R, or fabric roller blinds in the Leicaflex) running past the film just in front of the camera's focal or film plane. The first blind uncovers the film, the second one covers it up again. With times longer than $1/100$ sec the film is fully

uncovered before the second blind starts its run. At shorter times ($^1/_{125}$ to $^1/_{2000}$ sec) the second blind starts to close while the first is still running, in effect forming a travelling slit.

Focusing: Action of adjusting the lens-to-film distance to make the lens render objects at different distances in front of the camera sharply on the film. Achieved by rotating part of the lens barrel (the focusing mount) which also carries a scale to indicate the subject distance to which the lens is set. In a single-lens reflex such as the Leica R cameras you usually observe the sharpness change on the focusing screen as you adjust the lens.

f/stop: Generally aperture value (like f/number) but more specifically an exposure step or interval equivalent to the difference between two marked f/numbers on the aperture scale. One f/stop more exposure thus means opening the lens aperture from e.g. f/5.6 to f/4. (Same as 1 EV exposure difference, i.e. a doubling or halving of the effective exposure.)

Full-area metering: Method of exposure measurement where a photocell takes in a sample of most of the image-forming light and more or less averages it to establish a mean exposure. This makes automatic exposure control easy but is subject to exposure error with objects on uneven brightness distribution. Most current full-area metering systems are therefore weighted to pay more attention to the centre of the image (centre-weighted measurement).

Grain: Discontinuous microstructure of the photographic image, due to the irregular distribution in the film emulsion of the crystalline light-sensitive salts. May appear disturbing in big enlargements. Graininess tends to be more prominent in high-speed films (especially black-and-white) while slower emulsions have a finer grain structure and thus can yield bigger enlargements of high quality.

Guide number: A measure of flash output, established according to international standards. With a film of ISO 100 and a hypothetical lens aperture f/1 the guide No. is the distance (usually quoted for metres) from the subject at which the flash would yield a correctly exposed picture. In manual mode (without automatic flash duration control) the guide No. is also an aid to working out the correct exposure: Divide the guide No. by the flash/subject distance to get the required aperture, or by the aperture used to get the required distance. The guide number doubles for every quadrupling of the film speed — e.g. GN 30 with ISO 100 would become GN 60 with ISO 400. The effective guide No. depends also on other factors (lighting angle, subject reflectivity, other reflected light etc).

Highlights: Lightest parts of the subject or image in a print or slide.

Hot-shoe: Shoe on top of the Leica to take flash units, with built-in flash synch contact and dedicated control contacts (R5 and R4).

Infinity: Lens setting to the shortest lens-to-film distance. A subject is reckoned to be at infinity (marked by the symbol ∞) if it is more than 2000 focal lengths away (i.e. further than 100 m with the 50 mm lens). To yield a sharp image on the film of nearer objects you have to increase the lens-to-film distance, i.e. focus the lens.

Iris diaphragm: Set of thin metal leaves leaves built into the lens; they open or close to make the lens opening (aperture) larger or smaller for exposure control.

LED: Light-emitting diode, a minute lamp lit by comparatively small signal currents. Used in the Leica R5 and R4 to indicate meter-set shutter speeds or apertures, to signal the exposure mode in use and to signal the battery condition.

Lens hood: Front-of-lens attachment to screen the front lens surface against stray light from light sources outside the field of view. Intense light rays from such sources reflected from internal lens surfaces may reduce image contrast (flare) and possibly form unwanted ghost images (usually of the lens diaphragm). Most Leica R lenses of 35 mm and longer focal lengths have a built-in extending hood. For optimum image quality a lens hood should ideally be used all the time.

Lens speed: Largest aperture of a lens. A fast or high-speed lens has a large maximum aperture (low f/number), e.g. f/1.4.

Long-focus lens: Lens of longer focal length than the standard lens; i.e. lenses from 85 mm onwards on the Leica R. See also **Tele lens.**

Luminance: Measure of the brightness of an illuminated subject. The international unit is candelas per square metre (cd/m^2). Luminance values can compare subject brightnesses for exposure measurement and can specify metering limits. (Apostilb — asb — is a less used unit, $1\ cd/m^2 = 3.14\ asb$.)

Macrophotography: Strictly, photography at a scale of reproduction larger than 1:1 (1.0x) on the film. In practice often applied to closeups where the magnification in an average final print is likely to reach or exceed 1:1 — i.e. better than about 1:5 or 1:4 on the film.

Macro lens: Lens provided with an extended focusing movement to reach a 1:2 or even 1:1 reproduction scale on the film — e.g. the Macro-Elmarit-R and Macro-Elmar-R lenses. Usually are specially corrected for optimum performance at this close range. Macro lenses also include specially corrected short-focus lenses for high magnifications.

Microprism: Tiny version of the split-image wedge (q.v.) to emphasise the difference between a sharp and an unsharp image. In the microprism ring or spot (depending on the screen) an unsharp image shows typically ragged edges that become abruptly smooth at the correct focus setting.

Mirror lens: Optical system consisting of curved surface-silvered mirror elements as well as glass lenses. The folded light path yields a system of very short physical length (and light weight) for its focal length but the aperture is usually fixed.

Modulation transfer function (MTF): Modern measure of image quality reproduced by lenses and films. Established by measuring — often with automatic instrumentation — the contrast with which the system in question reproduces test targets at various resolution levels. By taking into account both contrast and resolution the MTF is claimed to correlate best with the visual impression of image sharpness and quality but is somewhat complex to evaluate.

Optical register: Distance from the front flange of the camera's lens mount to the film plane — 47 mm in the Leica R models. All lens mounts are matched to this distance for precise operation of any Leica R lens (if fitted with the right aperture control cams) on any Leica R camera.

Photocell: Light-sensitive element that responds to light falling on it by generating signals in an electric circuit. These signals correspond to light intensity and may in suitable systems indicate or control the exposure required for a photographic subject. Of photocells still in use, photodiodes (as used in the Leica R5 and R4) generate or control tiny currents that are then amplified; photoresistors (e.g. in the Leica R3) produce a signal by modifying the resistance in a circuit.

Photodiode: Type of photocell used in the Leica R5 and R4.

Programmed AE (P mode): Automatic exposure mode in the Leica R5 and R4 (but not R4s) in which the meter circuit sets a combination of both aperture and shutter speed for a correct exposure — a particularly automatic way of picture taking.

Push-processing or forced processing: By increasing film development it is possible to bring out a little more detail in low-exposure image portions, simulating the effect of a higher film speed. Such pushing or boosting can improve the appearance of underexposed pictures and may be offered as a service by professional processing labs.

Rangefinder: Optical device for measuring distances, usually by geometric triangulation. Incorporated in rangefinder cameras where it is often coupled with the lens's focusing movement. Most rangefinders rely on visually judging the coincidence or continuity of two images or of a split image. The split-image wedge in the centre of the standard Leica R screen acts in a similar way, though the optical principle is different.

Recycling time: With electronic flash units the minimum time interval between two successive flashes. Determined by the recharging delay of the power capacitors in the unit and depends on the design parameters of the unit, the current source (recycling time is often shorter with nicads) and — with modern automatic flashes — also on the flash/subject distance of the previous exposure. For with near subjects only part of the flash power is used and is thus topped up much faster (sometimes within a fraction of a second).

Reproduction: see Scale.

Resolution: Measure of the fineness of detail that an image-forming lens system and an image recording material (film) can reproduce. Usually measured by photographing or projecting targets of progressively finer black bars separated by white spaces and establishing how many such bars per unit width (line pairs per mm) can be distinguished in the image. The modern approach to image quality assessment also considers the contrast of the resulting image; that and resolution are involved in the modulation transfer function (MTF).

Scale of reproduction: Ratio in a picture of image size (of an object depicted on the

film) to object size (actual size of original object). Expressed either as this ratio (e.g. a 1:5 reduction) or as a straight magnification (0.2x). In an enlarged print the scale becomes the original magnification multiplied by the degree of enlargement.

Selective exposure metering: Light measurement setup where the photocell reads only a small central area of the image field — often called spot metering if that centre area is small enough. Can provide more accurate exposure settings if used intelligently but is often too slow for automatic exposure control.

Selftimer: Delay system that starts a release sequence but then actually releases the shutter only about 10 sec later, for instance to allow the photographer to rush in front of the camera for a self-portrait.

Sensor: Photocell in a flash unit, similar to the TTL flash meter cell in the Leica R5. It controls the flash duration in response to the amount of light reflected back from the subject. Some flash units take an external sensor mounted in the camera's flash shoe. The sensor then controls exposure reliably even with more complex lighting setups.

Shadows: In exposure terms the darkest areas of in subject (and in a print or transparency) that are expected to reproduce visible tone detail.

Shutter speed: Usual reference to exposure time, i.e. period during which the shutter allows light to act on the film. Can be set on the Leica R cameras in so-called geometric steps from 1 to $^1/_{2000}$ sec, with each step approximately half as long as the previous one: $1 - ^1/_2 - ^1/_4 - ^1/_8 - ^1/_{15}$ sec etc. A fast shutter speed implies a short time, a slow speed a long time. (At one time shutters yielded shorter times by running down faster — hence ''speed''. Leica shutter blinds run at the same speed at all settings; the interval between the blinds controls exposure times.)

Shutter speed priority AE: See Time priority AE.

Slave flash: Flash triggered by a light pulse reaching a photocell (slave cell) connected to the flash unit. That light is usually a flash mounted on, and fired by, the camera. This arrangement allows synchronised firing of any number of flash units without cumbersome synch cable connections.

Speed: See Film speed, Lens speed, Shutter speed.

Stopping down: Making the lens aperture smaller by turning the aperture ring to a higher f/number.

Synch contact: Connecting point (flash socket) for synch lead from flash units that cannot make contact through a hot shoe. The Leica R3 (and Leicaflex) has two synch contacts: One for electronic flash and one for — now hardly used — flash bulbs (the latter need different timing for the shutter contacts).

Synch time: Fastest shutter speed setting (shortest time) at which the shutter fully uncovers the film for flash synchronisation. Usually $^1/_{100}$ sec, set automatically by dedicated flash units on the Leica R5 and R4 series; also marked by a special setting on the shutter speed dial.

Tele lens: Telephoto or long-focus lens to magnify the image of more distant objects. Strictly, 'telephoto' implies lenses of a particular optical design that makes them shorter on the camera than their nominal focal length; nowadays 'tele' generally means any lens of longer than standard focal length.

Time exposure: Any exposure longer than the slowest manual shutter speed ($^1/_2$ sec on the R5, 1 sec on the R4 models, 4 sec on the R3). Made by opening the shutter with a cable release at the B setting and keeping it open (by continued pressure on the release) for the required period.

Time priority AE (T mode): Automatic exposure mode (R5 and R4 only, not R4s) in which the camera's meter system sets the aperture to match a preselected exposure time (shutter speed) for correct exposure.

Tripod bush: Threaded bush in camera baseplate (also on some lenses, bellows unit etc) for mounting the Leica on a tripod or table stand for a steadier support. Has a standard $^1/_4$ in. thread.

TTL: Through the lens. Refers to exposure measurement by a photocell inside the camera (as in nearly all Leica SLR models), registering luminances in the image projected by the lens. Also provides flash exposure control in the Leica R5.

Viewfinder: Originally a separate sighting device for aiming the camera at the subject, as a more convenient (but less precise) alternative to a focusing screen in the rear of the camera. The SLR camera combines the advantages of screen focusing with convenient direct viewing. Viewfinder cameras (rangefinder cameras if they also incorporate a rangefinder) are models with a separate, non-reflex, viewfinding system.

Vignetting: Darkening or loss of extreme picture corners or edges due to obstruction inside lens mounting or to too long a lens hood. Slight vignetting can arise with the 2x Extender-R used with the 400 and 560 mm Telyt-R lenses. The latter also show slight finder vignetting of a narrow band at the top of the screen, due to the mirror geometry. This does not however affect the image on the film.

Zoom lens: Lens with movable internal elements that vary the focal length. A zoom lens can thus replace several lenses of fixed focal length. Sometimes classified as one-touch (one ring or sleeve serves for the zoom as well as the focus adjustment, e.g. in the 70-210 mm Vario-Elmar R) and as two-ring zooms with separate zooming and focusing controls, as in the 35-70 mm Vario-Elmar-R.

Leica R lenses

Focal length & name	Max. Aperture	Min. Aperture	Angle of view Horiz.	Diag.	Configuration Elements/groups	Near limit ft	m	Scale	Dimensions (mm) Length	Diam.	Filter	Weight g	oz	Order code	Notes
WIDE-ANGLE AND ULTRA-WA															
15 mm Super-Elmar R	f/3.5	f/22	100°	110°	13/12	6"	0.16	1:3	92.5	83.5	(a)	815	28¾	11 213	
16 mm Fisheye Elmarit-R	f/2.8	f/16	137°	180°	11/8	1'	0.3	—	60	71	(a)	470	16½	11 222	
19 mm Elmarit-R	f/2.8	f/16	86°	96°	9/7	1'	0.3	1:10	60	88	82(b)	500	17½	11 225	
21 mm Super-Angulon-R	f/4	f/22	81°	92°	10/8	8"	0.2	1:6	43.5	78	72(c)	410	14½	11 813	
24 mm Elmarit-R	f/2.8	f/22	73°	84°	9/7	1'	0.3	1:10	48.5	67	60(c)	420	14¾	11 221	
28 mm Elmarit-R	f/2.8	f/22	65°	75°	8/8	1'	0.3	1:8	40	63	48(c)	275	9¾	11 247	nLx
														11 204	Lx
35 mm Elmarit-R	f/2.8	f/22	54°	63°	7/6	1'	0.3	1:6	41.5	66	55	305	10¾	11 251	nLx
														11 231	Lx
35 mm Summicron-R	f/2	f/16	54°	63°	6/6	1'	0.3	1:6	54	66	55	422	14¾	11 115	nLx
35 mm Summilux-R	f/1.4	f/16	54°	63°	10/9	20"	0.5	1:11	76	75	67	660	23¾	11 143	Lx
WIDE-ANGLE SHIFT															
35 mm PA-Curtagon-R	f/4	f/22	54°	63°(d)	7/6	1'	0.3	1:6	51	70	60(c)	290	10¼	11 202	(e)
STANDARD LENSES															
50 mm Summicron-R	f/2	f/16	39°	46°	6/4	20"	0.5	1:7.5	41	66	55	300	10½	11 216	nLx
														11 215	Lx
50 mm Summilux-R	f/1.4	f/16	39°	46°	7/6	20"	0.5	1:7.5	50.6	66.5	55	395	13¾	11 777	nLx
														11 776	Lx
LONGER FOCUS															
80 mm Summilux-R	f/1.4	f/16	25°	30°	7/5	32"	0.8	1:8	69	75	67	625	22	11 881	nLx
														11 880	Lx
90 mm Elmarit-R	f/2.8	f/22	22°	27°	4/4	28"	0.7	1:6	57	67	55	475	16¾	11 806	nLx
90 mm Summicron-R	f/2	f/16	22°	27°	5/4	28"	0.7	1:6	62.5	70	55	560	19¾	11 254	Lx
135 mm Elmarit-R	f/2.8	f/22	15°	18°	5/4	5'	1.5	1:9	93	67	55	730	25¾	11 211	
180 mm Elmar-R	f/4	f/22	11°	13½°	5/4	6'	1.8	1:7	100	65.5	55	540	19	11 922	
180 mm Elmarit-R	f/2.8	f/22	11°	13½°	5/4	6'	1.8	1:8	121	75	67	825	29	11 923	
180 mm Apo-Telyt-R	f/3.4	f/22	11°	13½°	7/4	8¼'	2.5	1:11	135	68	60	750	26½	11 242	(f)

Leica R lenses *continued*

Focal length & name	Max. Aperture	Min. Aperture	Angle of view Horiz.	Diag.	Configuration Elements/groups	Near limit ft	m	Scale	Dimensions (mm) Length	Diam.	Filter	Weight g	oz	Order code	Notes
LONG TELE															
250 mm Telyt-R	f/4	f/22	8°	10°	7/6	5¾	1.7	1:5	195	75	67	1230	43½	11 925	(g)
280 mm Apo-Telyt-R	f/2.8	f/22	7°	8½°	8/7	8¼	2.5	1:8	261	125	112	2750	6 lb	11 245	(g, h)
350 mm Telyt-R	f/4.8	f/22	6°	7°	7/5	10	3	1:7	286	83.5	77	1820	4 lb	11 915	(g)
400 mm Telyt-R	f/6.8	f/32	5°	6°	2/1	12	3.6	1:6.5	384	78	72	1830	4 lb	11 953	(g, i)
500 mm MR-Telyt-R	f/8	f/8	4°	5°	5/5	13	4	1:7.5	121	87	(77)	750	26½	11 243	(g, k)
560 mm Telyt-R	f/6.8	f/32	3¾°	4¼°	2/1	20	6.4	1:9	530	98	S.7	2330	5 lb	11 853	(g, i)
800 mm Telyt-S	f/6.3	f/32	2½°	3°	3/1	40	12.5	1:13	790	152	S.7	6860	15 lb	11 921	(g, i)
ZOOM															
35–70 mm Vario-Elmar-R	f/3.5	f/22	54–29°	64–35°	8/7	3¼	1	1:14(p)	64.5	72	60	420	14¾	11 244	
70–210 mm Vario-Elmar-R	f/4	f/22	29–10°	35–12°	12/9	3½	1.1	1:4(p)	157 (p)	73.5	60	720	25½	11 246	
MACRO ON CAMERA															
60 mm Macro-Elmarit-R	f/2.8	f/22	33°	39°(m)	6/5	11″	0.27	1:2(n)	62	67.5	55	390	13¾	11 253	
100 mm Macro-Elmar-R	f/4	f/22	20°	24°(m)	4/3	2	0.6	1:3(n)	90	67.5	55	540	19	11 212 / 11 232	
100 mm Apo-Macro-Elmarit-R	f/2.8	f/22	20°	24°(m)	8/6	18″	0.45	1:2(n)	104.5	73	60	840	29½	11 210	(f)
MACRO ON BELLOWS (see Chapter 11)						Scale range									
100 mm Macro-Elmar	f/4	f/22	—	—	4/3	Infin. to 1:1			62.5	68	55	365	13	11 230	(q)
50 mm Photar	f/4		—	—		1.2 × to 3.2 ×								549 027	(q, r)
25 mm Photar	f/2		—	—		3 × to 7 ×								549 026	(q, r)
12.5 mm Photar	f/2.4		—	—		7.5 × to 15.5 ×								549 025	(q, r)

General notes to table: Dimensions (and weights) are based on manufacturer's data. The lens length is measured from the front rim to the mounting flange, with the lens set to infinity – i.e. the extent to which the lens protrudes from the camera. The diameter is the maximum diameter of the largest control ring. Filters are usually standard screw-in filters (0.75 mm pitch for all except 112 mm). S.7, S.8, S.8.5 are series filters (2, 2½ or 3 in. dia.) that fit either in the lens hood (some wide-angle lenses) or in a filter slot in the rear tube (Telyt).

Special notes to table: nLx No Leicaflex cams. Lx With Leicaflex cams (present unless otherwise indicated.) (a) Four filters built in. (b) Filters are liable to vignet the image and are not recommended. (c) Also takes Series filters held in place by lens hood. (d) Lens can cover up to 71° and 78° respectively with shift. (e) Usable with working-aperture metering only. (f) Apochromatic correction. (g) Focuses beyond infinity. (h) Internal focusing. (i) Takes Series 7 filters in rear filter slot. Lens length and weight complete with mounting tube (11 906). (k) Fixed aperture; 32 mm screw-in rear filters supplied with lens. (m) At infinity focus. (n) At minimum focusing. (p) At tele setting. (q) Angles of view are not relevant with macro setups. The scale range refers to shortest and (n) Closer and larger with macro Adapter-R or special attachment. (p) At tele setting. (q) Angles of view are not relevant with macro setups. The scale range refers to shortest and longest bellows extensions, without additional extension tubes. (r) Photar lenses need a special adapter (14 259) for fitting to the bellows. The aperture is set manually.

Index

Note: As the book concentrates on the Leica R5 and R4 models, the index does not list specific references to these cameras. Nor does it include Technical Glossary entries (page 164ff) which have their own alphabetical sequence.